TEAM 10 EAST: REVISIONIST ARCHITECTURE IN REAL EXISTING MODERNISM

BOOKS
N°9

The MUSEUM UNDER CONSTRUCTION book series
We are building a Museum of Modern Art in Warsaw
We are writing a new history of art

TEAM 10 EAST: REVISIONIST ARCHITECTURE IN REAL EXISTING MODERNISM

EDITED BY
ŁUKASZ STANEK

MUSEUM OF MODERN ART
IN WARSAW 2014

BOOKS
N°9

PREFACE AND ACKNOWLEDGEMENTS

When in 2012 I suggested a study of the work of the Polish architect, educator and Team 10 member Oskar Hansen by means of the concept of a fictitious "Team 10 East," this study was intended to be a module within the broad research project on Hansen carried out by the Museum of Modern Art in Warsaw. However, the presentations of its first results during the conference "Oskar Hansen—Opening Modernism" (June 6–7, 2013) and the workshop "Team 10 East" (June 8, 2013) at the Museum of Modern Art in Warsaw proved that it is worthwhile to discuss postwar modern architecture from the perspective proposed by the Team 10 East project. Thanks to the generosity of the Museum of Modern Art in Warsaw and the Erste Stiftung, it was possible to present this project in a separate book whose publication coincides with the opening of the Oskar Hansen exhibition at the Museu d'Art Contemporani de Barcelona (MACBA), a collaboration with the Museum of Modern Art in Warsaw.

I would like to thank the participants of the conference and the workshop for their contributions and for our intense exchanges that followed, resulting in this publication. I would also like to thank Dirk van den Heuvel for our discussions about the pro-

ject, which started on the margins of the EAHN conference in Brussels (2012), and which are registered in our joint Introduction to this book. My gratitude goes to all those with whom I had extended conversations while working on this project, and who inspired it in ways that cannot always be captured in footnotes, in particular Eve Blau, Tomasz Fudala, Mary McLeod, Ákos Moravánszky, Joanna Mytkowska, Joan Ockman, Łukasz Ronduda and Felicity D. Scott. Special thanks go to Aleksandra Kędziorek for assisting me with the editorial process. Aleksandra, together with Monika Stobiecka, was also responsible for collecting the archival material and making it available to all contributors to this book, which allowed discussions about many sources until now unaccounted for in architectural historiography. This presentation of previously unpublished archival material would not have been possible without the assistance of the Warsaw Academy of Fine Arts Museum and particularly of Jola Gola, to whom I would like to express my gratitude. I would also like to thank Katarzyna Szotkowska-Beylin, who supervised the process at the Museum of Modern Art in Warsaw, as well as Cain Elliott, who was responsible for the copyediting of the texts, and Mark Bence and Alan Lockwood, the proofreaders. The book was designed by Ludovic Balland Typography Cabinet as part of the Museum under Construction series, published by the Museum of Modern Art in Warsaw.

Łukasz Stanek, October 2013

Łukasz Stanek is a lecturer at the Manchester Architecture Research Centre, University of Manchester. Stanek wrote *Henri Lefebvre on Space: Architecture, Urban Research, and the Production of Theory* (University of Minnesota Press, 2011) and he is currently editing Lefebvre's unpublished book about architecture, *Vers une architecture de la jouissance* (1973). Stanek's second field of research is the transfer of architecture from socialist countries to Africa and the Middle East during the Cold War. On this topic, he published "Miastoprojekt Goes Abroad. Transfer of Architectural Labor from Socialist Poland to Iraq (1958–1989)" in *The Journal of Architecture* (17:3, 2012) and the book *Postmodernism Is Almost All Right. Polish Architecture After Socialist Globalization* (Fundacja Bęc Zmiana, 2012). He taught at ETH Zurich and Harvard University Graduate School of Design, and received fellowships from the Jan van Eyck Academie, Canadian Center for Architecture, Institut d'Urbanisme de Paris, and the Center for Advanced Study in the Visual Arts (CASVA) at the National Gallery of Art in Washington, D.C., where he was the 2011–2013 A.W. Mellon Postdoctoral Fellow.

Dirk van den Heuvel is an Associate Professor at the Faculty of Architecture, TU Delft. He is the head of the recently established Jaap Bakema Study Centre at the New Institute in Rotterdam, a collaborative research initiative between TU Delft and the New Institute. Van den Heuvel is curator of "Open: A Bakema Celebration," the Dutch contribution to the 14th Venice Architecture Biennale. Together with Max Risselada he authored *Team 10—In Search of a Utopia of the Present* (NAi, 2005) and *Alison and Peter Smithson. From the House of the Future to a House of Today* (010, 2004). Together with Mark Swenarton and Tom Avermaete, he is the editor of the forthcoming anthology *Architecture and the Welfare State* (Routledge, 2014). He is an editor of the online journal for architectural theory *Footprint* and of *DASH—Delft Architectural Studies on Housing*. He was also an editor of the Dutch journal *OASE*.

ŁUKASZ STANEK
DIRK VAN DEN HEUVEL

INTRODUCTION: TEAM 10 EAST AND SEVERAL OTHER USEFUL FICTIONS

Team 10 East never existed. Team 10, the breakaway group of architects that disbanded the CIAM organization in the late 1950s in order to renew modern architecture, did not include separate regional branches nor a special group of architects from Central and Eastern Europe. In contrast to the short-lived CIAM-East, founded in the 1930s by architects from Austria, Czechoslovakia, Hungary, Poland and Yugoslavia, there was no similar attempt within Team 10. The participants of Team 10 meetings from Poland, including Oskar Hansen and Jerzy Sołtan, Charles Polónyi from Hungary and Radovan Nikšić from Zagreb in Yugoslavia, as well as other Yugoslav followers and those from Czechoslovakia, would have been reluctant to assume a unified identity that would serve to confirm the division imposed on the continent by the Iron Curtain.

What these architects shared with their Team 10 colleagues from Western Europe was the ambition to advance architecture and urban design in view of the technological and social development of Europe after the period of postwar reconstruction. Like Jaap Bakema, Georges Candilis, Giancarlo De Carlo, Aldo van Eyck, Alison and Peter Smithson and Shadrach Woods, architects from

socialist countries believed that the tenets of prewar modern architecture and functionalist urbanism did not offer sufficient basis for addressing the challenges faced by postwar societies, including technological progress, personal mobility, the increasing importance of leisure, varying scales of human associations and multiple modes of belonging. In response, these architects, just like their colleagues from the West, searched for new architectural solutions: open relational systems that allowed for growth and change; supposedly nonhierarchical structures that lent themselves to appropriation by inhabitants; and spatial configurations that combined permanent and temporary elements that allowed for the expression of individual subjectivity and the coherence of larger collectives.

What distinguished most architects of the fictitious Team 10 East, a name in use throughout this volume, was their affiliation with Central European architectural culture and, above all, the experience of architectural practice in state socialism. In the conditions of the Cold War, this experience included working under politically authoritarian regimes and dealing with the consequences of the political economy of state socialism for the production of space, especially central planning and the (partial) de-commodification of land.

Rather than being a retroactive manifesto, Team 10 East is a generative conceptual tool that grasps at an understanding of what was shared by these fellow travelers of Team 10. It is not the intention of this book to suggest that the work of the architects under discussion is exhausted by their contribution to the Team 10 discourse; nor that their work is to be strictly judged according to the criteria of Team 10. The "East" in the title of the book refers to their specific position from which modernism was rethought, even if it did not always coincide with figures operating from "behind" the Iron Curtain. This is why the book includes texts on Jerzy Sołtan, Charles Polónyi and Alexis Josic (Aljoša Josić) who traveled across Cold War divides that, besides making them drop the diacritical marks in their names, granted them a comparative perspective on the specificity of working in the sphere of real existing socialism. Likewise, architects from Yugoslavia held a separate position as citizens of a social-

ist country that was one of the leaders of the Non-Aligned Movement during the Cold War, and which tried to strike a strategic balance between the two blocs dominated by the United States and the Soviet Union. Similarly, we find a group of Finnish architects practicing within a non-socialist welfare state under the conditions of a "neutrality" carefully negotiated with the Soviet Union.

Contrary to the widespread perception that Team 10 discourse was limited to the Western European welfare state, with occasional excursions to former European colonies and the U.S., this book shows how the key themes and concepts of this discourse were given a differentiated understanding in European socialist countries and the countries included into "socialist globalization."[1] State socialism is seen not only as a condition of oppression, but also as a challenge to and an affordance of architectural practice and imagination, with such contributions as Hansen's biotechnological urbanism for socialist Poland, Polónyi's projects for the postcolonial countries linked to the Socialist Bloc, the projects for Liberec in Czechoslovakia by Miroslav Masák and SIAL Liberec and the rethinking of social-standards in the work of the "Zagreb revisionists."

At the same time, the concept of Team 10 East is a lens that allows for a more differentiated view on the Team 10 discourse as a whole, stretched between 1953, the year when the future members of Team 10 met for the first time at the ninth CIAM conference in Aix-en-Provence and when Stalin died, and 1981, when Team 10 ceased to exist due to the death of Jaap Bakema and when the Soviet Union was still the major rival of the U.S. and the West, even though by then this (second) superpower had become entangled in the Afghanistan war while its ossified *nomenklatura* was incapable of pre-

1 *Team 10, 1953–81. In Search of a Utopia of the Present*, edited by Max Risselada, Dirk van den Heuvel, Rotterdam: NAi, 2005; Dirk van den Heuvel, "Jaap Bakema et l'exemple de Leeuwarden: un paysage artificiel dans l'infinité de l'espace," in *Le Team X et le logement collectif à grande échelle en Europe: un retour critique des pratiques vers la théorie*, edited by Bruno Fayolle Lussac and Rémi Papillault, Pessac: Maison des sciences de l'homme d'Aquitaine, 2008, pp. 119–144; Tom Avermaete, *Another Modern: The Post-War Architecture and Urbanism of Candilis-Josic-Woods*, Rotterdam: NAi, 2005. On architecture and "socialist globalization" see: Łukasz Stanek, "Second World's Architecture and Planning in the Third World," *The Journal of Architecture*, vol. 17, no. 3, 2012, pp. 299–307; Łukasz Stanek, *Postmodernism Is Almost All Right. Polish Architecture after Socialist Globalization*, Warszawa: Fundacja Bęc Zmiana, 2012.

venting the gradual collapse of state socialism. In light of the alternative welfare-distribution systems competing within state socialism, it became possible to reassess the contributions by Team 10 to the welfare state system in general. Such a perspective also allows for the redefinition of the various modes of association and self-identification of the group members, including their political alignment and the international and regional networks in the context of the Cold War. Ultimately, this perspective highlights the various historical continuities at work between the socialist project and postwar architectural discourse.

Mobility and Scales of Association

Most of the narratives in this book begin with the postwar congresses of CIAM. Many participants in the 1949 Bergamo congress recalled the young Oskar Hansen, who publicly criticized a speech by Le Corbusier. With the support of Jerzy Sołtan, this critical voice was integrated as a member of the renewed CIAM and its network. Hansen started with the CIAM Summer School in London in 1949 and then was invited to subsequent CIAM meetings.[2] Other members of CIAM from Central Europe acted as ferrymen for their younger compatriots: József Fischer, who had no chance of acquiring a passport from the socialist regime in Hungary himself, had Charles Polónyi invited to the meeting in Otterlo instead (1959).[3] [FIG. 1] Such intergenerational solidarities might explain why these architects were attached to the idea of continuing CIAM and some, like Jerzy Sołtan, shared their affiliation with both groups, which was facilitated by his contacts with Sigfried Giedion, Walter Gropius, Josep Lluís Sert and Jaqueline Tyrwhitt at the Harvard University Graduate School of Design, where he was a professor from 1961 onward. Hansen also crossed borders between architectural groups; besides his links to Team 10 and CIAM, he was associated with GEAM (*Groupe d'Etude d'Architecture Mobile*) and claimed that his work developed the ideas of the "situationist movement."[4]

2 Jerzy Sołtan, "The Future of CIAM," no date, gta Archive, ETH Zurich,
 42-AR-17-46; Jose Luis Sert, Sigrfried Giedion, "Letter to Oskar Hansen,"
 March 6, 1956, gta Archive, ETH Zurich, 42-323-28-31.
3 Charles Polónyi, *An Architect-Planner on the Peripheries : Case Studies from the
 Less Developed World : The Retrospective Diary of Charles K. Polónyi*, Budapest:
 P & C, 1992, p. 42.
4 Oskar Hansen, *Towards Open Form / Ku Formie Otwartej*, edited by Jola Gola,
 Warszawa: Fundacja Galerii Foksal, Muzeum ASP w Warszawie, Frankfurt:
 Revolver, 2005, p. 203; Oskar Hansen, "Forma Otwarta," *Polska*, no.1, 1972,
 p. 48.

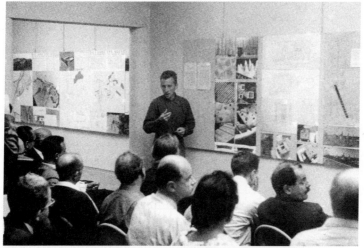

FIG. 1 OSKAR HANSEN DURING HIS PRESENTATION IN OTTERLO, 1959

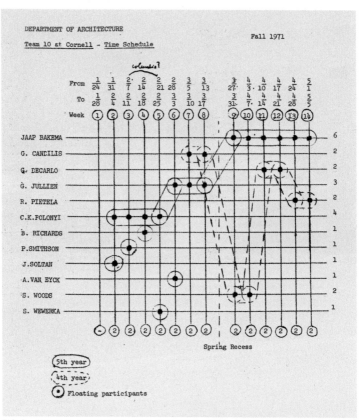

FIG. 2 "TEAM 10 AT CORNELL—TIME SCHEDULE," 1971

Much of this ecumenical approach stemmed from the desire of architects from socialist countries to be a part of debates in the West, while being less concerned about the ideological differences that emerged from these debates. Participating in them was a sufficiently difficult task, and if one compares the list of architects from the region who were present at the Otterlo meeting with the list of those who had agreed to attend, one sees the challenges they faced. Both Sołtan and Hansen arrived from Poland; from Yugoslavia Nikšić and Zvornimir Radić agreed to come, but only the former arrived; the Hungarians Fischer and Pál Granasztoi accepted the invitation, but did not come, while Polónyi attended instead; in spite of their intention to come, Václav Rajniš and Karel Stráník from Czechoslovakia never arrived. [5] In the years to come, Hansen and Polónyi would attend Team 10 gatherings until the 1966 meeting in Urbino, although invitations continued to be sent until the end of Team 10 in the early 1980s. Polónyi could still make it to the Team 10 seminars as organized by Oswald Mathias Ungers at Cornell University (1971–1972) [FIG. 2] and the 1973 conference in Berlin.

Several chapters in this book show that these "difficulties" in mobility can themselves be used to unpack the position of architects in the state socialist system. They faced financial shortages to pay for travel, lacked permission to leave state architectural offices, had to be delegated by their supervisors and receive endorsements from official institutions such as architects' organizations, not to mention these architects' political biographies, which were carefully vetted by regime institutions in charge of issuing passports. Sometimes, socialist countries' postcolonial allies offered alternative locations for professional exchanges with Western colleagues: such an opportunity was provided for Polónyi by the Kwame Nkrumah University in Kumasi, Ghana, where he was teaching in the 1960s. [6] Partners in the West were increasingly aware of these obstacles, and

5 Polónyi, *An Architect-Planner on the Peripheries*, op.cit., p. 42; *Team 10, 1953–81*, edited by Risselada, van den Heuvel, op.cit.; see also: "Meeting in Otterlo—List of Participants and Projects," "Meeting in Otterlo—September 1959—List of Participants and Projects," Oskar Hansen Archive, ASP Warsaw; Oskar Hansen, "Życiorys," Oskar Hansen Archive, ASP Warsaw; see also chapters by Maroje Mrduljaš, Tamara Bjažić Klarin and Marcela Hanáčková in this volume.

6 Ákos Moravánszky, "Peripheral Modernism: Charles Polónyi and the Lessons of the Village," *The Journal of Architecture*, vol. 17, no. 3, 2012, pp. 333–359.

the jokes about Sołtan and Hansen being communist spies or even double agents, as well as Bakema being called "the Tito of Team 10," convey something of the Cold War atmosphere that defined the period. [FIG. 3] Unlike the *Union internationale des architectes* (UIA), organized as an "architectural United Nations" with careful balances across Cold War divides, [7] the contacts between architects from socialist countries and Team 10 were often mediated through short-term apprenticeships and "secondary" networks. [8] These were often more important than formal gatherings. The 1956 conference in Dubrovnik, for example, did not become a meeting place for CIAM and Yugoslav architects, as only the Zagreb architect Drago Ibler attended, since he was in charge of organizing the running of the meeting. Therefore, the planned "Yugoslav CIAM group" never materialized. [9]

These trajectories of circulation were reflected in preferences for models of CIAM's reorganization. The figure of Sołtan is a case in point: his increasing mobility between Poland and the U.S. in the 1950s, followed by his decision to stay in the U.S., was paralleled by the shift in his views on the "future of CIAM." From being an advocate of architects from Eastern Europe, Sołtan moved to arguing that the "future CIAM" must be inclusive, open to "the average architect from all over the world." [10] However, this advice contradicted the vision of Team 10 favored by the Dutch and English members—as an avant-garde group that defined the dismantling of CIAM in two steps. First, as of 1953, younger architects were invited to become official members, and second, as of 1956, national representation at CIAM conferences was replaced by invitation on the basis of personal merit, as proposed by the CIAM Reorganization Committee, which included Team 10 members Bakema, Smithson and Woods. The regional and national CIAM branches were made "autonomous," which meant that in practice they were dissolved. [11]

7 *L'Union internationale des architects, 1948–1998*, Paris: Epure / Belles lettres, 1998.
8 See the paper by Marcela Hanáčková in this volume.
9 See the chapter by Mrduljaš and Bjažić Klarin in this volume.
10 Jerzy Sołtan, "Some Ideas Concerning the Charte de l'Habitat," June 3 / 8 1959, gta Archive, ETH Zurich, 42 JT 22 180-184; see the paper by Cornelia Escher in this volume.
11 See Eric Mumford, *The CIAM Discourse on Urbanism 1928–1960*, Cambridge, MA: MIT Press, p. 257.

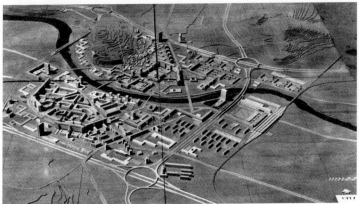

FIG. 3 JOHANNES VAN DEN BROEK AND JAAP BAKEMA, MASTERPLAN
OF THE CITY OF SKOPJE, COMPETITION ENTRY, 1965

The dismantling of national groups as the basis for the new CIAM did not mean that an effort was not made to secure a certain degree of regional representation: for the first large Team 10 meeting in Royaumont (1962), invitations were sent out to the U.S. (Christopher Alexander, Charles Eames, Louis Kahn), Japan (Kenzo Tange, Kiyonori Kikutake, Kisho Kurokawa, Fuhimiko Maki), India (Balkrishna Doshi) and Brazil (Lucio Costa). Amancio Guedes would bring projects from Africa, there were Scandinavian and Mediterranean architects on the list (Geir Grung, Giancarlo De Carlo, José Coderch, Fernando Távora, among others), as well as a range of architects from the U.K., Germany, France and the Netherlands, and last but not least, architects from Poland and Hungary (Hansen and Polónyi). [12] However, the general tendency within Team 10 was to integrate, and when in the 1968 edition of *Team 10 Primer*, Alison Smithson identified "Team Japan" as a special group, the reason was to contrast a separate cultural identity that differed from what Smithson called the "Team 10 way of thinking." Team Japan was described with such shortcuts as "big thunder styles," "'noise'-creating" and "'Samurai' architecture," in contrast to the supposedly proper "Team 10 thinking" that was described as "stress-free" architecture and "reticent acts of quietude"[13] and understood as an attempt to arrive at a specifically European approach. Smithson only listed European architects as core members of the group and this included Polónyi and Sołtan, whom she crucially insisted was a member from Poland, despite his new domicile in the U.S.[14]

12 *Team 10, 1953–81*, edited by Risselada, van den Heuvel, p. 350; largely based on the Smithson papers as kept in the archive of the former NAi, Rotterdam, the New Institute as of 2013.

13 *Team 10 Primer*, edited by Alison Smithson, 1968 edition, Cambridge, MA: MIT Press, 1968, p. 7; she even talks about a specific racial difference at this point. Clearly, Alison Smithson is referring to Japanese Metabolism whose members were present at various Team 10 meetings: Kenzo Tange at Otterlo in 1959, Fumihiko Maki at Bagnols-sur-Cèze in 1960, Kisho Kurokawa at Royaumont in 1962 and at Urbino in 1966.

14 The Irish-American Shadrach Woods is listed as being from France, and the former Briton Ralph Erskine from Sweden. The first edition of the *Primer* (*Team 10 Primer*, edited by Alison Smithson, first re-edition; reprint of the two special issues of *Architectural Design* of 1962 and 1964, without colophon, undated, probably 1965) lists the following as Team 10 members: J.B. Bakema, Aldo van Eyck (both from Holland), G. Candilis, S. Woods (both from France), A.&P. Smithson, John Voelcker (England), J. Soltan (Poland), Gier [sic] Grung (Norway), Ralph Erskine (Sweden), J. Coderch (Spain). The 1968 edition has a slightly different list (*Team 10 Primer*, 1968 edition, op.cit.; second re-edition based on the first, undated re-edition with a new 20 page preface): John Voelcker is deleted, while Giancarlo De Carlo (Italy), C. Pologni [sic] (Hungary) and S. Wewerka (Germany) are added.

A European Tradition?

Architects from socialist countries, including Charles Polónyi, were inclined to embrace this vision of a shared European tradition as the foundation for the "Team 10 way of thought," with Polónyi summarizing the contribution of the group as follows:

Jaap Bakema's moral responsibility of the Great Number as well as his Dutch rational hopefulness; Alison and Peter Smithson's worry about the loss of difference, nuances of scale, appropriateness, and the loss of the still wonderful idea of the working compactness of the village, town, city; and the Mediterranean self-evidence of the works of Candilis-Josic-Woods, accompanied by the writings of Shadrach Woods; Ralph Erskine's dreams of a friendly society; Louis Kahn's explorations of hierarchical organizations; the architectural quality reached in the buildings of Aldo van Eyck, Giancarlo De Carlo, and Reima Pietila [sic].[15]

However, what comes to the fore in this melancholic list is less a unified European tradition and more a number of individual reinterpretations of particular regional sensitivities, that, with the obvious exception of Kahn, might be broadly classified as Mediterranean and northern. Architects from socialist countries would add the architectural tradition of Central Europe to this classification. [FIG. 4]

Bringing together fellow travelers of Team 10 from socialist countries revealed their alliance with the modernist architectural traditions of the region. This included attention to the national—and nationalist—dimension of modernism in Central Europe and the complex relationships between modernism, modernization and nation-building in this region during the early 20th century. Within the broader framework of modernization efforts, various lines of modern architecture, art and design were embraced by the governments of the new nation-states emerging between the

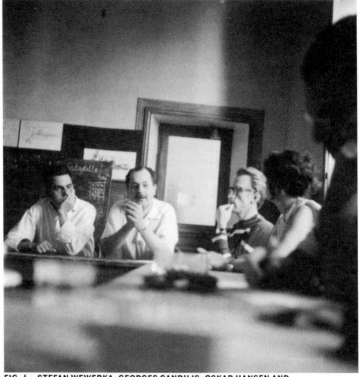

FIG. 4 STEFAN WEWERKA, GEORGES CANDILIS, OSKAR HANSEN AND
ALISON SMITHSON IN BAGNOLS-SUR-CĖZE, 1960

Adriatic and the Baltic Seas in the wake of the First World War.[16] This included avant-garde architecture, and in the contested territories of Central Europe after the First World War, such as Moravia and Silesia, modern architecture was interpreted as a rupture with the past and an embodiment of the new nation-states. This national dimension is very present in the Linear Continuous System, the urbanization model proposed by Oskar Hansen for socialist Poland. The four bands of urbanization suggested by Hansen were intended to link up the country and integrate the territory of the new state, whose borders had shifted west following agreements between the victors of the Second World War. This relationship between modern architecture and nation-building became particularly relevant for those architects from Central Europe who, like Polónyi, were designing in postcolonial states faced with the challenge of nation-building in territories that were characterized by ethnic divisions and culturally dependent on their former colonizers.

When working on export contracts in Ghana, Nigeria, Algeria and Ethiopia, Polónyi made reference to his earlier resettlement projects in rural Hungary and his later scheme for the Balaton region there. This belief that Central European architects had specific tasks and obligations toward rural areas, villages and small towns was another theme shared by the members of the Team 10 East group. Indeed, the recognition of this fact had been one of the reasons for creating CIAM-East, and it was at the center of the CIAM-East meetings in Budapest, Brno and Zlin in 1937, and on Mykonos in the Cyclades in 1938, which were attended by architects from Austria, Czechoslovakia, Hungary, Poland and Yugoslavia.[17] In particular, it was the Hungarian architect Virgil Bierbauer who addressed the question of the underdevelopment of rural territories. In Hungary, where the development of the countryside had been the focus of broad debates since the late 19th century, the decisive shift was to recognize villages as settlements where over half of the country's population lived in almost feudal conditions, which could only be

16 Andrzej Szczerski, *Modernizacje: sztuka i architektura w nowych państwach Europy Środkowo-Wschodniej 1918–1939*, Łódź: Muzeum Sztuki, 2010.
17 Monika Platzer, "From CIAM to CIAM-Ost. CIAM and Central Europe," in *Shaping the Great City*, edited by Eve Blau and Monika Platzer, Prestel, Munich, 1999, pp. 227–231.

addressed through a nationwide modernization project.[18] This argument was spelled out in Bierbauer's paper "Les bases de la reconstruction rurale en Hongrie," where he argued that an architectural intervention was dependent on the architect's alliance with powerful players. These included the state, which, according to Bierbauer, needed to create a network of centers to concentrate the social, economic, cultural and technical facilities of the rural population, and cooperatives intending to pool small farmers' land and organize production and other aspects of life for those involved. Only then would urgent architectural interventions become possible, including plans of the collective buildings of each settlement, and type plans of housing for agricultural workers, both individual and collective.[19] It was this very challenge of providing equal living conditions for all that Hansen acknowledged to be at the root of his Linear Continuous System, which was meant to link villages and small towns with the general welfare-distribution network and thereby provide inhabitants with social-standards that were previously limited to urban populations.[20]

Team 10 and the Socialist Project

Following Alison Smithson's focus on the European architectural tradition as the shared cultural basis of the Team 10 architects, one may detect a common system of references, as well as internal differences within the group. However, this perspective obscures the deep political divisions within Team 10. The 1968 edition of the *Primer* is a case in point. Edited by Smithson, the book carefully staged a polyphonic consensus among the members of the group by maintaining a unified level of generality in their lamentations on the state of affairs in housing, town planning and politics, and thereby abstracting from the specifics of Cold War oppositions.[21] [FIG. 5]

Nevertheless, looking at the Team 10 discourse through the lens of its fictitious Eastern group shows that, more

18 Moravánszky, "Peripheral Modernism," op.cit.
19 Virgil Bierbauer, "Les bases de la reconstruction rurale en Hongrie," gta Archive, ETH Zurich, "Dossier 5 Kongress: Andere Beiträge."
20 Hansen, *Towards Open Form*, op.cit.
21 *Team 10 Primer*, 1968 edition, op.cit., pp. 4–19.

often than not, what first appears as cultural differentiation actually points to fundamental political differences inscribed within the context of the Cold War. For instance, we might point to the postulate of "openness" shared by all members of Team 10, from Hansen's idea of Open Form to the Smithsons' designs of an "open city." Those versed in European art history might have linked the notion of "openness" to Heinrich Wölfflin's "open form"; those interested in British political philosophy might see a connection with Karl Popper's "open society"; those acquainted with French philosophy would look to Henri Bergson's "open totalities"; readers of post-structuralism would envisage "open structures"; yet others could relate this concept to the "opening" of Marxism after and against the Stalinist "closure," which itself can be taken in different directions, from Henri Lefebvre to Leszek Kołakowski, Adam Schaff, György Lukács, Ágnes Heller and the Yugoslav Praxis group. These references, ranging from Popper's anti-Marxism to Marxist dissidents from within the Socialist Bloc, make it clear that the discourse on "openness," rather than being a shared concept, was actually a field of political dissensus that was covered by the conciliatory tone of Team 10 publications.

Likewise, the key Team 10 concept of the "greatest number" makes this dissensus even more evident. Those working in socialist countries could not have missed this concept's affinity with Marxist discourse on the "masses" as the progressive subject of history. Hence architects like Hansen argued there was essential proximity between the "problem of the greatest number" and the project of socialism. [22] The consequences of such a position would reach far beyond what the Western members of Team 10 would have embraced, including an overarching program for the state expropriation of land, both in cities and in the countryside, which was one of the premises of Hansen's Linear Continuous System. [23] By contrast, the "greatest number" meant something very different in the work of Candilis-Josic-Woods when applied in France to migrants from the

22 Czesław Bielecki, "The Pragmatism of Utopia / Pragmatyzm utopii," interview with Oskar Hansen, *Architektura*, 1977, no. 3–4, pp. 12–25.

23 Hubert Mącik, "Utopia w służbie systemu?," in *Wobec Formy Otwartej Oskara Hansena: idea – utopia – reinterpretacja*, edited by Marcin Lachowski, Magdalena Linkowska, Zbigniew Sobczuk, Lublin: Towarzystwo Naukowe KUL: 2009, pp. 69–79.

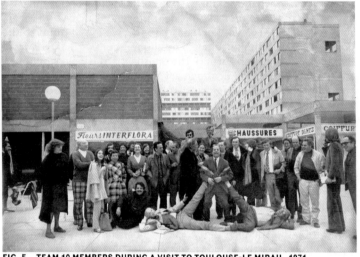

FIG. 5 TEAM 10 MEMBERS DURING A VISIT TO TOULOUSE-LE MIRAIL, 1971

countryside and from the former French colonies—work that was based on Candilis' earlier experience with the colonial administration in North Africa. [24] Yet another elaboration of the term can be found in the work of the Smithsons, who referred to the rise of a new "middle-class society" where the norms and aspirations of prewar society were seemingly leveled out and the former limits to social mobility had been removed. [25] The Smithsons also quoted the concept of the "Great Society" as used by Aneurin Bevan, the Minister for Health who initiated the National Health Service and was also involved in drawing up the new Town and Country Planning Act of 1947, which enabled the implementation of large-scale housing programs for the next decades, including the planning of New Towns. [26]

The concept of "participation" can be taken as a third example. What architects in Zagreb and Belgrade deemed an architectural interpretation of the self-management system in socialist Yugoslavia, and what Hansen saw as a consequence of socialism, took on an entirely different meaning in West Africa. There, Charles Polónyi saw residents' participation in the construction of their own houses to be an indispensable ingredient for tackling urbanization with insufficient resources. This can be contrasted with the Terni project by Giancarlo De Carlo (1969–1974), which was commissioned by the Italian national steel corporation for its workers and their families. In the Byker Wall project by Ralph Erskine in Newcastle-upon-Tyne (1968–1981), participation by users aimed both to gain information about their preferences and to organize shared responsibility. [27] From the early 1960s, the discourse in France or Britain regarding participation had been used by several architects to oppose the paternalism of the welfare state while announcing the emergence of a new system of governability, while in socialist countries it was launched by those who wanted to dispose of the

24 Colonial Modern: Aesthetics of the Past, Rebellions for the Future, edited by Tom
 Avermaete, Serhat Karakayali, Marion von Osten, London: Blackdog
 Publishers, 2010.
25 Dirk van den Heuvel, "Alison and Peter Smithson: A Brutalist Story
 Involving the House, the City and the Everyday (Plus a Couple of Other
 Things)," PhD dissertation, TU Delft, 2013.
26 Ibid.
27 Team 10, 1953–81, edited by Risselada, van den Heuvel, op.cit.

remnants of the Stalinist regimes, taking either reformist or dissident positions. In spite of these differences, participation of inhabitants always required a program of their education and the rethinking of models of governance—all key topics for Team 10, which called for specific answers in response to local conditions.

These divergent paths to the concepts of "openness," "greatest number" and "participation" make it clear that Team 10 discourse was essentially structured by what it almost always silenced: the socialist project. Herman Hertzberger addressed this intuition when he stated that "in architecture Team 10 and CIAM as well are the equivalent of socialism." He immediately qualified this: "I'm not saying literally. Maybe Giancarlo De Carlo is the only one who directly linked politics and architecture. Bakema certainly did not and Aldo van Eyck did it in a more philosophical way." [28] Hertzberger went as far as to suggest a connection between the breakdown of socialism and the end of Team 10. Even Alison Smithson, who was certainly not a Marxist, would testify that Sweden was to her the ultimate example of a society where everyone was "wonderfully equal, equal, equal...." The "Scandinavian invention of Social Democratic architecture," she wrote, "with its clean blend of rational functionalism and response to use, related to climate worthiness that was rooted in a still memorable vernacular." [29] To that representation she would add: "to my generation, the flags of Stockholm's Exhibition of 1930 signaled a joyful promise of a friendly, trusting society that believed socialism meant a togetherness of one extended family." [30]

This socialist imagination, itself heterogeneous and taking various directions, was the yardstick for Team 10 projects, and it constituted one of the main lines of continuity between modern architecture before and after the war. In the case of the prewar CIAM, it included admiration for architecture in the Soviet Union, not only during its initial avant-garde phase but also after the introduction of socialist realism, which led Hans Schmidt to argue for a more careful rethinking of the relationship between modern architecture

28 C. Tuscano, "I Am a Product of Team 10. Interview with Herman Hertzberger," in ibid., pp. 332–333.
29 Alison Smithson, "Heritage: *Carré Bleu*, Paris, May 1988," *Spazio e Società*, no. 45, 1989, pp. 100–103.
30 Ibid.

and the past.[31] Particularly strong were alliances between modern architects and social-democratic municipalities or progressive housing cooperatives in Amsterdam, Berlin, Budapest, Frankfurt, Hamburg, Lyon, Prague, Rotterdam, Vienna and Warsaw, as well as the garden cities of the Paris suburbs. Many of these experiences reverberated in the welfare-state project after the Second World War, and in a 1978 interview Peter Smithson qualified the immediate postwar period as follows: "At the time I would have said I was a socialist as well. It simply seemed like a good cause. I suppose everyone of my generation would say the same thing. If you would ask Bakema the same question you would get a similar answer, because a generation felt this way."[32] The affiliation between the welfare-state project and the Team 10 architects was evident in the work of the Smithsons, as well as other members of Team 10 from France, Italy and the Netherlands, whose designs were largely based on state commissions. However, already by the late 1960s and early 1970s the Smithsons viewed the initial project of the postwar years as morally perverted and they would speak most disdainfully of the "labor union society" and its all-pervasive materialism.[33] Disillusioned, they opposed the collective subjectivity that they felt the welfare-state system had produced; instead, they preferred a society composed of individuals with a sense of obligation, responsibility, creativity and "reasoned choice."

Real Existing Modernism and Its Revisions

These qualities rather exactly coincided with what Oskar Hansen had in mind when imagining the socialist society for which he proposed the Linear Continuous System. If for Aldo van Eyck the crisis of modernist urbanism stemmed from the "failure to govern multiplicity creatively,"[34] Hansen argued that the Linear Con-

31 Hans Schmidt, "Wie können wir das Erbe der architektonischen Vergangenheit ausnutzen?" (1933) in idem, *Beiträge zur Architektur 1924–1964*, Zurich: gta Verlag, 1993, p. 95–97; see also *Ernst May 1886–1970*, edited by Claudia Quiring, Wolfgang Voigt, Peter Cachola Schmal and Eckhard Herrel, München: Prestel, 2011.

32 Hans van Dijk, "Wat is er nu helderder dan de taal van de moderne architectuur," interview with Peter Smithson in *Wonen-TA/BK*, nos. 19–20, 1978, p. 31.

33 Van den Heuvel, "Alison and Peter Smithson," op.cit., pp. 79–80.

34 *Team 10 Primer*, 1968 edition, op.cit., p. 100.

tinuous System responded to this crisis by proposing a model of governance for socialist Poland that offered maximal freedom and choice for every individual, and allowed them to be mobilized within the collective. In Hansen's words, "the classless, egalitarian, and non-hierarchical character of the housing form for society in the Linear Continuous System [...] should make it clear how everyone is dependent on the collective and the collective is dependent on the individual."[35]

For Hansen, the new socioeconomic regulation of socialist Poland—a centrally planned economy as well as a socialized land market and construction industry—was the necessary precondition for implementing the Linear Continuous System. The socialist state was not only an indispensable agent for the execution of Hansen's project, it was also the object of that project. In other words, Hansen's architecture was not simply instrumental in the modernization processes as determined by the regime, but it was also conceptualized as a contribution to debates about the direction that modernization should take.[36]

This ambition to discuss alternative scenarios for socialist modernization, and hence alternative scenarios for modernization of socialism, was shared by most of the protagonists of this book. As Łukasz Stanek shows, Hansen's Linear Continuous System was a contribution to debates concerning the reform of socialist governance in 1970s Poland. Yugoslav architects were also rethinking the capacity of architecture to mobilize the population toward participation in political decisions, economic activities and social exchange according to the principles of socialist self-management, and to develop it beyond its Fordist phase.[37] The language of Team 10 architecture was particularly suitable for this task, and Block No. 22 in New Belgrade, as described by Aleksandar Kušić, is a case in point: designed as an interplay of the free articulation of cells between fixed points, this housing ensemble offers a snapshot of the ambitions, and disappointments, of an architecture designed

35 Oskar Hansen, "Linearny System Ciągły," *Architektura* nos. 4–5, 1970, p. 135; see also: Hansen, *Towards Open Form*, op.cit.
36 See the text by Łukasz Stanek in this volume.
37 See *Postfordism and Its Discontents*, edited by Gal Kirn, Maastricht/Ljubljana: Jan van Eyck Academie and Peace Institut, 2010.

to be appropriated by its inhabitants. Similarly, the spatial flexibility of the Workers' University in Zagreb aimed to have a pedagogical effect: to stimulate workers' intellectual and artistic capacities and their socialization processes, indispensable for advanced economic and political activities, as Renata Margaretić Urlić and Karin Šerman show. The Workers' University was one of many proposals through which Zagreb architects aimed to subvert ossified typological patterns and bureaucratic mainstream modernization procedures, as discussed by Maroje Mrduljaš and Tamara Bjažić Klarin. Their chapter shows that some buildings designed according to the Team 10 principles of additive structure and functional flexibility proved to be particularly suitable when the financial shortages of real existing socialism allowed only parts of these buildings to be completed.

 This paradoxical commensurability between the socialist state and open morphologies was very different from what Sołtan and his team imagined in early post-Stalinist Poland for the Polish Pavilion at Expo 58 in Brussels, described by Aleksandra Kędziorek. The search for an alternative to the housing neighborhoods, as they were built in socialist Czechoslovakia, resulted in urban structures that paralleled the work of Candilis-Josic-Woods. In particular, their reinterpretations of the traditional European city were guided by a renewed architectural language. An example of such an approach was the project for Liberec's lower-town center by Miroslav Masák and his team, analyzed here by Marcela Hanáčková, which integrated a new urban structure into the old fabric of the town by means of differentiated scales of urban experience, spatial complexity and a mixture of urban functions. Also for Polónyi, the Team 10 principle of "minimal intervention" seemed appropriate for urbanization schemes that respected and developed existing settlement patterns, social structures and local characteristics in the countryside of socialist Hungary, as discussed by Levente Polyák.

 All these proposals were formulated within the specific institutional, economic, social and intellectual conditions of state socialism in Poland, Hungary, Yugoslavia and Czechoslovakia. They were often critical of the ways in which several tenets of mod-

ernism had been mobilized by socialist regimes within modernization programs since the 1950s. This "real existing modernism"[38] was the immediate context for the work of the protagonists of this book, who contested, challenged and revised these realizations, and suggested alternatives. Rather than postulating that modernism should be abandoned, they explored its potentiality within a shared and interlinked set of references, concepts, images and experiences, and by this exploration they expanded the set in question. In these discussions, the lines between architecture, policy and politics were almost immediately intersected, since political actors determined the production of space in socialist states. These intersections could have taken many forms, as Stanek shows in his study of how Hansen's projects were perceived by the regime in Poland: from "productive" criticism introducing corrections to the course taken, through to "reformism" that did not fully grasp the possibilities of change provided by socialist states; irresponsible "utopianism" that might have led to state resources being squandered; stubborn "dogmatism" that misunderstood the logic of the historical moment; dangerous "revisionism" undermining the fundamentals of the Party; or political "dissidence" that sometimes took the form of an overidentification with the regime in order to take the Party at its word.

Interaction with the regimes required a constant adaptation of strategies, and in order to negotiate between these various modes of transgression, Hansen adopted a number of positions, including that of an experimenter, educator, polemicist and artist. Sometimes, architects were able to play with controversies between various sections of the Communist Party, and in this way present their own projects as "consensus": this is how Ákos Moravánszky discusses the success of Charles Polónyi's planning of the Balaton area. Polónyi, Hansen and Sołtan challenged the position of architects within the division of labor in their respective countries, and this was reflected in their ideas about the organization of CIAM and Team 10, as Cornelia Escher shows. As Mrduljaš, Bjažić Klarin and Jelica Jovanović argue, one avenue for such a reappraisal of architectural labor was to define research as a core competence of architects, and a neutral field with regard to the political divisions in socialist states.

38 See Stanek, *Postmodernism Is Almost All Right*, op.cit.

Such "neutrality" would have been attractive in particular to architects who, like Polónyi and Hansen, were never card-holding party members. But neutrality in the Cold War needed to be expressed actively, since impartial nonengagement was insufficient, as Eeva-Liisa Pelkonen contends in her comparison of architectural culture in Finland and Poland during the 1960s.

It is this multifaceted relationship between political and architectural revisionism that is conveyed by the concept of Team 10 East, and points to intersections between intellectual trajectories and political choices that otherwise appear disparate. More generally, this book shows that the Cold War in European architecture was restricted neither to the familiar narrative of the "self-representation" of the two regimes (with East and West Berlin as favored examples), nor to proxy wars in architectural exports to the "Third World." In fact, political dissensus surrounding socialist ideas continued to play a part in the reimagining of postwar modernism. While this book employs "Team 10 East" as a useful fiction to unpack the equally fictitious consensus within Team 10, it also begins to map the geometry of dissensus in postwar architectural culture, which was much more complex than the singular line of the Berlin Wall.

Ákos Moravánszky is Professor of Theory of Architecture at the Institute for the History and Theory of Architecture of ETH Zurich since 1996. He studied architecture in Budapest, and received his PhD in Vienna. He was a research fellow at the Zentralinstitut für Kunstgeschichte in Munich, and the Getty Center in Santa Monica. From 1991 until 1996 he was appointed visiting professor at MIT. During the academic term 2003–2004 he was appointed visiting professor at the Moholy-Nagy University of Art and Design in Budapest as a Szent-György Fellow. He worked as an editor, and serves on the editorial boards of several international architectural journals. His research and publication activities are principally focused on the history of Eastern and Central European architecture in the 19th and 20th centuries, the history of architectural theory, and the iconology of building materials and construction. He is the author of several books, including *Competing Visions: Aesthetic Invention and Social Imagination in Central European Architecture, 1867–1918* (MIT Press, 1998).

HUMANIZING MODERNISM: OSKAR HANSEN, CHARLES POLÓNYI AND THE ART OF SAILING WITH THE WIND

M*agyar Építőművészet* [*Hungarian Architecture*], the journal of the Union of Hungarian Architects, began publishing in 1962 with a cover that announced a new program. Instead of the Soviet-style, printed-word covers of the socialist-realist period and subsequent years, the journal's hesitant return to the abandoned modernism of the prewar years, with its organic pattern of a leaf and its fine system of veins, was understood as a clear alternative to the grid, the organizational model and emblem of the International Style. [FIG. 1] For the new graphics editor, the architect Elemér Nagy, Alvar Aalto's plea for an "elastic standardization" with his example of magnolia flowers was an important source when looking for images to capture this new spirit: to maintain the modernist goals of efficient mass production but endow them with the potential for individual variations. The idea of a system that is able to sustain diversity resonated well with the new cultural policy of the three T's in Hungary: *támogatás, tűrés, tiltás* [support, tolerance and ban]. This program had already been proposed in 1957 by the deputy minister of culture and pragmatic cultural politician György Aczél in a letter to the Political Committee of the Hungarian Socialist Workers' Party.

FIG. 1 COVER OF THE JOURNAL *MAGYAR ÉPÍTŐMŰVÉSZET,* **NO. 1, 1962**

FIG. 2 COVER OF THE JOURNAL
MAGYAR ÉPÍTŐMŰVÉSZET, **NO. 4, 1962**

However, tolerance only became a central element of political prac-
tice by 1960s, when Aczél started to reach out to noncommunist Hun-
garian intellectuals.

The cover of the fourth issue of *Magyar Építőművészet*,
from the same year, shows the construction of a prefabricated build-
ing, playing again with forms of permanence and change. [FIG.
2] The
contributions in this issue convey a sense of optimism and expecta-
tion. A large part of the issue was dedicated to Team 10 and the work
of architects related to the group, including Oskar Hansen. Charles
(Károly) Polónyi, who was in charge of this part of the journal, knew
the architects personally, following his invitation to the CIAM Otterlo
conference in 1959. Hansen and Polónyi were exceptional figures in
the architectural culture of the 1960s. Unlike most of their colleagues
in their respective countries, they traveled to the West when this was
a highly valued privilege, and were in regular exchange with Western
architects and artists who played decisive role in the development
of postwar modernism.

During the 1950s, foreign travel—with the exception of
visits by official delegations under the watchful eyes of the Commu-
nist Party—was not possible. After the political consolidation of Hun-
gary during János Kádár's leadership of the Communist Party (1956–
1988), borders to neighboring socialist countries could be crossed,
although Yugoslavia was a more difficult case than Czechoslovakia.
But the chief symbols of a new freedom were the blue passports that
allowed their holders to visit Western countries. To cross the bor-
der to the West meant not only breaking through the Iron Curtain
that divided the two worlds, but also reconnecting with a space
whose history and culture were more familiar than those of the East.
Journeys made before the wars were also present in the memory of
many families. All of this contributed to the perception that western
travel was the ultimate fulfillment of the desire for an authentic expe-
rience of freedom and culture, while leisure and consumption were
more connected to travels in socialist countries.[1] Conversely, travel-
ing to the West meant lodging in budget hotels and staying away

1 István Béres, "Go West! (or East). A külföldre utazás a hatvanas, hetvenes
 évek magyar turizmusában," in *Helye(in)k, tárgya(in)k, képe(in)k: A turizmus
 társadalomtudományos magyarázata*, edited by Fejős Zoltán, Szíjártó Zsolt,
 Budapest: Néprajzi Múzeum, 2003, pp. 121–141.

from restaurants to save money for sightseeing. While organized group travel was generally possible, individual blue-passport applications were frequently rejected. Applications for business or study trips by architects initiated by their employers (state-owned planning firms) underwent lengthy evaluation processes through a special office of the Ministry of Building. In the late 1940s and 1950s, being invited to conferences, starting with Paris (*Congrès Technique Internationale*, 1946), Bridgewater (CIAM VI Reunion congress, 1947) or Milan (Triennale 1947), was a highly political matter, and the Communist Party used such events to gradually replace invited guests who were members or sympathizers of the social-democratic party with their own candidates. New opportunities emerged in 1960, when Ernő Goldfinger—an architect of Hungarian origin—arranged what was officially called "a study trip with employment": every year, four Hungarian architects were invited to work at the London County Council or in an office, including Goldfinger's own. It was a highly successful program, overseen by RIBA and MÉSZ (the Union of Hungarian Architects)—the architects returning from London made a significant impact on the development of Hungarian architecture. [2]

Non-Aligned Architects

Both Polónyi and Hansen belonged to the generation of architects who started their careers in the immediate postwar years. Polónyi was born in 1928, six years after Hansen. They played similar roles at the time when socialist realism was abandoned following the famous speech of Nikita Khrushchev in 1954.

The two architects first met in person in 1959 in Otterlo, at the last CIAM meeting. Originally, the architect József Fischer, an important member of the prewar CIAM and a social democratic MP after 1945, was invited. Fischer, however, had already fallen victim to the *Szalámitaktika* [salami tactics] of the Communist Party at this time, which was at war with the social democrats, who had previously been their allies for tactical reasons. Fischer's position as director of the Budapest Board of Public Works was suspended. He was under police observation and traveling to Otterlo

2 Mariann Simon, *Kalandozások kora: Magyar építészek a 60-as évek Angliájában*, http://arch.et.bme.hu, date of access December 4, 2012.

was out of the question. He therefore nominated the young Polónyi, in whose apartment the CIAM documents were kept when Fischer suspected that his home would be searched.

The architect Pál Granasztói must have played a significant role in Polónyi's first contacts with Fischer and in his invitation to Otterlo. Granasztói was already an authority on cities and urban design before the war.[3] He had edited the journal of the Hungarian architecture avant-garde, *Tér és Forma* [*Space and Form*], with Fischer between 1942 and 1945, and was in charge of a department in Fischer's Board of Public Works. While Fischer rejected any cooperation with the communists along with their dictates on socialist realism and was ready to pay the price, Granasztói became an influential policy maker in the Ministry of Building. Both Granasztói and Polónyi belonged to the circle of "non-aligned" architects tolerated by the Communist Party and even supported by its more progressive wing, including Máté Major, the influential communist architect turned professor of architectural history and a member of the Academy of Sciences, who had good connections with politicians in the highest ranks of the government but never entirely rejected his modernist roots. Granasztói skillfully connected prewar and postwar urban theory (Brinckmann, Gibberd, Lurçat and Lavedan) with his own travel observations, also making scarce but obviously sufficient references to Russian authors and examples. Earlier, during the short coalition period, he participated with Fischer (and László Málnai) in the CIAM Bridgewater conference in 1947. What he sensed there, however, was the "obsoleteness and obsolescence" of the old CIAM.[4] He was a proficient writer on urban issues, and the book *Budapest holnap* (*Budapest Tomorrow*, 1959), co-written with Polónyi, shows an approach that came very close to that of Team 10.[5] In the French résumé of the book, the authors emphasize: "In conceiving this little book, preceded by many studies, projects and preparations for many years, the authors wanted to increase the desire and willingness of people to work for their city. For the construction and

3 Pál Granasztói, *Városok a múltban és a jövőben: Városépítészeti tanulmányok*,
 Budapest: Egyetemi Nyomda, 1942.
4 Granasztói, *Alakok, álmok*, Budapest: Szépirodalmi, 1974, p. 170.
5 Pál Granasztói, Károly Polónyi, *Budapest holnap*, Budapest: Gondolat, 1959.

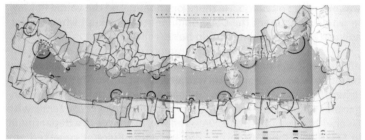

FIG. 3 DEVELOPMENT PLAN FOR THE BALATON REGION BY TIBOR FARKAS, JÓZSEF
CSILLAG, PONGRÁCZ GÁLL, ISTVÁN BÉRCES, CHARLES POLÓNYI (VÁROSTERV)

embellishment of a city does not depend only on projects and regulations, but above all on the strength and the will of its people."[6]

At the Otterlo conference, Hansen presented his manifesto "The Open Form in Architecture—the Art of the Great Number"[7] and Polónyi spoke about his Balaton project.[8] Two years earlier, in 1957, he was appointed chief planner of the south shore of this large Hungarian lake, with the task of developing a master plan for the region as the most important target for leisure and emerging tourism. It was an ominous year, when imprisoned participants in the 1956 uprising were executed.

At this time, the official Party position on tourism was still in the making. The institutional structure of international tourism had been dismantled in 1948, and organized leisure for Hungarians was delegated to the communist trade unions that now owned holiday homes in different regions of the country. Many Party officials opposed the "individualist," "petty-bourgeois," "consumerist" mentality that they associated with tourism, disapproving of feeble signs of prosperity while jealously guarding benefits to which they felt entitled. The debate ended with the victory of the pragmatic faction five years later when, at the eighth congress of the Hungarian Socialist Workers' Party in 1962—the one that adopted the famous "who is not against us, is with us" stance—declared that opening the borders of Hungary to Western tourists would debunk the fabrications of imperialist propaganda about Hungary. Into the 1970s, however, the two key tourist regions of Hungary, Budapest and Lake Balaton (a frequent meeting point for relatives living in the two Germanys), were regarded as ideological battlefields of the two political systems. 1962 was the year when the income from tourism first exceeded the investment required for its infrastructure, but it still remained an insignificant portion of the national economy.

6 Ibid., p. 127.
7 Oskar Hansen, Zofia Hansen, "The Open Form in Architecture—the Art of the Great Number," in Oscar Newman, *CIAM '59 in Otterlo*, Stuttgart: Karl Krämer, 1961, pp. 191–192.
8 Ch. Polonyi [sic], "Seasonal Buildings, Lake Balaton," in Newman, op. cit., pp. 43–47.

With its regional scope, the Balaton project was on a new and hitherto unexplored scale for Hungarian planners. The architect Tibor Farkas, who was in charge of the whole project, asked for the advice of Granasztói, but the urbanist could only encourage him to attempt an experimental approach. The Balaton plan was based on the evaluation of a wide range of analytical material and local knowledge, gathered in situ. [FIG. 3, 4] Polónyi decided to spend the summer on the lake, sleeping on an inflatable bed in his office, to work with the local population. This kind of practice remained the basis of his work long after completing his Balaton assignment.

In his Otterlo presentation, Polónyi emphasized the low budget and limited technical possibilities. The main goal was to develop the planned resort region with well-chosen infrastructural improvements—such as waterworks, canals, sanitary installations, roads—and by establishing a network of centers and subcenters.

Polónyi wanted to reverse the government's intention to establish a tourist region "where Western tourists could spend their hard currency undisturbed by the 'natives'."[9] He understood his task to be "stimulation, based on close cooperation between a team of architects, engineers and the local people."

To establish a connection between the master plan and the design of individual buildings, a new instrument was introduced: a "coordination plan" containing guidelines to ensure a homogenous appearance. For the buildings at Balaton, Polónyi and the structural engineer Boris Klimov used simple standardized elements of reinforced concrete, prefabricated in a workshop during the winter. In order to be used for various purposes, the supporting structure was designed as an independent element, very much in Hansen's sense of the Open Form. Polónyi explained that the "supporting structure had to be independent from the plan, as it had to be used for various kinds of buildings. A single type of pillar and a single type of beam composed a balance, which was similar to the draw wells used by peasants. This single element could be multiplied in a number of variations." During the summer months, the climate

9 Polónyi, *An Architect-Planner on the Peripheries: Case Studies from the Less Developed World*, Budapest: P&C, 1992, p. 27.

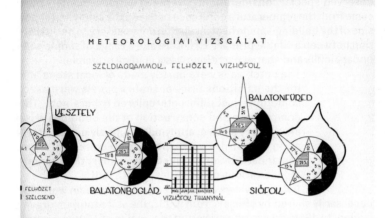

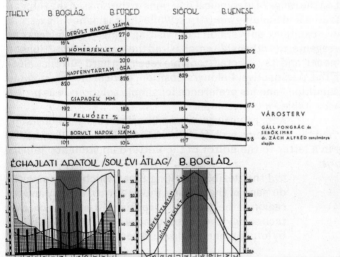

FIG. 4 DIAGRAM OF METEOROLOGICAL CONDITIONS IN THE BALATON REGION

deserved special consideration: "Overhead air movement—which came from the temperature difference between the sunny and shady side of the building—made heat insulation unnecessary." The distinction between a simple primary structure and a range of simple secondary infills and spatial partitions was a guiding principle:

> The outer walls were mostly made of local stone and for the partitions brick or timber panels were used, sometimes just differently colored fishers-nets. The composition and construction of the buildings were always very simple, applying commonly used materials in the spirit of vernacular architecture. The effect of standardization was more disciplinary than hindering the various possibilities.[10] [FIG. 5, 6]

Polónyi's views on architecture for tourism were not necessarily shared by officials from IBUSZ, the state tourism organization. In 1964, its experts criticized the quality of tourist accommodation around Balaton, saying that it equaled that of Bulgarian seaside hotels, although the prices were higher.[11] Again, this sheds light on the range of ideological positions in the ranks of the Hungarian tourist and building industries. While the dogmatic wing warned against capitalist subversion from visiting Hungarian émigrés and other agents, the other side emphasized the success of the "Hungarian model" and its expected, tangible results in hard currency. Seen from this perspective, Polónyi's position, critical of "conspicuous consumption," and his preference for simple solutions, was probably acceptable for both camps.

After returning from the Otterlo meeting, Polónyi summarized the problems architects in both the East and West had to face in a letter to the editor of the Rotterdam students' journal *Draakje*:

> [...] the flexible dwelling type, which can solve the demand of the masses; the pattern of the city and the region of the great town; regaining a leading role over technology; the consequences of uncertainties driven by future technical development in our plans; the con-

10 Ibid., p. 28.
11 Géza Rehák, "Turizmuspolitika Magyarországon különös tekintettel a Kádár-korszak első tíz évére," PhD dissertation, Debreceni Egyetem, 2011.

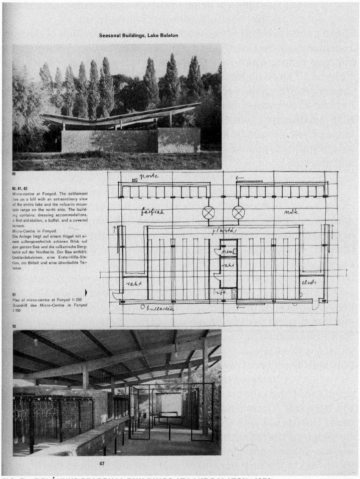

Seasonal Buildings, Lake Balaton

60

60, 61, 62
Micro-centre at Fonyod. The settlement lies on a hill with an extraordinary view of the entire lake and the volcanic mountain range on the north side. The building contains: dressing accommodations, a first-aid station, a buffet, and a covered terrace.
Micro-Centre in Fonyod.
Die Anlage liegt auf einem Hügel mit einem außergewöhnlich schönen Blick auf den ganzen See und die vulkanische Bergkette auf der Nordseite. Der Bau enthält: Umkleidekabinen, eine Erste-Hilfe-Station, ein Büfett und eine überdachte Terrasse.

61
Plan of micro-centre at Fonyod 1:200
Grundriß des Micro-Centre in Fonyod 1:200

62

47

FIG. 5 POLÓNYI'S SEASONAL BUILDINGS AT LAKE BALATON, 1959

sideration of demands which surpass physical and bio-
logical needs (tradition, continuity, etc.)[12]
These points seemed to resonate well with the position of Hansen,
as explained in his Open Form manifesto. Hansen likewise argued for
a larger vision, when he spoke of "city-planning on the scale of
a region."[13] More importantly, he also stressed what Polónyi called
the uncertainties, the necessity of recognizing that the architect can-
not know "everything himself," and must therefore play a "concep-
tual-coordinating role." Both urged the importance of surpassing
mere physical-biological needs, but while Polónyi emphasized the
role of tradition and continuity, Hansen first mentioned psychology
and morality.

Team 10 in the First, Second and Third Worlds

In his introductory essay to the aforementioned issue
of *Magyar Építőművészet* (4/1962), Polónyi briefly outlined the history
of CIAM from the first congress in La Sarraz to the 1959 meeting in
Otterlo, declaring: "while the old CIAM had to fight the external
enemy, now the time of infighting has arrived."[14] The Team 10 mem-
bers criticized positions that focused on the moment to establish
a rigid "order." Polónyi's argument was that the need for stability must
be coordinated with the steady change of life, the need for growth,
and mobility. He dedicated one part of the magazine to introducing
"some characteristic figures" of Team 10 with their writings and pro-
jects: Alison and Peter Smithson, Candilis, Josic and Woods, and Jaap
Bakema's short text "1960–2000."[15]

To stress the necessity of recognizing the "subjective"
practice of the inhabitant, Polónyi published his translation of
the Hansens' "Open Form in Architecture—The Art of Great Num-
bers," illustrated with the design for a Polish pavilion for interna-
tional fairs, covered with trapezoid elements and usable on plots of
various shapes, and a photograph of one such pavilion at the São
Paulo fair. In the final paragraph of his introduction to the Team 10
essays, Polónyi added, in an apologetic manner characteristic of

12 "Dear Mr Reid," letter by Polónyi in *Draakje* 7, Rotterdam 1959, pp. 15–16.
13 Oskar Hansen, Zofia Hansen, op. cit., p. 190.
14 Polónyi, „CIAM-TEAM X", *Magyar Építőművészet*, no. 4, 1962, p. 38.
15 Ibid.

publications that might have raised some eyebrows at the time: "there is a lot of crudeness, inconsistency, and debatable contradiction" in the published statements. But this is characteristic of our time, he added, and it is "exactly the inconsistency that fuels the kind of vitality that might be inspiring in our country."[16]

Polónyi announced that in the future, other groups would be introduced in the magazine: Japanese architects, GEAM (*Groupe d'Etude d'Architecture Mobile*) and the group behind the journal *Le Carré Bleu*. Polónyi, like Hansen, was a regular contributor to that journal, founded in Helsinki in 1957, which strongly supported the goals of Team 10, disseminating its members' contributions internationally. The need to test the lessons of his Balaton assignment in the new, even larger context of the "less developed world," was an opportunity that he eagerly seized, as did many other architects from the *Le Carré Bleu* circle. His intention to regularly update readers of *Magyar Építőművészet* about Team 10 activities had to be suspended when he left with his family for Ghana in 1963.

Despite the international success of the Balaton plan, including the Sir Patrick Abercrombie Prize of the UIA in 1965, Polónyi's career as an architect-designer seemed to come to a full stop when a Communist Party official made it clear to him that without Party membership he had no chance of getting larger commissions. Since he did not want to leave Hungary for good, a new option opened up for him and many other like-minded professionals: to work in the so-called Third World.

In Hungary, the TESCO International Organization for Technical-Scientific Cooperation was established by the government in 1962 as an employment agency with a profile for "intellectual export," that is, to place Hungarian professionals abroad, riding the wave of development aid from the USSR and the socialist countries. The chance to travel, an extremely treasured privilege as we already mentioned, along with a salary in hard currency, contributed greatly to the attractiveness of this arrangement. From 1963 to 1969, Polónyi worked for the Ghana National Construction Corporation with architects and planners from Britain, the Americas (both North and

16 Ibid.

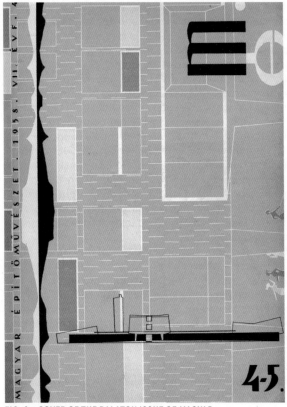

FIG. 6 COVER OF THE BALATON ISSUE OF *MAGYAR ÉPÍTŐMŰVÉSZET*, **NO. 4–5, 1958**

South), West Germany, Poland, Yugoslavia and Hungary. In Ghana, Kwame Nkrumah had been elected as the country's first prime minister after a period of unrest in 1951. He embraced the idea of Africanization that in 1949 had replaced government policy during the colonial period. Questioning the basically British orientation of professional culture, Nkrumah supported the work of experts from the so-called Eastern Bloc and the study of Ghanaians in those countries, hoping for financial aid.

Polónyi was appointed professor of the Architectural School of the University of Science and Technology in Kumasi. With his colleague Brian Fewings, he taught a four-term postgraduate course in urban planning. Their intention was to work on various scales, cutting across the traditional boundaries between regional planning, urban design and architecture. A team of students collected data and analyzed the national and regional role of Kumasi, the geography, history, economy and demography of the area, and its visual aspects, and then they prepared individual proposals for "Kumasi 2000."

Polónyi was very impressed by the Fort Lamy project by the Candilis-Josic-Woods (CJW) office, made in 1962 and published in the 1/1965 issue of Le Carré Bleu.[17] Located in today's N'Djamena, the capital of Chad, between the African and the European quarter, the project proposed primary and secondary structures based on the "stem to cluster" principle.

Polónyi and Graham Wilton, his colleague in Kumasi, wrote a letter dated the 15th of March 1965, published in the 3/1965 issue of Le Carré Bleu, in which they interpreted CJW's approach in relation to "Open Form." They emphasized that the project was very instructive for architects working in Africa, where proposals must be made according to life patterns which will supposedly be the result of a new economy, but for people whose old living habits persist.

We have to study their existing life; we have to suppose the future... Usually it is hardly possible to build more than a "core" house, to be completed by people previously living in self-made houses...[18]

17 Fort Lamy, Le Carré Bleu, no.1, 1965, unpag.
18 Charles Polónyi, Graham Wilson, "Tribune libre", Le Carré Bleu, no. 3, 1965, unpag.

Speaking about their resettlement project for the Volta River Authority in Ghana, Polónyi and Wilton stressed:

If we apply the "every scale open structure" approach to the family unit who will live in our "core house," we have to make it possible for the families themselves to extend the core to include whatever number of cells and storage spaces they may need, but without creating a slum-like environment. [19]

They proposed changing the traditional courtyard to a linear model, open to one direction. This program comes very close to Hansen's belief that buildings are incomplete until they have been appropriated by the users in an unfolding process of life.

In Kumasi, Polónyi and his colleagues combined teaching activities with resettlement planning, often relying on students to perform evaluations and develop hypothetical improvement schemes. Such tasks became important for the revision of the curriculum of the school of architecture, when the interest in cultural identity and tradition started to abandon a utilitarian approach for a more cultural one. This was reflected in the restructuring of the first postgraduate urban planning course in West Africa, in which rural settlement structures were documented in a very detailed manner. The so-called Occasional Reports by Polónyi and his colleagues formed the core of an ambitious mapping process that had to reflect the variety and range of cultures of dwelling and settlement typologies throughout the country, differences that the official government planners had neglected due to a lack of resources. [FIG. 7]

Polónyi and his team determined the factors that would continue to shape urban development in Kumasi until the end of the century: rapid urbanization, large-scale industrialization, the rise of motorized traffic and growing living standards. "The combination of all these factors will inevitably produce a city in 2000 AD that is totally different from that of today, but which nonetheless is distinctively tropical, distinctively Ghanaian, distinctively Kumasi," he wrote. [20]

19 Ibid.
20 B.T. Fewings, C.K. Polónyi [sic], *Kumasi Study: Report on the Postgraduate Urban Planning Course*, Kumasi: Faculty of Architecture, 1967, unpag.

FIG. 7 POLÓNYI (TOP CENTER), ANIKÓ POLÓNYI (WITH HAT)
BIDDING FAREWELL TO COLLEAGUES AND FRIENDS AT KUMASI
AIRPORT, AROUND 1968

FIG. 8 COVER OF *KUMASI STUDY:
REPORT ON THE POSTGRADUATE
URBAN PLANNING COURSE.
OCCASIONAL REPORT NO. 7* BY B.T.
FEWINGS AND C.K. POLÓNYI, 1967

The problems of development, its pace, possibilities and instruments for planning and the role of the planner occupied a central position in Polónyi's thinking. Since his projects were always dependent on the shifting fortunes of the countries and governments for which he was working, he reflected on this issue in a number of texts. He was convinced of the nonideological nature of technological thinking. In a contribution written for issue 1/1968 of *Le Carré Bleu* with his colleagues J. Max Bond and J.P.R. Falconer, he criticized the usual characterization of development in various countries on different scales in terms of right or left.

> We think that on the contrary, there are a variety of strategies and tactics and the technological development and the economic requirements precede the ideology.[21]

Flexibility and openness were the principles emphasized in his reports. In this proposal, recommended for government/ quasi-government requirements, he explains the use of multistory structures as follows:

> Fixed elements are only the floor slabs, columns, stairs and the ducts for water, sewage and electricity. They can accommodate offices, agencies, workshops, flats, and so forth on their upper floors, while the ground floor provides space mainly for trade purposes. This would include the numerous small shops, petty traders, craftsmen and hawkers. Instead of prohibiting "partisan architecture" normally produced by such people, the intention is to encourage it. They are invited to participate, and control is attempted by providing at least a roof and essential services.[22] [FIG. 8]

An interest that Polónyi and Hansen shared with a number of other architects of the time was planning the linear city. Issue 2/1969 of *Le Carré Bleu* published Oskar Hansen's "Proposition pour un système d'urbanisme linéaire," on the Linear Continuous System,

21 J.M. Bond, J.P.R. Falconer, C.K. Polonyi [sic], "De la transformation à l'innovation", *Le Carré Bleu*, no.1, 1968, unpag.

22 *Housing and Urbanization: Report on the Postgraduate Urban Planning Course (1967–68, Term 1–2), Occasional report on student progress*, edited by S.B. Amissah, J.P.R. Falconer, C.K. Polonyi [sic], Kumasi: Faculty of Architecture, University of Science and Technology, 1968.

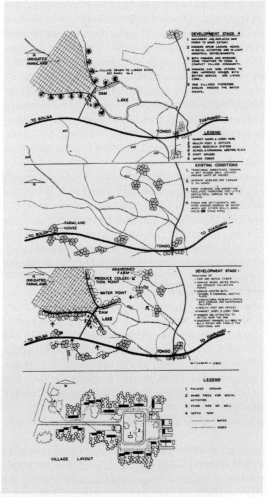

**FIG. 9 IRRIGATION PROJECT FOR NORTHERN GHANA BY
E. DEI-AGYEMANG, ARCHITECTURAL SCHOOL OF THE
UNIVERSITY OF SCIENCE AND TECHNOLOGY IN KUMASI**

an urban plan based on a linear spine, as opposed to "centric" cities, which grow in response to demand (a form that Hansen likened to the organic form of gangrene). [FIG. 9] Le Corbusier's scheme of the linear city was certainly well known to both Hansen and Polónyi, not only directly, but also through André Wogenscky, an architect of Polish origin, who was the main assistant and *chef d'atelier* to Le Corbusier and who published in issue 5–6/1946 of the latter's journal *L'homme et l'architecture* the manifesto-like essay "La cité linéaire industrielle." Polónyi's colleague in Kumasi, J. Max Bond, the Harvard graduate who later became the first black chairman of Columbia University's school of architecture, started his career as an architect in Wogenscky's office.

Polónyi wanted to combine the idea of the linear city with flexible low-cost building technologies in 1969, when his employer TESCO-KÖZTI, the export and consulting department of the large state planning office for public buildings KÖZTI, won the competition for planning the city of Calabar in Nigeria. Polónyi had to assume a key role in developing a master plan. A range of dwellings were proposed for various incomes; the closed street-front idea has been developed further:

> A narrow "priority-for-pedestrians" street, which carries the storm and waste water, is flanked by a wall carrying electricity, water pipes, and separates public activity from private life. This wall has openings like doors, vents, and occasionally an entrance for shop, workshop and bar, if required by the owner. On the private side of the wall are located a shower, a W.C., two water taps and a cooker. Each house can be extended as required by the family. [23]

The declared intention of Polónyi was to exert as little aesthetic control as possible:

> Instead of prohibiting and persecuting, we also intended to encourage a kind of "partisan architecture", which produced temporary structures under the arcades of the buildings in the business districts. [24]
> [FIG. 10, 11]

23 Ibid., p. 24.
24 Polónyi, *An Architect-Planner*, op.cit., p. 84.

In the same year, 1969, Oskar Hansen was working on a housing project with very similar goals. The Office of Experimental Building Construction of the United Nations organized an international competition for the best method of building engineering for Peru. The task was to design a low-cost housing estate for 10,000 inhabitants on the northern periphery of Lima. Among the 13 invited teams was the group with Oskar Hansen and Svein Hatløy as architects. A life-size fragment of the structure had to be executed. Two stages were proposed for the execution. First, building the housing estate by using industrial methods and materials. The basic elements for one- or two-story house were hollow reinforced concrete-wall elements and ceiling slabs. Because of high humidity in Lima, Hansen's team proposed what they called wall-cases with a ventilated cavity between the shells. In the second phase, individual extensions of houses were foreseen, depending on number of inhabitants and their financial means. As with Polónyi's use of fishermen's nets, the doors in this model were made of cane plait to provide fresh air. To finish each house individually, the team proposed to use blocks, beams, glass plates, plaiting, paper and textiles.

This will give the inhabitants the opportunity to create interiors that will fit their needs and wishes. [...] The project complies urban conditions, public transport, the influence of natural conditions, determines social conditions and guarantees ecological balance inside the housing estate—commented the planners. [25] [FIG. 12, 13]

In analyzing the role of the actors of modernization in Ghana, Polónyi divided the "total resources" into public and private sectors. The public sector belonged to the government: the capital and technical assistance of the state, including its legislative and communication controls, alongside its control of resources. The private sector was subdivided into categories of the commercial (private capital) and popular; the latter included skills, initiative, enterprise, organizational ability, and also "increasing" political power. For Polónyi, the role of the state was, first of all, planning, the distribution and control of resources as well as technical assistance provided by experts like himself.

25 Oskar Hansen, Svein Hatløy, "Modelowy projekt taniego osiedla mieszkaniowego w Limie (Peru)," in *Architektura*, no. 3, 1971, pp. 107–111.

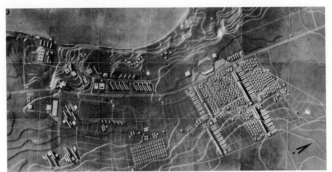

FIG. 10 CALABAR, MODEL OF THE CITY CENTER,
GOVERNMENT HILL AND THE RESIDENTIAL SECTOR, 1970

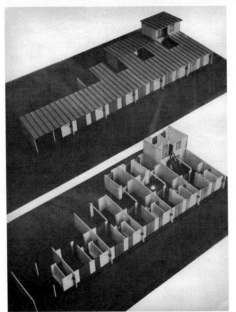

FIG. 11 CALABAR, MODEL OF LOW-RISE
HIGH-DENSITY HOUSING, "EARTH SCRAPERS," 1970

Planning seems to be an Anglo-Saxon profession—he wrote in a short statement in 1990.—It has to co-ordinate, resolve conflicts and help to make decisions regarding the activities of authorities, various private organizations and individuals in a democratic society. In the East or in the Third World the role of the planning organization is mostly restricted to the technical and aesthetic solutions of the decisions already made.[26]

While Polónyi was optimistic that the program of economic liberalization, with growing space for—however limited—private initiatives, would help to realize planning in its Anglo-Saxon sense, and limit the significance of state administration and bureaucracy, he considered a planned economy to be superior to capitalism. In a longer study for the important and widely read review of social science, *Valóság* [*Reality*], he concluded in 1981:

Forms of planning, financing, supervision, organization and motivation need to be readjusted as the economic premises change, according to the actual state of development of the productive forces. Consequently, the balance of central regulation and local interests will be shifting toward the latter. It should not be forgotten, however, that a planned economy, that is, the socialist system of economic regulation is still the more efficient system of production and distribution than the capitalist economy, with its wasteful concurrence-fight of private enterprise, that is not free of state interventions, protectionism, monopolies and bans, and which—assuming the same resources—forces larger strata of the population to the periphery of society.[27]

Urban design provides the know-how to negotiate conflicting interests, but it has to rely on the "organizing ability" and "political power" of the population. Polónyi did not need to revise

26 Polónyi, "East-West and North-South perspective 1990," statement for the Università degli Studi di Reggio Calabria, October 12, 1990, manuscript courtesy of Mrs. Anikó Polónyi.
27 Polónyi, "A Nagy Számok építészete," *Valóság*, no. 2, 1981, p. 74.

this thesis—the lack of planning and the failures of privatization after the collapse of socialism proved him right, he thought. The positive role that he attributed to the intellectual as planner was, however, much debated by the political opposition in Hungary before the collapse of socialism. The writer György Konrád, who contrasted attempts at city planning by the state and its experts with vibrant, "unplannable" urban life, distrusted the benevolent intentions of the intellectuals in socialist countries, accusing them of adjusting themselves readily to the administrative-dictatorial apparatus, in order to become the true ruling class while abandoning the proletariat. [28]

Polónyi had to disagree, since he insisted on the responsibility of the engineer in helping the population in their everyday needs by providing houses in large housing estates, if that is what could be achieved under the given historical circumstances. He saw himself as a sailor who had to sail with the winds since he could not change the weather—this was one his favorite metaphors, which reminds us today of Rem Koolhaas' image of the surfer—and unlike Konrád, he was not ready to go abroad and to embark on a successful teaching and publication career as a dissident from the Eastern Bloc. The debate about reformism versus revolution was and is part of everyday discussions in Hungary. Every schoolchild learns about the dilemma of 1848, the debate of Lajos Kossuth, leader of the failed revolution against the Habsburgs, and Ferenc Deák, who initiated the so-called compromise with Austria and the economic and cultural upswing that followed. The failed uprising of 1956, crushing the hopes for a radical change in the foreseeable future, strengthened the case of those who argued for reforms, and the development in the 1960s seemed to prove them right. After all, most of the so-called dissidents such as György Konrád, Iván Szelényi or Ágnes Heller were critical of capitalism themselves, and thought that state socialism can and must be reformed.

"Re-humanizing" modern culture as a program has particular relevance under these circumstances. On the one hand, in the United States, this call was meant to resuscitate neglected community life in the big cities, using means not really associated with

28 George Konrád, Iván Szelényi, *The Intellectuals on the Road to Class Power*, New York: Harcourt, Brace, Jovanovich, 1979.

FIG. 12 PREFABRICATED MODULES, LOW-COST HOUSING
ESTATE FOR 10,000 INHABITANTS ON THE NORTHERN
PERIPHERY OF LIMA, DESIGN: OSKAR HANSEN AND SVEIN
HATLØY, 1969–1972

modernism, such as monumentality and the spectacle—reminding its critics of totalitarian strategies of political propaganda. In the socialist countries, the notion of socialist humanism appeared in various contexts, generally, opposing the rigid schemes of socialist-realist literature, for example, and emphasizing instead the tradition of the realist novel with its interest in everyday life and optimistic messages (György Lukács, Tibor Déry). Jean-Paul Sartre's postwar essay "L'existentialisme est un humanisme" was received with much interest (and critical attention) in both political blocs. For a philosopher like Ágnes Heller—a member of the Budapest School that emerged around the person of György Lukács—humanism first meant an opposition to the ruling Party apparatus only interested in retaining its privileges. For Heller's formation as a philosopher, Sartre and the philosophy of existentialism were crucial.

For the architect, "re-humanizing" required attention to everyday life, and empathy-based strategies, rather than just providing space for the "Existenzminimum" as architects of the modern movement declared. Hansen called for the rethinking of the basic principles of Polish urban planning in his "humanization studies," urging for the possibility of individual formation and occupation, rather than the mere distribution of space. For Polónyi, as for his Team 10 colleague Oswald Matthias Ungers, humanism also meant "learning from history, accepting and absorbing other cultures, a continuum of space and time." In his autobiography, Polónyi wrote of his appreciation of his professors at the TU Budapest because of their analysis of historic precedents as the precondition for modern work. Polónyi described one of them, the architect Károly Weichinger, as follows: "He taught us to 'humanize' modernism by introducing some regional and historical elements into the design, [...] avoiding pseudo or pastiche categories."[29]

The "Etatist Elite"

Intellectuals with credentials acknowledged in the West, like Hansen and Polónyi, played an important role in the particular force field of state socialism. Liberal politicians of the Party needed them as allies against the conservative wing, and were ready

29 Polónyi, *An Architect-Planner*, op.cit., p. 20.

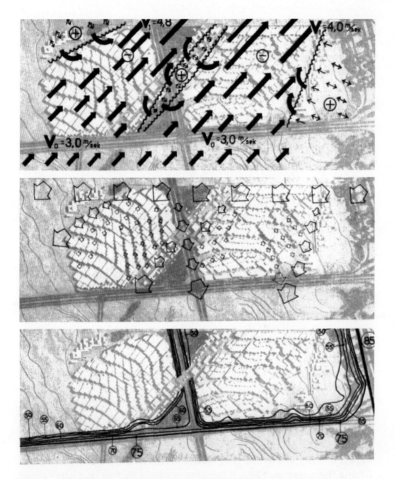

FIG. 13 LOW-COST HOUSING ESTATE FOR 10,000 INHABITANTS ON THE NORTHERN PERIPHERY OF LIMA, DESIGN: OSKAR HANSEN AND SVEIN HATLØY, 1969-1972

to give them some "privileges"—like travel to the West. They themselves were hoping for the continuation of reforms, an increasing severance between Party and state, while they were also critical of the capitalist market economy. This was very clear in the previously quoted statement of Polónyi about the planned economy. In this essay in *Valóság*, he referred to the sociological research by György Konrád and Iván Szelényi in prefabricated housing estates, to pose the following question:

> How should we proceed? It is obvious that the "etatist" planned economy must be maintained. Not only in socialist countries, where the conditions characteristic for capitalism do not exist anymore and cannot be restored, but even under capitalist conditions. Urban design has taken on a regional or national scale, and because the resources of the Earth are limited and shared, after all, the scale of urban design must be extended to encompass the whole earth, turning it into an orbistic surface. This is only possible through state and even international institutions, with etatistic instruments.[30]

But, the "etatistic elite" cannot assume responsibility to "determine all manifestations of life"; decisions on a range from the local to national scale must be made on the appropriate level. Polónyi warned of leaving such decisions to the market, since this would result in segregation: "this would exclude huge masses from the possibility of having an apartment, since the banks only give credit to those who belong in one way or the other to the prosperous."[31]

This statement and the notion of "etatistic elite" closely reflects the self-understanding of Polónyi, who rejected both the party-state and market capitalism. In a biographic essay published in 1987, he wrote that he had to leave the Balaton and go to Ghana "because by 1960, it became obvious for me that our etatist projects were realized in a plebeian way, and this destroys the Balaton."[32] "Elitism," a term with positive connotation for him, had much to do with the bourgeois middle-class tradition of Central Europe.

30 Polónyi, *A nagy számok építészete*, op. cit., p. 70.
31 Ibid., p. 71.
32 Polónyi, "Magyar tervező a harmadik világban," in *Válogatás a ,Magyarok szerepe a világ természettudományos és műszaki haladásában' című konferencia előadásaiból*, edited by Mihály Ágoston, Ernő Pungor, Emil Szluka, Budapest: Országos Műszaki Információs Központ és Könyvtár, 1987, p. 263.

When speaking about the positive effects of colonization, he stressed that the colonizers established a peace on lands with local wars and tribal animosities that was similar to the Pax Turcensis and Pax Austriaca on the Balkans and in the east of Central Europe. "They built up not only effective public administration, but also constructed roads, railways, towns, harbors, schools and hospitals." [33] And it was this elitism that prevented him from embracing political power even when it was within reach. After the collapse of state socialism, "nonaligned" intellectuals like Polónyi were handled as potential candidates for positions in city governments. In 1990, Polónyi was on top of the list of the Alliance of Free Democrats party as a candidate for mayor of Budapest. When the deputies of the party interviewed him, however, Polónyi closed his statement with the remark that even in the case that he would lose the election, the nominee of the competing party, the Democratic Forum, would be a good expert. No wonder his name was immediately dropped from the list. [34]

The motif of in-betweenness, the metaphor of navigation, the oft-repeated maxim of retaining loyalty and preserving rights [35] might make Polónyi appear as a figure unable to make decisions. Oskar Hansen occupies a similar middle ground between artist-architect and recipient—who is not a mere recipient anymore but rather a participant in the creative process. Fellow architects in their respective countries looked at them as outsiders, who did not or could not build a sizable oeuvre. But this is exactly the place where they wanted to position themselves as intellectuals. Rehumanizing architecture was for them a program for rebalancing the roles of the state and the public: the state's role restricted to providing the necessary financial, legislative and technical resources, while the public should be empowered to assume responsibility for initiative, organization and execution. Both Polónyi and Hansen developed methods and techniques for putting this program into practice on various scales. In his autobiography, Polónyi summarized the task that Oskar Hansen must have been in full agreement with: "the inflexibility of the First Machine Age had to be developed into adaptability in the Second Machine Age." [36]

33 Polónyi, An Architect-Planner, op.cit., p. 43.
34 Ferenc Kőszeg, "K. történetei – Építész," Magyar Narancs, March 13, 2008.
35 Ákos Moravánszky, "Peripheral Modernism: Charles Polónyi and the Lessons of the Village," The Journal of Architecture, vol. 17, no. 3, 2012, pp. 333–359.
36 Polónyi, An Architect-Planner, op.cit., p. 42.

Levente Polyák is an urbanist, researcher and critic. He studied architecture, urbanism, sociology and art theory in Budapest and Paris and he has been visiting lecturer at the Moholy-Nagy University of Art and Design, the Budapest University of Technology and TU Wien, where he taught urban studies and architectural theory. He worked on urban projects in New York, Paris, Budapest and Pécs. As a founding member of the KÉK—Hungarian Contemporary Architecture Centre, he organized events and exhibitions dealing with various contemporary urban and architectural phenomena, which have included the *Budapest Architecture Film Days* since 2007, and the *Vacant City* lecture and workshop series since 2012. He was a visiting fellow at Columbia University in New York City, OrangeLabs, and the École d'Architecture Paris-Malaquais in Paris. Currently, he is a PhD candidate at the Central European University in Budapest.

MAPPING OPPORTUNITIES:
THE INTERNATIONAL SUMMER SCHOOLS OF
CHARLES POLÓNYI

Starting in the 1960s, Charles Polónyi spent much of his time working in developing countries. The experience of initiating and heading the postgraduate planning course in Accra, the first in West Africa, and creating the master plan of Calabar and Addis Abeba, along with his exchanges within Team 10, resulted in numerous invitations to architectural schools such as the Architectural Association, Nottingham University, Cornell University and the Middle East Technical University, which complemented his teaching at Budapest Technical University (BME) from 1980. Such an international teaching career was rather unusual for an Eastern European urban planner: most of his colleagues from Hungary who did not emigrate to the West were working for state-managed planning companies and architectural firms, predominantly on domestic development projects.

Given the mobility constraints in socialist Hungary, students at BME also faced such a choice: either to stay in the country, with its politically framed professional fields, or to leave for the West. As a teacher, Polónyi fully understood this dilemma and therefore devoted himself to creating connections between universities around the world and his students in Budapest, with the aim of familiarizing them with international architecture and discourses of planning. The most prominent materializations of these connections were the English-language architecture training at BME and his summer schools in Hungary.

In teaching at the university and organizing the summer schools, Polónyi effectively combined his international reputation and peripheral position locally to his advantage. For him, the "periphery" was "an open field, with its own hierarchical structure where ideas forged in the centers are questioned, tested and modified—or fall into oblivion."[1] His cultivation of this peripheral position also helped him to develop an extended professional network based on personal connections, giving him the role of a mediator of knowledge and expertise between developing countries, namely the Socialist Bloc and the West.

Polónyi likewise recognized that his access to international expertise and freedom to produce unsolicited projects was a potential that could best be used in intense summer schools which focused on a specific case studies in a predefined area. This recognition gave birth to the summer schools, or "international workshop seminars," which he organized in 1983, 1985 and 1987.

The first of these International Workshop Seminars (Ráckeve '83) was located in a baroque castle in the town of Ráckeve, near Budapest, tasked with investigating the role of the architect in the local development and the potential improvements of the Hungarian model of agriculture. Ráckeve was chosen because the town suffered from an environmental crisis characteristic of many places across the country, and the newly renovated castle offered a unique venue for the event. Polónyi understood his task as a stimulation of cooperation between architects and clients: the local council, the cooperative and the inhabitants of Ráckeve.[2]

At the same time, the reconsideration of the architect's role in the development processes in rural areas was a long-held concern for Polónyi, which drew on his personal involvement in resettlement projects in Hungary, Ghana and Nigeria. Yet Polónyi's projects were a rare exception to the general tendency of the Hungarian architectural

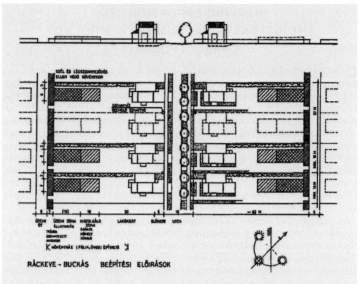

FIG. 1 RÁCKEVE 1983 AND 1985: "A SEARCH FOR A HUNGARIAN MODEL LOW DENSITY AREA WITH INTENSE GARDENING AND LIVESTOCK FARMING," TEAM OF ANDRÉ SCHIMMERLING AND CHARLES POLÓNYI

profession, paying little attention to rural areas during the postwar period. While cities and towns were experimental sites for the new, state-provided prefabricated housing estates, villages developed in a more self-organized way: the 1970s construction boom resulted in rural settlements becoming denser, losing their original character and identity.

The summer school in Ráckeve brought participating architectural students together with a local agriculture cooperative that intended to provide about 120 families with plots and assistance in constructing their houses. To respond to the needs of the cooperative, acting as a client, the summer school aspired to elaborate a new housing model for Ráckeve, serving also as a reference for environmentally friendly development across the country. The desirable plot size and orientation were organized in order to obtain maximum solar radiation in the winter and to ensure natural protection against the sun in summer. The recommended street network (following the road network of the former vineyards) and the compact housing typology (improving the new suburban house type) were defined with respect to maximum energy efficiency and adaptability to changing settlement patterns as well as to new government policies. The housing model developed for Ráckeve included not only a workshop in the basement, office space and a rentable second flat to increase the loan-repayment capacity of the owners, but also potential extensions to the houses addressing the need of homeowners to adapt to ever-changing market demands. [FIG. 1]

Polónyi's curiosity for new, more location-sensitive planning solutions was shared by his fellow travelers at Team 10, including Alison and Peter Smithson. The second International Workshop Seminar (Ráckeve '85) was a materialization of Polónyi's desire to bring Team 10's architectural thinking to Hungary.

The architectural profession in Hungary was late in responding to the construction boom of the 1970s, and realized that the decade's insensitive master plans resulted in environments that did not correspond to existing settlement patterns, social structures or local characteristics. In response, the second summer school was organized around the theme of "Acupuncture Instead of Surgery in Urbanism: The Strategy of Minimal Intervention," referring to the Team 10 principle of "minimal intervention." Participants agreed that "the routine of the previous boom period is neither desirable, nor affordable anymore; [...] there is no time now for modern surgical operations."[3]

The summer school aimed at restoring the sense of territory in Ráckeve by providing an alternative to the official plan of development. The workshop was organized in 10 task forces, each focusing on different areas of the town with their work coordinated by Group 0, the Guidelines Group (including Alison and Peter Smithson). The entire key to developing a coherent strategy for the territory was to emerge from coordination among the teams and communication with the clients.[4]

The final proposal, as drafted by Alison Smithson during the evening presentations, included a modest modification of traffic patterns by relocating one-way streets and refurbishing streets with important pedestrian flow by adding new trees and widened pavements. Instead of creating new roads, the original street network was preserved to protect the inviolate habitable islands of the town tissue; the proposal also suggested maintaining the existing riverside, keeping it natural as an "alternative space," and potentially adding floating elements to accommodate new uses at the riverside.[5]

The summer school moved to Budapest in 1987 and focused on the area near the tomb of Gül Baba, the Turkish poet and holy man, a pilgrimage site for Muslims, situated in a very

FIG. 2 COVER OF THE PROGRAM OF THE "INTERNATIONAL
WORKSHOP SEMINAR—GÜL BABA," 1987

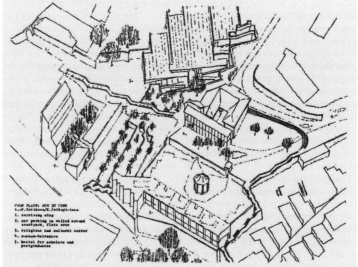

FIG. 3 THE CALM PLACE OF GÜL BABA, TEAM OF ALISON AND PETER SMITHSON,
CHARLES POLÓNYI, 1987

central location, in the proximity of major public-transportation lines and high-prestige residential neighborhoods. The summer school aimed at elaborating proposals for the Gül Baba tomb to adapt new elements, while retaining the site's sense of territory. Besides the 83 participants from 23 countries, there were professors invited from the Middle East: Enis Kartan from Ankara, Hazem Ibrahim from Cairo and Kamil Mumtaz from Islamabad to help think about ways that an Islamic religious-heritage site might connect to the contemporary city. The school itself was organized on a boat anchored near Margaret Island, emphasizing the necessity of linking the site to the Danube River.

The summer school consisted of several task forces that developed a variety of proposals, taking into account not only the topography and the existing buildings, but also the various kinds of sensitivities and the territory of the area. Some of the groups concentrated on conceiving new religious and cultural centers, in the form of a pseudo-Ottoman mosque complex, with new domes and minarets designed for the site.

Other groups, like the one including Polónyi and Alison and Peter Smithson, sought a "more tactful approach."[6] [FIG. 2] Defining the site of the Gül Baba tomb as a "cluster of oases," or a "country in the town," they chose to renew the existing mosque instead of adding new buildings to the area that would endanger the nature of the place: an adjacent two-story building, refurbished and converted, could accommodate historic relics related to the period of Gül Baba. The focus on existing resources, advocated by Polónyi and the Smithsons, reflected the main convictions of the previous summer schools where the notion of "minimal intervention" was cultivated and elaborated: it allowed the site to maintain its commemorative and contemplative character. [FIG. 3]

Polónyi saw the summer schools as his most important achievements in education: "our most characteristic contribution to the international exchange programs."[7] The recruitment was organized mostly through his personal network: while the resources available did not allow for proper advertisement for the summer schools, Polónyi's colleagues at the International Union of Architects chose their best students from various universities of the world to participate. The summer schools were not only able to assist the students by giving them access to international expertise, a variety of approaches and new methodologies, they also served the cities that hosted them. The results of the summer schools were presented in various lectures, exhibitions[8] and publications[9]: while the elaborated proposals did not significantly alter official development plans, they opened up new approaches in addressing the development of historically significant sites.

Polónyi saw his summer schools as valid alternatives to costly design competitions: they were "more productive and cost-efficient in mapping the opportunities of the site's transformation than an international competition. In the case of a competition, the program is already established in the call; consequently, participants can only address its aesthetic or technical articulation."[10]

Besides bringing prominent Western architectural thinkers such as Alison and Peter Smithson to Hungary, Polónyi's summer schools also brought BME into contact with other universities in the world: linking Hungarian architectural discourse to those in the West and other peripheral or semi-peripheral locations, the summer schools ultimately became momentous meeting points between relatively isolated architecture scenes and a defining experience for a generation of Hungarian architects.

1 Ákos Moravánszky, "Peripheral Modernism: Charles Polónyi and the
 Lessons of the Village," *The Journal of Architecture*, vol. 17, no. 3, 2012, p. 335.
2 Ibid., p. 339.
3 Alison Smithson, "Guidelines," in *Ráckeve '85: Építészhallgatók nemzetközi
 alkotótábora*, edited by Charles K. Polónyi, Budapest: TIT, 1985, p. 32.
4 Ibid., p. 30.
5 Ibid., p. 32.
6 Charles K. Polónyi, *An Architect-Planner on the Peripheries*, Budapest: P&C,
 1992, p. 169.
7 Ibid., p. 160.
8 The resulting works were exhibited on the sites during and after the
 summer schools, to introduce the concepts to inhabitants, decision-
 makers and the profession.
9 See, for instance *Az építész szerepe Ráckeve fejlesztésében. Ráckeve '83:
 Építészhallgatók namzetközi alkotótábora*, edited by Polónyi, Budapest: BME,
 1984; *Ráckeve '85: Építészhallgatók nemzetközi alkotótábora*, edited by Polónyi,
 op.cit.
10 Polónyi, "Tervek a Gül Baba környékének rendezésére," *Magyar Építőművé-
 szet*, vol. 19, no. 4–5, 1988, p. 85.

Marcela Hanáčková is an art historian specializing in Central and Eastern European modern architecture. She graduated from Charles University in Prague where she received her bachelor's degree in Human Sciences and master's degree in Art History. She has worked for Prostor Publishing House in Prague since graduation and was employed as an assistant in the Faculty of Architecture at Czech Technical University in Prague and in the Catholic Theological Faculty of Charles University in Prague. Currently, she is working on her dissertation, "CIAM and the Cold War. Discussions on Modernism and Socialist Realism," at the Institute for the History and Theory of Architecture, ETH Zurich. She has published on the postwar Czechoslovak CIAM group, SIAL Liberec and Central and Eastern European contacts with Team 10. Her interests include Central and Eastern Europe, urban history and film/architecture relations.

TEAM 10
AND CZECHOSLOVAKIA:
SECONDARY NETWORKS

The beginning of the Cold War in Europe in the late 1940s was reflected within the CIAM (*Congrès internationaux d'architecture moderne*) by the conflict between modernism and socialist realism. This confrontation culminated in 1949 at the seventh congress in Bergamo, where the Polish architect Helena Syrkus, recently elected the CIAM vice president, engaged in an act of strong self-criticism and rejected her former support of modern architecture in favor of socialist realism.[1] Her speech provoked a highly controversial debate within CIAM[2] and ultimately led to CIAM's negative position toward the East during the Cold War. At the same time, a symmetrical hardening of positions occurred in the Eastern Bloc, and in three Central Eastern European (CEE) countries present in the CIAM (Poland, Hungary and Czechoslovakia) modern architecture was declared to be a perverse style and collaboration with CIAM was to be ended.[3]

1 Joan Ockman, *Architecture Culture 1943–1968: A Documentary Anthology*, New York: Rizzoli, 1993, pp. 120–122.
2 For example, see Sigfried Giedion, *Architecture, You and Me: the Diary of a Development*, Cambridge: Harvard University Press, 1958, pp. 79–92; or Oswald M. Ungers and Lisolotte Ungers, *CIAM 7: Bergamo 1949*, Nendeln: Kraus Reprint, 1979, unpag.
3 In the case of Czechoslovakia, see Marcela Hanáčková, "Československá skupina CIAM po druhé světové válce," MA Thesis (Ústav pro dějiny umění FF UK), Praha, 2007, pp. 112–114.

While the CEE groups could not participate in CIAM congresses between 1950 and 1955, a rebellious group of architects attacking modernism emerged out of CIAM and was eventually put in charge of organizing the 10th CIAM congress in Dubrovnik, Yugoslavia, in 1956. This congress became a place where the CEE groups could participate again and finally be confronted with Team 10 ideas, [4] after the death of Stalin and after Khrushchev's famous speech given at the 7th Builders Conference (1954), which criticized Stalin's decorative buildings and encouraged typifying and industrial-building methods.

This chapter focuses on the interaction between Team 10 and groups of CEE architects beginning with the Dubrovnik congress. Primary attention is given to the question of the missed connection between Czechoslovak architects and Team 10 during the last CIAM congresses in Dubrovnik and in Otterlo. This will be compared with Poland where the establishment of such relations was much more successful. In the second part of this chapter, links between Team 10 and Czechoslovakia will be shown to have been established by means of a secondary network emerging since the early 1960s and marked by several projects delivered by Czechoslovak architects.

Czechoslovakia and Team 10: A Missed Connection

Czechoslovak architects had the first chance to get in touch with Team 10 members in 1956 in Dubrovnik. Their representatives included Josef Havlíček, Vladimír Krafík, Karel Stráník and Stanislav Sůva, who took part in congress committees and presented two panels representing the architectural work of Karel Havlíček (the Kladno-Rozdělov housing estate) and the research work of the Institute for Research of Building and Architecture, the so-called VÚVA (*Vědecký ústav pro výstavbu a architekturu*). [5]

On returning from Dubrovnik, Josef Havlíček, a member of the first generation of modernist architects, shared his opin-

4 Ibid., pp. 150–162.
5 Ibid., pp. 153–158.

ions on the congress, the future of CIAM and Team 10 with his com-
patriot Bohuslav Fuchs, who belonged to the same generation:

> The Cold War entered CIAM, it is quite strange. [...] The
> whole thing is not very clear to me. There are several
> parts, an American section (Sert, Gropius, Giedion,
> Tyrwitt [sic]), a Bakema section, an Emery section and
> a Roth section that was charged with organizing the La
> Sarraz meeting. Something like a youth CIAM should be
> created and those who are over 35 are supposed to dis-
> appear somehow. [...] It is all quite complicated and it
> is hard to differentiate what is good and what is bad. It
> seems that anarchistic elements (... Smithsons,
> Korsmo etc.) have been brought to light and it is pos-
> sible that all that was good in CIAM will disappear.[6]

In the letter, Havlíček also accused Sigfried Giedion of
prolonging the Cold War within CIAM by ignoring Central and East-
ern European countries and their architecture. Concerning the
future of CIAM, Havlíček imagined creating an organization that
would be called CIA (*Congrès internationaux d'architecture*) without an
M (*moderne*) to replace CIAM, and to function like a United Nations of
architects as part of UNESCO.

Havlíček admitted that the conflict between CIAM and
Team 10 was not very clear to him. He was not very excited by Team
10, referring to it as "anarchistic elements" and identifying it as the
worse side of the CIAM. At the same time, he was not satisfied with
the older generation. He accused Giedion of creating a Cold War in
CIAM and called those around him "the association of prima don-
nas."[7] His idea for the future of CIAM was then probably closer to the
UIA organization, where architects could freely share their experi-
ences and ideas on architecture regardless of their origin.[8]

A much more positive position was taken by another
Czech participant, Stanislav Sůva. However, his support was implicit
and can be discerned in two articles. In one, "K otázce vzrůstu

6 A letter from Josef Havlíček to Bohuslav Fuchs is held by Muzeum města
 Brna at the bequest of Bohuslav Fuchs.
7 Ibid.
8 A similar position might be also expected from Vladimír Karfík, who was
 from the same generation as Josef Havlíček, and whose experiences from
 Dubrovník I have, unfortunately, not yet found.

a proměny sídlišť" ["Toward the Question of Growth and Change of Housing Estates"], Sůva, dealing mainly with Czechoslovak housing estates, reflected on several Team 10 ideas:

The question of growth and change in new housing estates has been recently discussed by a CIAM group in England. Peter Smithson judges that the concepts of linear streets that intersect are historical relicts. He thought that housing, housing estates and towns should be organized somehow "from one point to the other" and along important communications, so that each of these points could represent unified and compact wholes both aesthetically and functionally. [9]

Later in the same text, he speaks about: "An extraordinary project of Dutch CIAM members called Alexander Polder designed for 35 thousand that was brought to and presented in Dubrovnik-Lapad." According to Sůva, its architects did not demonstrate the direct connection between the project and the principle of growth and change, though he saw the project as indeed enabling a certain variability in the building process. In his article, Sůva pointed out an analogy between architecture in the East and West. He asserted that Czechoslovak housing estates, just as their Western counterparts, were facing the very same problem of growth and change identified by Team 10, as they did not have enough visual and stylistic unity: "Our housing estates are subordinated to the law of growth and change nearly in front of our eyes, [...] only some of them, though, sustain a unified artistic expression." [10]

At the time when Sůva was in Dubrovnik, he was employed by VÚVA and presented results of its research and theoretical work on new housing estate units, especially the so-called theory of *okrsek* [11]—often translated in the Dubrovnik documents with the French term *îlot d'habitation* (housing unit or district). Sůva, not very well known in Czech architectural historiography, was one of two Czech architects (together with Jan Dvořák) who managed to

9 Stanislav Sůva, "K otázce vzrůstu a proměny sídlišť," *Architektura ČSR*, no. 9, 1957, pp. 485–488.
10 Ibid.
11 The presentation of VÚVA for the Dubrovnik congress is held by gta Archive, ETH Zurich, folder 42-JT-15-572.

advocate Western architecture or were even ready to declare publicly that Western architecture was "better" than its Czechoslovak counterpart. [12] Of course, this assertion needed a certain courage. Judging by his articles written between 1957 and 1959, Sůva appears to be a devoted expert of modern architecture. Most probably, Sůva organized an exhibition of Western architecture in Prague in 1957 under the patronage of the UIA [13] and had participated in the 4th UIA congress in The Hague in 1955, where he is believed to have come into contact with Jaap Bakema's partner Johannes van den Broek. Unfortunately Sůva, for some reason, did not make a personal effort to get in contact with Team 10 and did not participate in Team 10 meetings. Therefore his support remains confined to his articles. [14]

It does not seem that any real interest in the work of Team 10 could have been expected from Karel Stráník, the fourth Czech participant in the Dubrovnik congress. Often neglected by Czech historiography, [15] Stráník was one generation younger than Josef Havlíček and worked for the studio of Karel Honzík in the interwar period. His real career started in the postwar Stalinist era, when he was appointed the first president of the centralized Association of Czechoslovak Artists. This powerful position required him to be a loyal defender of socialist-realist ideology and state architecture politics. [16] It also resulted in a raised profile and often left him as the sole delegate from Czechoslovakia at international architectural conferences, such as UIA or CIAM, [17] where he represented the state rather than a CIAM group, of which he had never been a member. Stráník attended the critical Bergamo congress in

12 Rostislav Švácha, "Architektura 1958–1970," in *Dějiny českého výtvarného umění*, edited by Rostislav Švácha – Marie Platovská, Prague: Academia, 2005, pp. 42–43.
13 Karel Honzík, "Zamyšlení na výstavě UIA 1957," *Architektura ČSR*, 1957, pp. 274–280.
14 Aside from the previously quoted article on growth and change of housing estates, Sůva also mentions Team 10 in a poll of *Architektura ČSR*, see Stanislav Sůva, "V čem vidíte umělecké hodnoty západní architektury?," *Architektura ČSR*, 1957, no. 3, 1957, p. 149.
15 See the entry "Karel Stráník" in *Nová encyklopedie českého výtvoraného umění. Dodatky*, edited by Anděla Horová, Prague: Academia, 2006.
16 See, for example, Karel Stráník's articles in *Architektura ČSR* from the late 1940s and 1950s.
17 Oswald M. Ungers and Lisolotte Ungers , *CIAM 7: Bergamo 1949*, op.cit., Addresses of Council, Delegates and Commission Members of CIAM Groups, p. 3. See also Stráník, "Navazujeme opět na spolupráci s CIAM," *Československý architekt*, no. 4, 1956.

1949 as an observer, and later on, after Stalin's death, he also attended the meeting in La Sarraz (1955) and the Dubrovnik congress (1956). At La Sarraz, he was recorded at the meeting speaking about the future of CIAM (1957), where he declared that Czechoslovakia was more inclined to work within the UIA than within CIAM.[18] Together with his other activities,[19] this declaration prevented Czechoslovak architects from taking part in the Otterlo congress in 1959.

Stráník's position toward Team 10, CIAM and Western architecture in general is conveyed in his article "Navazujeme opět na spolupráci s CIAM" ["We Are Getting in Touch with CIAM Again"] published in *Československý architekt* in 1956,[20] where he reports on the meeting in La Sarraz (1955). Though the conflict between Team 10 and the old CIAM is noticed by Stráník, these two groups do not make any real difference for him as CIAM and Team 10 were both representatives of Western architecture that he saw as individualistic, formalistic and chaotic. Stráník claimed that the Czechoslovak exposition in the forthcoming Dubrovnik congress needed to overcome all these negative capitalistic factors and demonstrate the progressivity of Czechoslovak socialist architecture.[21]

However, Stráník had an opponent who had the courage to attack his position toward Western architecture: Jan Dvořák, an architect and teacher at the Faculty of Architecture in Prague.[22] Dvořák opposed Stráník's article and argued: "This article did not properly inform readers on the CIAM conference, it simplifies the result of its work, and it in general does not find any positive evaluation of the event. The author of the article declares improperly that all Western architects are individualists."[23] Dvořák attacked the Czechoslovak participants of international conferences: "The civic

18 gta Archive, ETH Zurich, folder 42-AR-17, Minutes of Reorganization Committee.
19 Stráník prevented Václav Rajniš (see the text cited below) from participating in the Otterlo congress in 1959 and sent an excuse himself. See the folder g5–g8, box BAKE 0152 in NAi archives in Rotterdam, Bakema bequest.
20 Stráník, "Navazujeme opět na spolupráci s CIAM," op.cit.
21 Ibid.
22 Švácha, "Architektura 1958–1970," in *Dějiny českého výtvarného umění*, op.cit., pp. 42–43.
23 Jan Dvořák, "Otevřenou diskusi k lepším výsledkům. Za vážné hodnocení práce architektů na Západě," *Československý architekt*, no. 10, 1956, p. 2.

and professional duty of those of our colleagues who are allowed to be present at international conferences seems to be to bring us the most negative reports from their voyages." These strong words and his opposition to official state politics deprived Dvořák of the teaching post at the Faculty of Architecture and ultimately ruined his professional career.

These controversies were embedded in the general tone of architectural culture in Czechoslovakia around 1956, when architecture critics differentiated between Eastern and Western modernism. Western architecture was viewed as individualist, selective, eccentric, and could be instructive only in the case in which it followed the humanistic goals close to socialism.[24] Eastern architecture was then more properly described as "humanized functionalism/modernism." Although socialist realism was denied in Czechoslovakia after the death of Stalin (1953), the dogma prevailed that Western architecture was in itself a product of declining and contemptible imperialistic culture.[25] Furthermore, Czechoslovak architects who participated in the Dubrovnik congress were not members of a Czechoslovak CIAM group, as this group was dismissed in the year 1949—they were the representatives of the state. It is no wonder that Stanislav Sůva could not have been successful with his individual support for Team 10, and that Havlíček could not find any positive factors either in the Team 10 members or in the older generation of architects represented by Sigfried Giedion (though he still could appreciate the work of Walter Gropius). His position might also have come from the fact that he could not forgive CIAM for its turn back to CEE groups while they were forced to accept socialist realism. What gained the upper hand was the ideological dogma in socialist Czechoslovakia which led to the discrediting of Western architecture, including Team 10, by functionaries like Karel Stránik, who was responsible for the selection of participants in international architectural conferences and their reflections in the architecture press.

24 Švácha, "Architektura 1958–1970," in *Dějiny českého výtvarného umění*, op. cit. pp. 42–43.
25 Ibid.

Antagonisms in the Polish Postwar CIAM

The situation in Czechoslovakia can be specified when compared with that in Poland, where the process of getting in touch with Team 10 was much more successful. As was the case in Czechoslovakia, the participants from Poland of postwar CIAM conferences were representatives of the new state's politics. These included Helena and Szymon Syrkus, along with the architect Jerzy Sołtan,[26] at the time professor at the ASP (*Akademia Sztuk Pięknych*, the Academy of Fine Arts) in Warsaw.

The Syrkuses belonged to a group of founders and promoters of modern architecture in Poland who collaborated with CIAM nearly from its very beginning and became very active, especially at the end of the interwar period, mainly thanks to a new regional plan for Warsaw called *Warszawa funkcjonalna*.[27] Nevertheless, they became supporters of socialist realism after the Second World War,[28] though they later rejected this affliation after Khrushchev's declaration of a return to the industrialization of construction, and helped to re-establish modernism as the dominant architectural ideology. Helena Syrkus was given a professorship at the Warsaw University of Technology in 1954 [29] and the Syrkuses' housing estate Koło in Warsaw, by and large a work of modernist aesthetics, was presented at the Dubrovnik CIAM congress.[30]

On the other hand there was Jerzy Sołtan, who represented a younger generation. He might also be considered a state representative and modernist, since he worked in Le Corbusier's atelier in the postwar period and translated the Athens Charter into English for the students at ASP.[31] His major interest at the Dubrovnik congress was to distinguish between the older generation of Polish CIAM, represented by the Syrkuses, and the younger generation of which he was the primary representative. Whenever Sołtan was

26 For example, see Eric Mumford, *The CIAM Discourse on Urbanism, 1928–1960*, Cambridge, MA: MIT Press, 2000, p. 248.
27 Ibid., pp. 104–130.
28 Józef Piłatowicz, "Poglądy Heleny i Szymona Syrkusów na architekturę w latach 1925–1956," in *Kwartalnik Historii Nauki i Techniki*, no. 3-4, 2009, pp. 123–162.
29 See, for example, the personal folder of Helena Syrkus in the archives of Warsaw University of Technology, folder 3055.
30 gta Archive, ETH Zurich, folder 42-JT-15-1/163.
31 Jerzy Sołtan bequest, the Archive of the Warsaw Academy of Fine Arts Museum.

asked to identify himself, he put down the name ASP Group consisting of himself and Oskar Hansen, though other colleagues from the school were also included. [32] On the other hand, and possibly in reaction to Sołtan's behavior, Szymon Syrkus put down the name *Groupe Pologne*. [33]

Beyond tensions between generations, the discrepancies between Polish representatives were probably based on the animosity between two universities: Warsaw University of Technology (Sykuses) and the ASP (Sołtan). At the same time, the support of the Syrkuses for socialist realism in the Stalinist era and their critique of CIAM must have played a role as well. This claim is very well documented in a letter from the French architect R. E. Aujame to Jacqueline Tyrwhitt dated the 9th of February 1956, in which Aujame cites a letter he received from Sołtan, his colleague from Le Corbusier's atelier in the postwar period: "Sołtan has written that Syrkuses have carried on since 1949 against the ideas of CIAM, saying that they were the worst possible from the political, social and architectural points of view." [34] Then Aujame quotes from Sołtan's letter:

> In Poland they are likewise known as enemies of CIAM.
> [...] Nobody who is any good could work with them. [...]
> And I assure you that there are many young people among us that would love to side with CIAM, and not because of being snobs!

Aujame goes on to convince Tyrwhitt that Sołtan is the best person for CIAM or for the future CIAM:

> I know Sołtan has been very unhappy to be out of contact for such a long time with Western architects and architecture, and that he will do everything in his power to come to the congress [Otterlo] with a "guide" and a delegation, if given the chance. I hope, however, that the contents of my letters do not get around as they would certainly make the situation vis-à-vis the Syrkuses even worse and might even cause troubles for Sołtan with Poles, one never knows.

32 gta Archive, ETH Zurich, folder 42-JT-15-1/163. The group is listed as follows: O. Hansen, Z. Ihnatowicz, B. Lisowski, J. Sołtan and W. Wittek.
33 Ibid. Compare the list of general assembly: *ASP groupe, Groupe Pologne*. Szymon Syrkus in another document (same folder) then also added the name of B. Lachert representing *Groupe Pologne*.
34 gta Archive, ETH Zurich, folder 42-JLS-28.

Sołtan's position was later confirmed by Jacqueline Tyrwhitt, who worked with others to include him on the board that prepared the CIAM congress in Otterlo. In a letter to José Sert, the CIAM president, Tyrwhitt wrote:

> Syrkus did his best to prevent Sołtan from being put on the small "Co-ordinating Committee" [the new governing body of the organization]. He tried to get Stráník accepted. In the end we got Sołtan accepted as a member who could be co-opted later by the committee. It seemed important to have someone from the East, and someone not of the older generation, AND someone who was an active and good architect. [35]

As a result, Sołtan and Hansen were able to attend the 10th congress of CIAM in Otterlo in 1959 [36] that was actually more of a Team 10 meeting than a CIAM congress. In view of these discussions, it becomes clear that while the Polish and the Czechoslovak groups might have had equal chances to get in touch with Team 10 at the congress in Dubrovnik, it was the Polish group, and in particular Sołtan, who seized the opportunity and, by using his previous contacts with architects in the West, managed to bypass the Syrkuses.

This different course of action by the Czechoslovak and Polish groups might be also explained by the differences in political conditions in the two countries. In Poland, the political thaw came immediately after the death of Stalin and the inauguration of Khrushchev's politics. In Czechoslovakia, by contrast, the thaw did not come earlier than the second half of the 1960s, and this was reflected in the maintenance of an ideological straitjacket in architectural culture. A different dynamic was represented by another socialist country in CEE: probably due to the revolution in 1956, Hungary was not represented at the Dubrovnik congress. However, thanks to the personal involvement and support of formal CIAM member József Fischer, Charles Polónyi was sent to the Otterlo congress and presented his work there. [37] Yet these political differences leave unan-

35 gta Archive, ETH Zurich, folder 42-JT-22-177/404.
36 Oscar Newman, *CIAM '59 in Otterlo : Arbeitsgruppe für die Gestaltung soziologischer und visueller Zusammenhänge*, Zürich: Girsberger, 1961.
37 Ibid. See also Charles Polónyi, *An Architect-Planner on the Peripheries. The Retrospective Diary of C. K. Polónyi*, Budapest: Müszaki Könyvkiadó, 2000, pp. 39–43.

swered the one question which was implicit in much of what has been discussed until now: Did CEE architects try to approach CIAM or the early Team 10 because of their admiration for the architecture these organizations represented, for their specific themes as well as their criticism of principles of modern architecture, or did they simply want to stay in touch with Western architecture at any cost?

Secondary Networks: Liberec and Brno

While Czechoslovak architects failed to achieve a more durable connection with Team 10 during the formative meetings of Dubrovnik (1956) and Otterlo (1959), the real chance came only in the second half of the 1960s with the liberalization of the regime in Czechoslovakia. This new atmosphere was also reflected in Czechoslovak architecture and the architecture press, where articles on Western architecture appeared without the previously obligatory ideological subtext. This also included interest in Team 10 discourse, and in what follows I will revisit several projects in order to question the influence of Team 10 ideas on Czechoslovak architectural culture, as found in specific designs and theoretical proclamations. The focus will be on two unofficial centers of Czechoslovak architecture: SIAL Liberec and Stavoprojekt Brno.

Viktor Rudiš, who worked for the Stavoprojekt Brno since 1958,[38] was sent to the Paris studio of Candilis-Josic-Woods in 1967,[39] for a three-month internship. Why did the nearly 40-year-old architect, who had a solid architecture career in Czechoslovakia and was awarded with a national state prize, decide to work in the atelier of Candilis-Josic-Woods?

At the time when Rudiš decided to work for the Paris studio, Stavoprojekt Brno had just finished one of the most respected housing projects in Czechoslovakia: the Brno-Lesná estate (1961–1968)[40] that received a national state prize and international publication. Brno-Lesná is located on the edge of Brno and it was largely

38 Viktor Rudiš: stavby a projekty 1953–2002, edited by Viktor Rudiš, Brno: Obecní dům, 2005.
39 The internship was described by Rudiš himself in an article: Victor Rudiš, "G. Candilis–Paříž," Československý architekt, no. 25–26, 1966, p. 5. Rudiš stayed from January to March 1967.
40 Viktor Rudiš: stavby a projekty 1953–2002, op.cit., pp. 11–30.

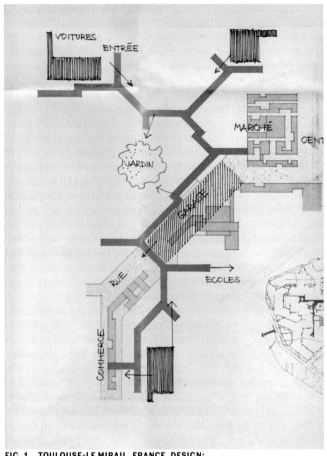

FIG. 1　TOULOUSE-LE MIRAIL, FRANCE, DESIGN:
STUDIO CANDILIS-JOSIC-WOODS, 1961–1971

influenced by a concept of Scandinavian housing estates, specifically the town of Tapiola, Finland, which embodies a design philosophy of "living in greenery." Brno-Lesná was designed along similar lines, and it consists of slabs and pointed buildings in greenery accompanied by public services.

At the same time, Rudiš claims that as Lesná was being completed he and his colleagues from Stavoprojekt Brno were studying Western projects that criticized modernism and modernist housing estates of which Lesná was also an example. [41] These projects, published in Czechoslovak architectural magazines, criticized modernism in relation to the functional inflexibility of its realized examples and the lack of urban qualities that were abundant in old towns mixing systems of public spaces, streets and squares. One of the most influential projects that attracted the attention of Czechoslovak architects was a project for Toulouse-Le Mirail in France [42] [FIG. 1] described by Rudiš as having a local center which leads a hierarchical structure of streets. According to Rudiš, it also recalled the traditional European town [43] that was highly concentrated in the middle and sprawled at its edges.

This architectural knowledge probably served to attract Rudiš to the internship in the Candilis-Josic-Woods studio in Paris, negotiated at one of the UIA's congresses by Zdeněk Chlup, the chief architect of the city of Brno. Beside the regular studio work, including the Barcarès project—a seaside resort build for 3,000 people elaborated in prefabricates and based on the model of African villages—Rudiš tried to enlarge his knowledge of other studio projects such as the Free University of Berlin, ETH Zurich and Frankfurt-Römeberg. He also studied and collected the review Le Carré Bleu, strongly related to Team 10, which was freely available in the studio. Based on these projects, he speculated about the grid as an architectural pattern. The grid had flexible and inflexible parts: the inflexible parts were intersecting paths, while the flexible ones were filled or empty squares that could change their functions over time. Rudiš highlighted the time factor and the questions of growth and change

41 Based on an interview with Viktor Rudiš done in the middle of July 2013.
42 Also described and published in Rudiš' interview, see above.
43 Described in Rudiš's short handwritten text dated the 14th of July 2013.

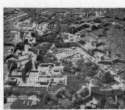

VIKTOR RUDIŠ

G. Candilis–Paříž

FIG. 2 VICTOR RUDIŠ'S ARTICLE ON HIS INTERNSHIP IN CANDILIS-JOSIC-WOODS STUDIO, *ČESKOSLOVENSKÝ ARCHITEKT*, NO. 25–26, 1966

as the principles of the Candilis-Josic-Woods studio in his retrospective article published in *Československý architekt,* where he argued: "The space-time relations are more important than the geometrical relations. The most important constant is the constant of growth and change [...]." [44] [FIG. 2]

Rudiš's interest in Team 10 was not limited to the atelier of Candilis-Josic-Woods. He also paid attention to the projects of Jaap Bakema, which he knew from the Czechoslovak architecture press. [45] Rudiš discussed Bakema's urbanization pattern of a *tree* that has a center from which a major street runs outward and is intersected by other streets that are further subdivided by minor streets and paths on both sides. The highest buildings with public services are concentrated along the main street. The height of the buildings decreases toward the edges, where family houses are placed.

After his return from Paris, Rudiš and his other colleagues from Stavoprojekt Brno took part in many competitions in Czechoslovakia and abroad: Espoo (Finland, 1967), Brno-Bohunice (Czechoslovakia, 1970), Trnava-Hluboká (Czechoslovakia, 1971), Wien-Süd (Austria, 1971) and Uhříněves-Kolovaraty (Prague, 1977). [46] The majority of these plans applied patterns that Rudiš described as *grids* (in reference to Bakema's projects for universities), *stems* (like in the Toulouse-Le Mirail project by Candilis-Josic-Woods) or *trees* (in Bakema's polder layout), though they mix in various ways.

These influences of Candilis-Josic-Woods and Jaap Bakema on the Brno group can be best seen in the unrealized projects for a new housing estate in Espoo, Finland, dated 1967 and for a new city quarter called Wien-Süd, Austria, dated 1971. The international competition for the new housing estate on the edge of Espoo was announced in 1967, the year when Rudiš returned from his internship in Paris. The given area was characterized by a typical Finnish landscape that encompassed hilly terrain with greenery and lakes. [47] Viktor Rudiš and Jaromír Sirotek submitted a project [FIG. 3] that respected this landscape and proposed a plan that was very

44 Victor Rudiš, "G. Candilis–Paříž," op.cit., p. 5.
45 According to Rudiš, the architectural magazine *Československý architekt* included strips presenting Western architecture that he cut out.
46 See Rudiš's book *Viktor Rudiš: stavby a projekty 1953–2002,* op.cit., pp. 31–40.
47 This text is based on Rudiš's description of the project—the interview took place in mid June 2013.

close to the Candilis design principles, in particular the concept of the stem. The proposal was derived from the dense, traditional European town. There was a busy center with services, shops and public facilities. [FIG. 4] Paths were laid out from this central knot, accompanied on both sides by housing clusters of various types: apartment blocks were located close to the center and single-family houses were placed at the edge of the plan.

In contrast with Espoo, the project for Wien-Süd [48] [FIG. 5, 6] was closer to Bakema's *trees* as they were described by Rudiš. Wien-Süd was delineated by Rudiš as flat land on the outskirts of the Austrian capital for which a new city quarter was planned, surrounded by factories. The Rudiš team included Jaromír Sirotek, Aleš Jenček and Igor Meduna, and submitted a project (1971) that introduced a main road which forms a spine, or trunk, crossed by smaller branches that splinter as they reach the edges of the city quarter. The major busy street serving as the main public space was supposed to be surrounded by the highest buildings that would guarantee a high concentration of people in the core of the new quarter. The height of the buildings lowered toward the quarter's edges, where the single-family houses were placed. This idea was again derived from the Candilis-Josic-Woods image of the traditional European town and reused for a later project: the Uhříněves-Kolovraty housing estate in Prague (1977).

None of these projects were ever built. Regarding the proposals in Czechoslovakia, the reasons might well be explained by the project for the Brno-Líšeň housing estate (Viktor Rudiš, Vladimír Palla, František Zounek and Aleš Jenček, 1968) that was eventually realized by Stavoprojekt Brno as a direct commision and was dated closely to the project for Espoo (1967). [FIG. 7] In contrast with Espoo, which was inspired by projects of the Candilis studio in Paris, Líšeň returned to the patterns already used for Brno-Lesná (1961), including two groups of modernist slab buildings connected by a shared civic center. Brno-Líšeň thus revealed the limited possibilities of Czechoslovak building systems that were only capable of producing modernist slabs and probably would never have enabled Rudiš to build one of the Team 10–inspired projects like Brno-Bohunice (1970)

48 Ibid.

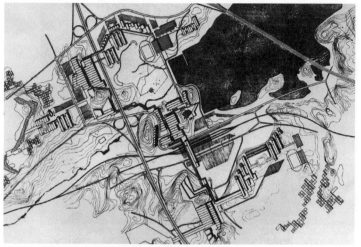

FIG. 3 HOUSING ESTATE IN ESPOO, FINLAND,
DESIGN: VIKTOR RUDIŠ AND JAROMÍR SIROTEK, 1967

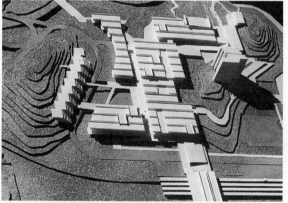

FIG. 4 CENTER OF THE HOUSING ESTATE IN ESPOO, FINLAND,
DESIGN: VIKTOR RUDIŠ AND JAROMÍR SIROTEK, 1967

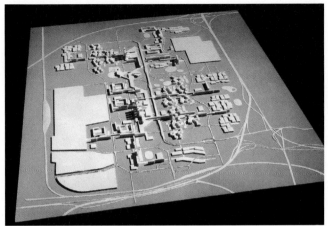

FIG. 5 HOUSING ESTATE WIEN-SÜD, AUSTRIA, MODEL, DESIGN:
VIKTOR RUDIŠ, JAROMÍR SIROTEK, ALEŠ JENČEK, IGOR MEDUNA, 1971

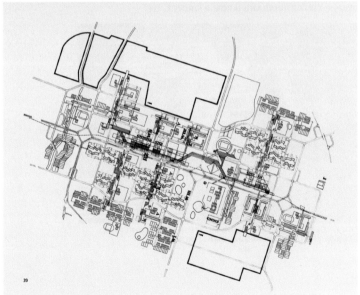

FIG. 6 HOUSING ESTATE WIEN-SÜD, AUSTRIA, DESIGN:
VIKTOR RUDIŠ, JAROMÍR SIROTEK, ALEŠ JENČEK, IGOR MEDUNA, 1971

or Uhříněves-Kolovraty in Prague (1977), which seemed to be too complicated for the Czechoslovak building industry at the time.

However, the influence of Team 10 on Czechoslovak architecture can be recognized in the north Bohemian town of Liberec, which was the seat of a respected architectural studio: SIAL Liberec (*Sdružení inženýrů a architektů Liberec*/Association of Engineers and Architects in Liberec). SIAL Liberec was founded by Karel Hubaček, whose iconic Ještěd project for a TV tower/hotel on top of Ještěd Hill won him the UIA's August Perret prize in 1969. After this success, he managed to attract some of the most talented architects from Czechoslovakia to work under his supervision in Liberec. These included Miroslav Masák, whose projects for Liberec lower center demonstrated a certain correlation with Team 10 ideas.

Masák distinguished himself among Czechoslovak architects by his interest in human sciences [49] that were only reestablished as academic fields in the early 1960s after being banned during the Stalinist era. This shift was reflected in the Czechoslovak architecture press that published studies on the relationship between man and the environment (for example, the writings of the sociologist Jiří Musil). [50] Masák plunged into this new atmosphere and studied Czech and international literature on psychology, sociology and social history, and collaborated with scholars in these fields. He believed that the human sciences could help him to find a new form that would substitute a modernism whose limits were all too apparent in state housing estates as they were being built in Czechoslovakia. The first result of this endeavor was a spa building for the Šanov housing estate on which he collaborated with a musician, a psychologist and an artist and where its inhabitants could retreat from the grey socialist environment. Studies for the Liberec lower center (an area bordering the historic town center to one side and new buildings from 19th and 20th centuries to the other) were the second application of his humanist philosophy of architecture that resulted in the Ještěd shopping center in Liberec.

The first project for the Liberec lower center dates from 1966 and it was a direct result of a so-called Symposium on the

49 This text is based mainly on an interview with Miroslav Masák conducted at the beginning of September 2013.
50 See Jiří Musil, "Lidé ve městě," *Architektura ČSSR*, no. 8, 1962, pp. 542–545, or Jiří Musil, "Rodina a bydlení," *Architektura ČSSR*, 1962, pp. 124–125. Finally, Musil published a very well-respected book based on knowledge of French and British sociology of the cities: Jiří Musil, *Sociologie soudobého města*, Praha: Nakladatelství Svoboda, 1967.

Use of Young People's Leisure Time. [FIG. 8] Eight international teams were invited, which besides architects included artists, sociologists and psychologists. [51] Participants in the symposium were expected to come up with a study dealing with an old redevelopment area alongside Pražská Street, which connected the upper and lower town centers.

Masák's team [52] won the internal competition during the symposium. [53] The model submitted by his group suggested that the houses along the street were intended to be retained while the houses behind them were supposed to be replaced by new structures that were, in scale and proportion, fine-tuned with the street houses. Together, the old and the new buildings formed a new unified whole. This project was quite unique amongst those presented during the symposium that by and large proposed to destroy the old area and replace it with modernist buildings out of scale with the historical context. According to Masák, his proposal was influenced on one hand by the arguments of the director of the local museum, Hana Seifertová, who highlighted the value of the historic buildings in the lower center, and on the other hand by the proposal of the English team participating in the symposium, recognizing the value of this historic quarter and recommending that it be preserved as a whole. [54]

The text accompanying Masák's proposal highlighted the human, or rather anthropological, character of the new structure while claiming that:

> only by the intersection of the new and the old buildings it will be possible to create new spaces that would produce a homelike and unique atmosphere which will saturate [inhabitants] with intimacy, anonymity, home feeling and new experiences. [55]

51 A working method known as *travaux d'équipe* [teamwork] that was imported from Paris Biennial by SIAL.
52 Masák's team included Otakar Binar (architect), Stanislav Hanzík (sculptor), Václav Pospíšil (painter) and Vladimír Beran (psychologist).
53 Plans and models of all the groups are included in the workshop's booklet: *Mezinárodní pracovní symposium mladých architektů a výtvarných umělců o využití volného času mládeže*, Liberec, 1966.
54 The project of the English group can be seen in *Mezinárodní pracovní symposium mladých architektů a výtvarných umělců o využití volného času mládeže*, op.cit.
55 Ibid.

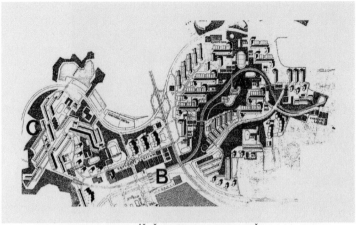

FIG. 7 HOUSING ESTATE BRNO-LÍŠEŇ, DESIGN: VIKTOR RUDIŠ,
VLADIMÍR PALLA, FRANTIŠEK ZOUNEK AND ALEŠ JENČEK, 1968

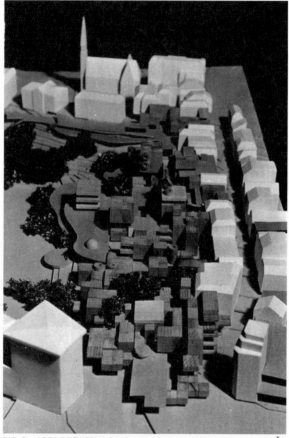

FIG. 8 AREA BETWEEN UPPER AND LOWER LIBEREC CENTER, PRAŽSKÁ
STREET, DESIGN: MIROSLAV MASÁK, OTAKAR BINAR, STANISLAV HANZÍK,
VÁCLAV POSPÍŠIL AND VLADIMÍR BERAN, 1966

The proposed structure with all these attributes was further identified by Peter Vaďura, the most talented architecture critic at the time, as "an obvious reaction to the work of the Candilis-Josic-Woods studio."[56]

The products of the symposium convinced the representatives of the city council to commission a new study for Liberec that would ideologically and formally elaborate the results of the winning project. Thus Masák started to work on an independent vision covering a large area from the lower town center to the main railway station of Liberec. [FIG. 9] His new proposal intersected administrative buildings with housing, services, cultural buildings, public spaces and areas for free-time activities. In Masák's words, he proposed a "carpet structure" close to the "character of a traditional town" but "not its exact copy." The urban structure was imagined as "a corridor, a river" with a main current but also with lanes that allowed for a flow of various activities. This form was intended to "generate a harmonious, homelike and variable space,"[57] an anthropological vision that he already elaborated in the previous study and which he contrasted to sterile modernist architecture.

Only one part of this urban study was realized: the Ještěd shopping center. Its final form was derived from the structures proposed in the previous projects and from their theoretical background so that it echoed the structure of a traditional town. The shopping center thus was not a box but consisted of three independent, irregular buildings [FIG. 10] that were interconnected by a complex system of terraces, staircases and ramps. On the ground level, three local streets led toward it and at the intersecting point they changed into a covered passage. [FIG. 11] The project had nine different investors that opened many different shops and services, and the clients could also visit restaurants, bars, cafés and wine shops; a podium for fashion shows was likewise envisioned.[58]

56 Petr Vaďura, Studie "Střed města" a její místo ve vývoji kontextu názoru na problematiku městského centra v Liberci, unpublished text, Liberec, dated December 1972–March 1973, p. 40.
57 Masák wrote an accompanying text for the study; its reprint can be found here: Ludmila Hájková, "Texty Karla Hubáčka a Miroslava Masáka z počátku skupiny SIAL," Umění, no. 1–2, 1999, pp. 118–121.
58 Concerning the program of the shopping center, see "Nové obchodní středisko v Liberci," Investiční výstavba, no. 12, 1974, pp. 430–431.

Masák described the shopping center as a "sheltered town market", an *organized labyrinth*, like those designed by Aldo van Eyck, and a *polyvalent space*, reminicent of those conceived by Herman Hertzberger.[59] While a deliberate focus on Team 10 designs was denied by Masák, he confessed an interest in several buildings by Aldo van Eyck and Herman Hertzberger, published in the magazines *Werk, Bauen und Wohnen* and *L'Architecture d'aujourd'hui* that were usually present at SIAL Liberec and accessible to employees.[60]

While the work of Masák did not derive any direct influence from Team 10, his architecture and theory shows a certain common ground with Team 10 ideas. This common ground can be called structuralism, which, in the reconstruction of Jean-Louis Violeau, was characterized by three major features: the interconnection of architecture with social sciences around the question of the relationship between man and his environment, the lesson of traditional urban structures, and the critique of modernist architecture.[61] All these features can then be identified in Masák's proposals for the Liberec lower-town center.

There are other hints on the various relations between Czechoslovakia and Team 10 that might be further elaborated. To my mind, this connection relates principally to the participation of Milan Hon in the meeting of Team 10 in Berlin that took place in 1964. Also left unscrutinized is the attendance of Jáno Stempel in workshops organized by Charles Polónyi in Hungary while Stempel was studying at Budapest Polytechnic University. The public space (a shopping street) built at the Pankrác II housing estate in Prague should also receive careful consideration. Its architect, Jiří Lasovský, tried to make good use of his visit to the Rotterdam city center called Lijnbaan, designed by the studio of Van der Broek and Bakema, and designed a very similar structure at Pankrác. We should also take into account Zdeněk Zavřel's internship at Bakema's studio in Rotterdam that was partially reflected in several Školka SIAL projects after his return to Czechoslovakia.

59 Miroslav Masák, "Obchodní středisko Ještěd," in *Liberec. Ročenka liberecké architektury*, Liberec, 2007, pp. 58–59.
60 Based on the interview with Miroslav Masák from the beginning of September 2013.
61 Jean-Louis Violeau, "Team 10 and Structuralism: Analogies and Discrepancies," in *Team 10, 1953–81: In Search of a Utopia of the Present*, edited by Max Risselada, Dirk van der Heuvel, Rotterdam: NAi, 2005, pp. 280–285.

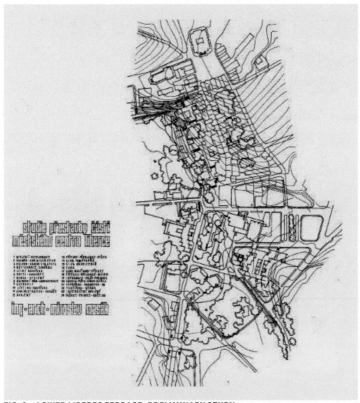

FIG. 9 LOWER LIBEREC TERRACE, PRELIMINARY STUDY,
DESIGN: MIROSLAV MASÁK, 1968

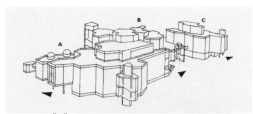

FIG. 10 JEŠTĚD SHOPPING CENTER, LIBEREC, 1968

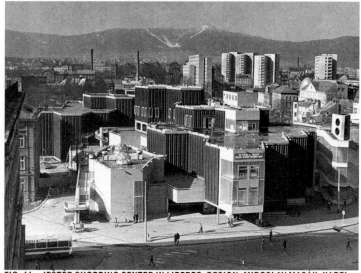

FIG. 11 JEŠTĚD SHOPPING CENTER IN LIBEREC, DESIGN: MIROSLAV MASÁK, KAREL HUBÁČEK, VÁCLAV VODA, ŠKOLKA SIAL, 1968-1979, DEMOLISHED

Conclusion

What is clear from this broad overview is that the relationships between Team 10 and Czechoslovakia were very problematic and complex. These complexities stemmed especially from persistent Cold War dynamics, though architects from other CEE countries such as Hungary and Poland that had reestablished CIAM groups in the early postwar period (1945–1949) managed to get in touch with Team 10 and participated in some of its meetings. The architectural situation in Czechoslovakia seems to have been particularly influenced by the political regime and state ideology, hostile to Western architecture even in the post-Stalinist period. The chief delegate at the last CIAM congresses was Karel Stráník, who contributed decisively to this negative attitude toward the West.

The second chance to establish contact with Team 10 came in the mid 1960s, when the political regime was increasingly liberalized and the first architectural projects inspired by Team 10 discourse started to appear, including those designed by Viktor Rudiš and Miroslav Masák. Both these architects fought against the simplified state modernism that had been reestablished around 1956 and continued to influence state construction policies as late as the 1980s. Rudiš, equipped with his knowledge based on the theory and practice of Candilis and Bakema, struggled against limitations of state-planned modernism that were reflected in Czechoslovak housing estates. His fight for new housing schemes was based on the urban principles of traditional towns, but they did not have a chance to be realized given limited technical capabilities of state building companies. Masák fought against state modernism in a different way: rather than focusing on housing estates, he tried to invent a new architectural form by collaboration with artists and social scientists. This new architectural and anti-modernist form took various shapes, including designs for the Liberec lower-town center that highly resembled Team 10 designs.

Cornelia Escher is a historian of architecture and curator. She is currently preparing a dissertation on the *Groupe d'Étude d'Architecture Mobile* (GEAM) and has been a researcher at the Institute for the History and Theory of Architecture, ETH Zurich, since 2011. Her research and publications focus on architectural theory of the 20th century with special interest in its intersections with technology, the sciences and in the history of exhibition design. She has published articles in *AMC*, *Bauwelt* and *ARCH+*, where she has been a member of the editorial team (2009–2011). She was part of the curatorial teams of exhibitions such as "Atelier Bow-Wow" (ETH Zurich, 2013) and "Megastructure Reloaded" (Former State Mint, Berlin, 2008).

BETWEEN CIAM AND TEAM 10:
THE "EAST" AND THE PERIPHERIES OF CIAM

"The English group is right but we hope to be right also!!" With these words in their letter of the 27th of August 1957, Oskar Hansen and Jerzy Sołtan politely underscored their claim to a say in debates about the reorganization of CIAM. By articulating their opinion "that the existence of an active organization continuing the CIAM line is of great importance to our 'milieu' as well as to many architects of middle and younger generations of eastern [sic] Europe," they made clear their own position, both as active members of CIAM and as representatives of specific "Eastern" interests.[1] [see INSERT]

Looking at the Polish members can help to differentiate some established narratives about the development from CIAM to Team 10 that occurred between the 10th Congress in Dubrovnik in 1956 and the 1959 meeting in Otterlo. Since the mid 1950s, the renewal of CIAM—in terms of its organization and with respect to its orientation—was discussed in occasionally fierce disputes. The internal front lines were not only drawn between different CIAM generations—the prewar CIAM versus Team 10—but also between the organizational core and the peripheries of the group.[2] In the postwar period, the CIAM meetings experienced significant growth in participation and saw the arrival of new groups, also non-European. The transition from CIAM to Team 10 meant a reduction of the number of members, questioning the further participation of members and national groups that were less actively involved. In this situation, Sołtan made himself the spokesman of those who were at the peripheries. [FIG.1]

In Dubrovnik, Sołtan joined CIAM as a representative of a newly formed Polish group, the ASP Group (*Akademia Sztuk Pięknych*). In so doing, he took particular advantage of relationships he formed during his stay in France from 1945 to 1949 and while working in Le Corbusier's team, thus marginalizing the former Polish delegate, Helena Syrkus, as a presumed advocate of socialist realism.[3] Hansen had taken part in the CIAM Summer School in 1949 during his stay in France during that period at Pierre Jeanneret's studio, and he was also invited to Dubrovnik on Sołtan's request, but did not attend. Both architects had reason to feel connected to the CIAM tradition but in terms of their attitudes, they, and especially Hansen, belonged to the reformist wing.

Toward the end of the congress in Dubrovnik, the future of CIAM was discussed and a decision was made to reduce the number of members to 30. Following the meeting, competing lists of future members were circulated, and at the same time, Peter Smithson—as the most "radical" representative of Team 10—pleaded for a complete end to CIAM, expressing preferences for an informal continuation of debates.[4] Under these conditions, a crisis meeting was held in La Sarraz on the 1st and 2nd of September 1957, in which the CIAM Council, the delegates and the Reorganization Committee attempted to reach a final decision on the future of the organization. In his capacity as secretary, Jaap Bakema gathered expressions of opinion and summarized them in a letter sent in advance to all the participants, in which three positions were highlighted. In addition to the "English" (William Howell, Denys Lasdun, Peter Smithson and John Voelcker) and the "Americans" (Sigfried Giedion, Walter Gropius, Jacqueline Tyrwhitt and José Luis Sert), the new and the old generations, respectively, Sołtan represented a third stance, which Bakema tersely

labeled *Continue CIAM*.[5] Sołtan answered in the letter quoted above, written jointly with Hansen, reaffirming his previously voiced position and making it heard by those attending the meeting in La Sarraz.

Sołtan's stance on the continuation of CIAM arose from his understanding of the condition of architecture in socialist Poland, and his own professional prospects in such a condition. In 1955, Sołtan told Le Corbusier that prospects for his own projects had improved but remained subject to fluctuations:[6] this uncertainty provided a personal motivation to establish solid international contacts. At the same time, this position made Sołtan feel sympathetic to the countries that were more on CIAM's periphery, and he accordingly acted as their advocate: "A steady exchange of thought in the CIAM spirit, if now just less necessary for the architects of western [sic] Europe and the Americas, BEGINS only to have a real importa[nce] for the architects of eastern [sic] Europe, the Middle East, India and so on." This statement sheds light on Sołtan's priorities for the future of CIAM.[7] He saw the tasks ahead for CIAM as being related primarily to development work and the dissemination of the principles of modern architecture—an opinion that he shared with Sert.

In contrast, the Dutch and English members had no reason to see modern architecture in danger in their personal or professional contexts. They were more interested in formulating, as precisely as possible, a concrete architectural notion of a new avant-garde that overcame the identified shortcomings of functionalism. They opposed the old guard inside CIAM, while simultaneously seeking to restore the basic character of the group as an avant-garde union, just as it had been defined in the late 1920s. By selectively restricting membership to active participants with a radical stance, the group was supposed to remain agile and productive, supported by a common spirit: a "family," as Team 10 described itself.[8]

Even the forms of communication within Team 10 did not follow the model of a democratic organization, but rather that of an avant-garde group of artists who fought for a pure doctrine. In a letter following the Team 10 meeting in Bagnols-sur-Cèze in 1960, where Hansen had been verbally attacked by Alison Smithson, he criticized the authoritarian culture of discussion at the meeting: "Let us cast off the 'general's uniform' and listen to each one of us. Even should one who has the opportunity to speak remain silent—he has spoken in the opinion of all."[9] According to the Japanese architect Kisho Kurokawa, who attended two of the Team 10 meetings, the group championed a destructive type: "it tends to alienate members, in some cases it drives out all but one single member."[10]

The last CIAM meeting was held in Otterlo in September 1959, to which a mere 43 people were invited—as opposed to 150 participants in Dubrovnik. [FIG. 2] At the congress, Hansen pleaded for individualizing architectural aesthetics with respect to the specific needs of inhabitants, and brought "psychological" categories into play vis-à-vis functionalism. Although Smithson found the design presented by Oskar and Zofia Hansen for the Rakowiec housing estate to be "quite arbitrary," it showed that Hansen was largely in line with Team 10.[11] However, Sołtan was no longer arguing from the perspective of a modernism endangered by socialist realism, but against its "interior enemy," the spread of a modern style without constructive, social or functional foundation by architects who were not familiar with the true principles of modern architecture. This speech made Aldo van Eyck see red: his "enemy" remained the reductionism of the "functional city," i.e. the tradition of modernity itself, whose

FIG. 1 JERZY SOŁTAN AT THE CIAM MEETING IN OTTERLO, 1959

blatant damage could, according to him, be observed in the Netherlands.

Sołtan's position was more global. He had been in contact with the *Groupe d'Etude d'Architecture Mobile* (GEAM) since 1957, which had emerged at the periphery of CIAM around notions of mobility and the participation of users in the design of their built environment. Since the beginning of 1959, he had also intensified his contact with Harvard. In June, he presented Sert and Tyrwhitt with a proposal to the very *Charte d'Habitat* that Team 10's majority viewed as an expression of an outdated approach. At the time, Sert supported the idea of an international CIAM, which would be more closely linked to the work of the United Nations.[12] In his proposal for the *Charte*, Sołtan stressed that it should serve the "average architect from all over the world (the so-called backward and [u]nderdeveloped countries included) more than the 'braintrust' of the CIAM," and in so doing maintained his commitment to a global mission for modernism.[13]

In the interest of this mission, Sołtan also tried persuading Kenzo Tange to remain in Team 10. Tange, who had left the meeting earlier, appeared rudely surprised by the decision taken in Otterlo to part with the name CIAM, and he regretted what he saw as the "family's" omission of the crucial role of technological development. In a letter to Tange, Sołtan described the current realignment as "richness," in that it "means above all the possibility of the expression by everybody, by every user, by every inhabitant of the world (not by the architect only) of his own needs and dreams. Richness therefore means above all creating FLEXIBILITY, mobility and interchangeability instead of STIFFNESS and RIGIDITY, it means creating more architectural 'framework' than finished 'masterpieces'."[14] Sołtan called less for an avant-garde renewal of modernism and more for the continuity of a modern attitude under different circumstances, based on faith in the emancipatory potential of modernization. Using the term "framework," Sołtan appropriated thoughts from Hansen's theory of Open Form and also from the prefabrication-oriented designs of GEAM and Charles Polónyi, fusing them with ideas originating from the colonial projects of Candilis-Josic-Woods to attain, by starting from the fringes, an integrative definition of the goals for Team 10.

1 Oskar Hansen and Jerzy Sołtan, "Letter to the Council Members," Warsaw, August 27, 1957, gta Archive, ETH Zurich, 42 AR 17 46.

2 Marilena Kourniati, "L'auto-dissolution des CIAM," in *La modernité critique. Autour du CIAM 9 d'Aix en Provence*, edited by Jean-Lucien Bonillo, Claude Massu and Daniel Pinson, Marseille: Imbernon, 2006, pp. 63–75.

3 R.E. Aujame, "Letter to Jacqueline Tyrwhitt, Boulogne, Seine," February 9, 1956, gta Archive, ETH Zurich, 42 JLS 28 30.

4 Annie Pedret, "CIAM and the Emergence of Team 10 Thinking 1954–59," PhD dissertation, Massachusetts Institute of Technology, 2001, p. 219.

5 Jaap Bakema, "C.I.A.M. en réorganisation," August 13, 1957, gta Archive, ETH Zurich, 42 SG 49 9-17.

6 Jerzy Sołtan, "Letter to Le Corbusier," March 15, 1955, Fondation Le Corbusier, R3 4 546.

7 Sołtan, "The Future of C.I.A.M.," [before July 28, 1957], gta Archive, ETH Zurich, 42 JLS 33 14.

8 Kees Somer, *The Functional City. CIAM and the Legacy of Van Eesteren*, Rotterdam: NAi, 2007, pp. 26–30; Alison Smithson and Peter Smithson, "Letter to Jacob Bakema," July 28, 1958, NAi, bake g5.

9 Oskar Hansen, "The Open Form in Architecture. The Art of the Great Number," [1960], NAi, bake g121.

10 Kisho (Noriaki) Kurokawa, "Will the Future Suddenly Arrive" [1967], in *Metabolism. The City of the Future*, edited by Mami Hirose [et al.], Tokyo: Mori Art Museum, 2011, pp. 255–60, here p. 258.

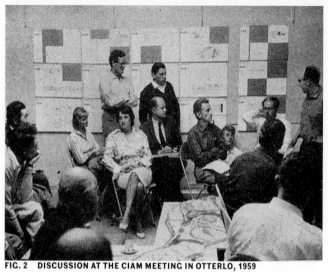

FIG. 2 DISCUSSION AT THE CIAM MEETING IN OTTERLO, 1959

11 Oskar Hansen and Zofia Hansen, "The Open Form in Architecture—the Art of the Great Number," in Oscar Newman, *CIAM '59 in Otterlo*, Stuttgart: Karl Krämer, 1961, p. 190; Oskar Hansen and Zofia Hansen: "Residential Quarter 'Rakowiec' in Warszawa," in *CIAM '59 in Otterlo*, op. cit., p. 196.

12 Eric Mumford, *The CIAM Discourse on Urbanism, 1928–1960*, Cambridge, MA: MIT Press, 2000, pp. 256–57.

13 Sołtan, "Some Ideas Concerning the Charte de l'Habitat," June 3/8 1959, gta Archive, ETH Zurich, 42 JT 22 180-184.

14 Sołtan, "Letter to Kenzo Tange," Cambridge, May 2, 1960, Warsaw Academy of Fine Arts Museum, Jerzy Sołtan Archive.

Aleksandra Kędziorek is an art historian and a coordinator of the Oskar Hansen research project at the Museum of Modern Art in Warsaw. She participated in international research projects on the history of architecture launched at ETH Zurich and Universidade de Campenas, São Paulo, and contributed as a curatorial and research assistant to exhibitions on modern and contemporary architecture in the SPOT Gallery in Poznań, the Fourth Design Festival in Łódź and the Museum of Modern Art in Warsaw. In 2013, she co-organized a conference on Oskar Hansen's oeuvre at the Museum of Modern Art in Warsaw. Currently she is coediting the volume *Oskar Hansen—Opening Modernism. On Open Form Architecture, Art and Didactics* (together with Łukasz Ronduda, Museum of Modern Art in Warsaw, 2014) and working on the Oskar Hansen exhibition that will be presented in Spain and Portugal in 2014 and 2015.

JERZY SOŁTAN AND THE ART AND RESEARCH UNIT'S PROJECT FOR THE POLISH PAVILION AT EXPO 58

W ithin the framework of its main topic, *Bilan du monde pour un monde plus humain* [Evaluation of the World for a More Humane World], Expo 58, which took place on the Heysel plateau in Brussels from April to October 1958, attempted to discuss the most important issues related to the human condition after the Second World War. The loss of faith in the positive aspects of technological development, general anxiety, a lack of a sense of security, and solitude experienced in the globalizing world were identified as the most urgent problems of the moment. Accompanied by the call to promote and establish a peaceful coexistence and cooperation among countries, the Expo's program situated the individual at the very center of its interest. A similar objective was at work in the design for the Polish pavilion by Jerzy Sołtan, bridging CIAM and Team 10, and the project team composed of Zbigniew Ihnatowicz, Lech Tomaszewski and Wojciech Fangor, all affiliated with the Art and Research Unit at the Warsaw Academy of Fine Arts. The project's main intention was to create a new image of the Peoples' Republic of Poland, presenting its experience in peace-building and its ability to introduce technological innovations as well as establish new relations between the individual, history and the state.

The Polish government treated participation in Expo 58, the first world's fair after the Second World War, as an opportunity to improve state's external image, a fact that was quickly revealed as both an inspiration and curse for the never-executed Polish design. Accepting the Belgian invitation only six months after it was received,[1] the government hoped to make use of the exhibition to enthusiastically present Poland's new political system. Moreover, as explained by Józef Cywiak, chargé

d'affaires in Brussels, the government felt that Poland's presence at Expo 58 would alleviate the danger that the German Federal Republic would use the event as an opportunity to question the new postwar Polish border along the Oder-Neisse line.[2] Another motivation was the opportunity to attract the attention of masses of Polish emigrants and to lure them to return to the homeland through a manifestation of Poland's prosperity. This aspiration of constructing an overwhelming image of the country through its presence at the Expo was already at work during the selection of the building plot—the one of 3,000 m² proposed by the Belgians turned out to be unsatisfactory, and the Polish government came up with a triangular plot of 10,600 m² situated in the very center of the Expo's terrain, but such development was, as it turned out, beyond its financial means.[3]

In Sołtan and the Art and Research Unit's project, selected in an open competition announced in 1956, they decided to reduce the architecture to a minimum, covering the plot with a roof with openings for tree trunks and situating the exhibition on bare ground, fulfilling almost literally one of the Expo's rules which stated that "the given terrain should remain generally untouched with respect to its topography and vegetation."[4] The key idea was to treat the pavilion as a piece of the exhibition itself. The plot was divided into two parts. [FIG. 1] The first one, located next to the Avenue du Gros Tilleul, in the proximity of Finnish and Norwegian pavilions, would house an open-air exhibition. The pavilion would be located in the second part, in a corner delineated by the overpass crosscutting the entire Expo's terrain and the Avenue du Hallier. Its main element—the steel roof composed of tetrahedron modules and cov-

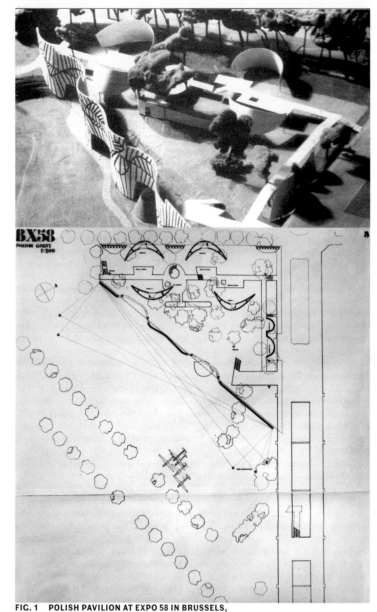

FIG. 1 POLISH PAVILION AT EXPO 58 IN BRUSSELS,
A PHOTO OF THE MODEL AND A PLAN

ered with reinforced glass—leaned on a wave-form curtain wall, and was supported on the north side and in the middle by narrower curved walls and two additional pillars. Accessible from almost all around, the pavilion had as its main entrances three openings located under the curtain wall. [FIG. 2] The interiors were adapted to the existing landscape and divided into two levels. The ground floor remained almost unchanged, presenting objects in showcases located on the ground. The upper level comprised a mezzanine, accessible from different sides and directly connected with the Expo's overpass.

As the Unit's team explained, "the pavilion was created as a technical and artistic exhibit [...], composed of materials and techniques manifesting Polish capabilities and character."[5] The innovative construction of the roof, designed by Tomaszewski, who changed the tetrahedron modules into a crystal form by an accurate distribution of construction forces [FIG. 3]; Fangor's large-scale paintings covering both sides of the curtain wall; Stanisław Skrowaczewski's musique concrète penetrating the exhibition space; alongside exhibited posters and films carefully chosen by Ludwik Perski, the elements would create an architectonic spectacle comparable to the Philips Pavilion at the same Expo. However, in comparison to the project by Le Corbusier, Iannis Xenakis and Edgar Varèse, where visitors' moves were calculated down to the minute, the Polish pavilion design provided more space for individual expression, allowing visitors to choose the paths they walked through in the pavilion, the way they perceived the exhibition space and, as Andrzej Osęka stated, "did not divest them from the joy of co-creation."[6] This openness to users' contributions had much in common with Oskar Hansen's idea of Open Form, formulated within the same creative circle and adding to the general spirit of the Art and Research Unit. Al-

luding to some major concepts of Sołtan's former collaborator, Le Corbusier, including the idea of integration of arts, the architectural promenade and ineffable space, the pavilion represented a step toward the more humanistic approach of Team 10.

The imprint of Team 10's ideas was even more visible in the interpretation of architectural space, outlined in one of the exhibition scenarios. The image communicated through the exhibition space—its shape, exhibits and Fangor's painting depicting the history of the People's Republic of Poland from 1945 to 1958 in childlike drawings [FIG. 4]—was that of a country striving for peace and historically predestined to play such a role among European states. "Poland," explained the scenario, "lies on the route of great roads: East-West. In the time of war, those are the routes of destruction and annihilation. In the time of peace, those are the routes of trade, culture and progress. Poland's fate is therefore naturally bound with world peace."[7] As the space of the pavilion, similar to embassy grounds, became a symbolic representation of the state's territory during the world's fair, visitors entering the Polish pavilion at Expo 58 from various directions and walking through its premises would array across the territory of Poland like those routes of war and peace in the aforementioned passage. The individual would then become an active participant in shaping history, which was a key message of the Polish display.[8] [FIG. 5]

The government's determination to seize the opportunity resulting from participation in Expo 58 and thereby improve the external image of the state turned out to be equally important after changes that had taken place in Polish politics. The political crisis in October 1956, when the government would no longer control lower civil servants and mass media, resulted in the famous speech by the

FIG. 2 POLISH PAVILION AT EXPO 58 IN
BRUSSELS, A COMPETITION BOARD

FIG. 3 LECH TOMASZEWSKI, CONSTRUCTION OF A MODULE FROM THE
PAVILION'S ROOF STRUCTURE

FIG. 4 WOJCIECH FANGOR, CONCEPT FOR A PAINTING ON THE PAVILION'S
CURTAIN WALL, VIEW FROM THE INTERIOR

first secretary of the Communist Party, Wiesław Gomułka, condemning "errors and deviations" in the realization of socialist ideals.

What became the symbolic start of the Polish Thaw indicated, at the same time, the suspension of Polish preparations for Expo 58. After work on the competition project stopped in February 1957, the designers were asked to adapt their ideas to the new vision of the state, which took savings as its new ideology, and to a significantly lower budget. The urgent need to generate savings, inspired by Gomułka's speech and trumpeted by the media and socialist youth organizations, encouraged, however, a heated press debate on the necessity of participating in Expo 58. "The total cost of Polish exposition at the Brussels World's Fair could amount to 100 million Polish złoty [...]. We are convinced that Poland cannot now afford such an enormous expense, and we demand the withdrawal of the Polish declaration to participate in the Expo," announced the Union of Socialist Youth operating in the Ministry of Culture, proposing to spend the assigned funding to build housing estates for Ministry employees.[9] An exchange of similar letters in the press ended with a pompous declaration by Stanisław Neumark, member of the bureau of the commissioner of the Polish pavilion: "We must not go out to the world with a grandiose mania of building pavilions. We should not strive to hide our shortages and lacks under a pretty cover."[10] The plot in the center of Heysel plateau was left empty.

1 The invitation sent in September 1954 defined the deadline for declaring the country's participation as the end of September 1955. The Polish government adopted a resolution on the country's participation in Expo 58 already in February 1955, stating that "according to the Ministry of Foreign Affairs, a quick declaration of Polish participation should have a significant political overtone." See The Central Archives of Modern Records in Warsaw: *Generalny Komisarz Sekcji Polskiej na Powszechnej Wystawie Międzynarodowej w Brukseli w 1958 r. Biuro Wykonawcze w Warszawie* [hereinafter referred to as: CAMRW, Expo 58], file 1: *Protokół z XXIV posiedzenia Rady Programowej do Spraw Wystaw i Targów z dnia 11 stycznia 55 r.*

2 Archive of Ministry of Foreign Affairs: *Międzynarodowa Wystawa w Brukseli "Expo 58,"* zb. 8, w. 70, t. 980, p. 18–20: *Tajne pismo [charge d'affaires a.i., Józefa Cywiaka] do Dyrektora tow. W. Mencla, MSZ, Departament Prasy i Informacji [z dn.] 26 września 1955.*

3 It was probably beyond its capability from the very beginning, as just after receiving the planned plot, Poland asked for special permission to construct a pavilion covering less than 70% of the grounds, which was against one of the rules imposed by the Belgian commissioner. See J. Sołtan, "Bruksela 58," *Przegląd Artystyczny,* 1957, no. 2, p. 35; A.W. Wys., "A jednak 'Bruksela'," *Życie Warszawy,* 1957, no. 43, p. 1–2; CAMRW, Expo 58, file 8: *Notatka w sprawie informacji szczegółowych o Powszechnej Wystawie Międzynarodowej w Brukseli 1958 r. z dnia 17 stycznia 1956 r.*

4 CAMRW, Expo 58, file 45: *Projekt wstępny architektoniczny pawilonu polskiego na PWM w Brukseli 1958.*

5 Ibid.

6 Andrzej Osęka, Anna Piotrowska, *Styl „Expo,"* Warszawa: Państwowe Wydawnictwo Naukowe, 1970, p. 72.

7 CAMRW, Expo 58, file 16: *Notatka w sprawie scenariusza wystawy brukselskiej.*

8 The project of the interior exhibition is described in detail in Aleksandra Kędziorek, "Modernistyczna wizytówka PRL. Projekt pawilonu polskiego na wystawę światową w Brukseli," MA Thesis (University of Warsaw), supervisor: Waldemar Baraniewski, Warsaw 2011, unpublished.

9 "Uwagi i wnioski aktywu ZMP Ministerstwa Kultury i Sztuki," *Po Prostu,* 1956, no. 46, p. 7.

10 S. Neumark, "Polska nie powinna brać udziału w Światowej Wystawie w Brukseli. Zaoszczędzone dewizy i złotówki należy użyć na rozwój kraju," *Głos Pracy,* 1957, no. 26, p. 1.

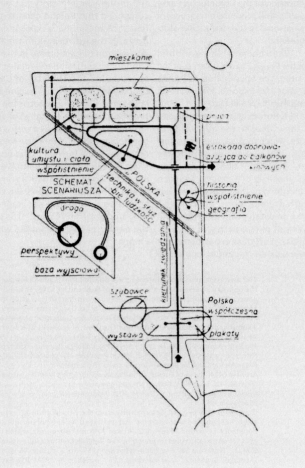

FIG. 5 SCENARIO OF THE EXHIBITION

Eeva-Liisa Pelkonen is an Associate Professor at the Yale School of Architecture, where she teaches architectural design, history and theory. Her scholarly work focuses on the language of modern architecture viewed from various national and historical perspectives. She is the author of *Achtung Architektur! Image and Phantasm in Contemporary Austrian Architecture* (MIT Press, 1996), *Alvar Aalto: Architecture, Modernity and Geopolitics* (Yale University Press, 2009), which won the Alice David Hitchcock Prize granted annually by the Society of Architectural Historians (SAH), and *Kevin Roche: Architecture as Environment* (Yale University Press, 2011). Her book *Saarinen: Shaping the Future* (Yale University Press, 2006), which she coedited with Donald Albrecht, won the Philip Johnson Award (SAH) and the Sir Banister Fletcher Award (Author's Club, London). Pelkonen's scholarly work has been supported by the Getty Foundation, the Graham Foundation, the Finnish Academy of Arts and Sciences and the Austrian Ministry of Science and Research. She holds an MArch from the Tampere University of Technology, Finland, an MED degree from Yale University and a PhD from Columbia University.

HELSINKI-WARSAW, C. 1960

The Polish Team 10 member Oskar Hansen was one of the international notables invited to write a eulogy for a special issue of *The Finnish Architectural Review* when Alvar Aalto died in 1976. Here is what he had to say:

> Aalto introduced a new sense of space into Finnish architecture through his idea of the coexistence of nature and man.
>
> Through his clear, comprehensive works Aalto showed us a better way to develop our incoherent environment, dominated as it is by technology.
>
> Aalto created a spatial thinking which is a stage for Finnish life, composed, as it were, of natural landscape and architecture combined.
>
> The social nature of Aalto's spatial thinking is a step away from the introverted way of thinking of artifact architect towards an open and structural way of thinking.
>
> My son bears his name.[1]

1 Oskar Hansen, "Eulogy for Alvar Aalto," *The Finnish Architectural Review*, July/August 1976, p. 39.

Hansen's emphasis on "space," "spatial thinking" and "structural way thinking" underscored that Aalto, in Hansen's view, understood architecture through a set of relationships between people, nature, society and culture; and that these relationships were activated in and through architectural space. The notion of "spatial thinking" equaled for Hansen a highly sophisticated form of "structural thinking," which allowed complex relationships and multifaceted aspects of individual, natural and social life to coexist. Aalto's architecture became operative only within this larger seamless topology with human life at its center.

Having been born in Helsinki in 1924, by the time Hansen wrote these words his circle of Finnish friends and colleagues had come to include several highly intellectual members of the Finnish Team 10 group centered around the magazine *Le Carré Bleu*, which was founded in Helsinki in 1958.[2] Hansen named his son after Aalto in 1960, a year after he had met Aulis Blomstedt, the senior leader of the group, which led to the publication of his seminal text "La Forme Ouverte—l'Art du Grande Nombre" ["Open Form—the Art of the Great Number"] in the magazine and subsequently to a trip to lecture in Helsinki the following year. To be sure, Finland was important both professionally and personally to Hansen.

In what follows, I will discuss the intellectual and artistic project Hansen shared with his Finnish friends, namely establishing form and space as a legitimate realm of architectural inquiry and, in so doing, challenging the technological and economic imperative of architecture and planning during the postwar years when Europe was focused on rebuilding and meeting basic needs, such as housing. I am particularly interested in why such ideas gained currency in Finland and Poland, considering that, in addition to facing the task of rebuilding and rehousing after the war, both countries were going through major social and political reorientation, developing themselves, respectively, into a democratic welfare state in the shadow of the Soviet Union and a socialist country in the Eastern Bloc.

2 For a full chronology of Hansen's life, see Oskar Hansen, *Towards Open Form / Ku Formie Otwartej*, edited by Jola Gola, Warszawa: Fundacja Galerii Foksal, Muzeum ASP w Warszawie, Frankfurt: Revolver, 2005. I thank Monika Fabijańska for making the book available to me.

To be sure, aesthetic ideas were hardly without a social and geopolitical subtext during the Cold War, especially when they were put forward in Helsinki and Warsaw, cities with names inscribed into some of the main documents of that geopolitically charged era. It is worth noting that Hansen wrote the eulogy for Aalto just a year after world leaders had gathered at the Conference of Security and Cooperation in Europe in Aalto's Finlandia House (1975), the last of his buildings to be completed in his lifetime, in an attempt to put an end to the Cold War. As history was to tell, it took more than 15 years to reach that goal. Yet the conference marked a turning point in the Cold War, yielding the so-called Helsinki Accords, which emphasized human-rights issues, including "the freedom of thought, conscience, religion or belief," and the "self-determination of peoples."[3] By that time, Finland had become a respected mediator between East and West and a leading welfare state, achievements much admired by Poles,[4] who shared a geopolitical destiny with Finland. Both countries had been part of Tsarist Russia, yet unlike Finland, Poland was included in the Soviet sphere of influence after the Second World War and saw its horizon for political self-determination fade within the socialist sphere. Hansen's focus on the human and social life gains particular meaning against the backdrop of the workers' revolts that took place in Poland throughout the 1970s. In fact, while he was writing his ode to Aalto in the summer of 1976, workers were striking outside Warsaw over food prizes.[5]

Therefore, rather than looking at the discussion of form and space as somewhat peripheral to Team 10 debates, I will show that Hansen and his Finnish colleagues made an important contribution by rethinking architecture's social role in postwar Europe, albeit viewed from its two easternmost countries, where calls for architecture's constructive social role from a humanist perspective gained a particularly loaded meaning. The prioritization of

3 Conference on Security and Cooperation in Europe, "Helsinki Accords:
 Declaration on Human Rights," *Making the History of 1989*, Item #245,
 www.chnm.gmu.edu; date of access August 2013.
4 I owe this information to Irena Grudzińska-Gross, who read an early
 version of the talk I gave at the "Oskar Hansen—Opening Modernism"
 conference that took place at the Museum of Modern Art in Warsaw in
 June 2013, which formed the basis of this article.
5 Discontent about food prices led to three major workers' revolts:
 1970–1971, 1976, and 1980–1981.

form and space and how they entered human experience could in this context be considered a kind of "zero degree"[6] of architecture, that is, architecture as a total experience and a zone of freedom. By reclaiming the aesthetic dimension of architecture from a humanistic perspective, their goal was to resist the absorption of architecture into the state apparatus by becoming a mere container of services, such as housing. The architects under discussion did this without challenging the respective political systems—welfare state and socialism—per se. Rather, I would argue that their goal was corrective, harking back to the shared core principle of both systems, namely, the improvement of the quality of life.

I am therefore particularly interested in their shared call for a more "humanistic" approach to architecture in the footsteps of Aalto, which can be linked to the period of wider soul-searching that took place in the rest of Europe after the war, laying the foundation for various forms of socialist ideas, which translated into the two dominant political models, namely the welfare and socialist states, both promising a better life for Europe's citizens—what indeed should the new Europe that emerged from the ashes stand for if not for human life! For these eastern Team 10 members, it was important that it was Aalto, a former member of CIAM who had grown increasingly critical of modern architecture after the war, and not Le Corbusier, the guiding star for many Western members of Team 10, who loomed large in their search for architecture that would endorse humanity in all its richness and complexity, taking into consideration individual life without forgetting the world at large.

History Lessons

First, I would like to propose an alternative history of Team 10 that highlights contributions made by its Finnish and Polish members. I will point out that, although not part of the canonical narratives of CIAM, which tend to focus on the discourse surrounding housing and urbanism dominated by British, French and Dutch members of the group, the emphasis on form, space and human experience that was put forward on the pages of *Le Carré Bleu*

6 Here I refer to Roland Barthes' *Writing Degree Zero* (1967 [1953]), which put forward an idea for a new type of writing that breaks free of stylistic and narrative constrains, where "form [is] considered as human intention."

FIG. 1 REIMA PIETILÄ, COVER OF THE INAUGURAL ISSUE OF *LE CARRÉ BLEU*, NO. 0, 1958, TITLED "INTRODUCTION AU DEBAT PAR LE GROUPE C.I.A.M. DE HELSINKI"

should not be overlooked. Here are some key dates and names that expand the canonical histories of Team 10 in this regard: In 1953, Aulis Blomstedt (1906–1979) and Keijo Petäjä (1919–1988), a younger Finnish architect, attend the Aix-en-Provence CIAM meeting and upon their return form the Finnish CIAM faction called PTAH. (PTAH is an acronym for *Progrès Technique Architecture Helsinki*, as well as the name of an Egyptian demiurge, god of architects and craftsmen.)[7] The group organizes a weeklong summer school the following summer in Imatra, a small town located near the Soviet border, to explore the "relationship between matter and form, structure and function" under the leadership of Blomstedt and Petäjä. The group's manifesto "Theses on Form" was sent to the CIAM council in Paris on July 1, 1954. In it they declare: "In nature and in the man-made world, form is as much an *a priori* as is content. Form is thus not an antidote or enemy of functionalism."[8] In 1956, Blomstedt attends the CIAM meeting in Dubrovnik with another theoretically minded young architect, Reima Pietilä.

In 1958, Finnish Team 10 members Blomstedt, Petäjä and Pietilä, along with art historian Kyösti Ålander and architects Eeri Eerikäinen and André Schimmerling, found the review *Le Carré Bleu* with the mission of fighting the hegemony of functionalism. Blomstedt serves as the first editor-in-chief; the Frenchman Schimmerling serves as secretary. The first issue, edited by Blomstedt, is dedicated to proportional systems. [FIG. 1]

In 1959, Oskar Hansen presents the first version of his "Open Form" paper at the CIAM meeting in Otterlo, calling for a new type of art and architecture with strong existential and humanistic overtones; the goal is the discovery of the "self" and triggering a "passion for existence." In his review for *Le Carré Bleu*, John Voelcker highlights Hansen's contribution without mentioning presentations made by international notables including Louis Kahn and the Smithsons.[9] Hansen builds the Polish pavilion called the Fan, consisting of a simple kite-like tensile roof, for the biennial in São Paolo. [FIG. 2]

7 Other members included the town planner Pentti Ahola, Aarne Ervi, the main architect of the Tapiola Garden suburb, and the prize-winning designer Ilmari Tapiovaara.
8 Quoted by Helena Sarjakoski in *Aulis Blomstedt: Suhteiden Taide*, Helsinki: Rakennustieto, 2003, p. 33.
9 John Voelcker in *Le Carré Bleu*, no. 3, 1959.

In 1960, Hansen and Blomstedt meet in the last post-CIAM meeting in Bagnols-sur-Cèze, where Hansen presents another variation of the Open Form talk "La Forme Ouverte—l'Art du Grande Nombre," which focuses on the relationship between the individual and collective. [FIG. 3]

Blomstedt invites Hansen to lecture at Helsinki Technical University in 1961 and to organize an exhibition of the work of his students at the Warsaw Academy of Fine Arts. [10] Blomstedt, who was serving as the editor-in-chief of *Le Carré Bleu* through the end of the year, publishes Hansen's "La Forme Ouverte—l'Art du Grande Nombre" in the first issue of the year, titled "La Forme Architecturale." [11]

Schimmerling takes the helm of *Le Carré Bleu* in 1962 and moves the editorial offices to Paris. The review shifts its focus to large-scale urban project done by such offices as Candilis-Josic-Woods. At this point, the Finnish presence, along with a discussion about form and space, disappears from its pages.

A short history lesson of the two countries during the immediate aftermath of the Second World War helps in understanding the social and political backdrop of their work and words:

Finland emerged after two Finno-Russian Wars with heavy human and material losses and became something of a Cold War exception as Europe was being divided into Eastern and Western Blocs, a process that started right after the war ended. [FIG. 4] After a period where it was unclear whether Finland would fall on the Western or Eastern side of the equation, the signing of the Treaty of Friendship, Cooperation and Mutual Assistance with Soviet Union in 1948 sealed its destiny. The Soviet Union maintained a military presence in the country till 1956 and its influence was palpable in Finnish politics for years to come, while at the same time the country remained culturally and economically oriented to the West. The concept of *Finlandisierung* was coined to describe the condition of a small

10 Blomstedt served as a professor at the Technical University of Helsinki
 from 1958 to 1966.
11 Oskar Hansen's article was published in the first issue of 1961.

FIG. 2 POLISH PAVILION, SÃO PAULO BIENNIAL, FAN-BIOTECHNOLOGICAL
STRUCTURE, DESIGN: OSKAR HANSEN, 1959

FIG. 3 TEAM 10 CONFERENCE, BAGNOLS-SUR-CÈZE,
SUMMER 1960. FROM LEFT: RALPH ERSKINE, OSKAR
HANSEN, AULIS BLOMSTEDT

country under the influence of a larger, more powerful nation. [12] To be sure, both the country's sovereignty—Finland gained independence from Russia in 1917—and neutrality, which the country had adopted as a foreign policy during the interwar period, were both relative terms in postwar Finland.

Much of Finland's success in navigating complex political terrain can be attributed to the so-called Paasikivi-Kekkonen Line, a political strategy named after two successive presidents who governed Finland from 1946–1956 and 1956–1981, respectively, whose goal was to align Finland with the West while maintaining good relations with the Soviet Union. There were many close calls, particularly around the period of the building of the Berlin Wall in 1961, when Finland learned the hard way that it needed to walk a thin line to earn its special position. [13] Moscow's interference in Finland's internal affairs was accepted without much political public debate; the majority of the population agreed that it was still a rather small price to pay for sovereignty, especially since the Finnish economy prospered under a special trade agreement with the Soviet Union, which allowed the country to develop its welfare programs during the years of the Cold War. [14]

There were many parallels between Finland and Poland's postwar experience. Both countries had lost significant portions of their respective territory, had their boundaries redrawn and their future shaped in the shadow of a powerful neighbor. According to Tony Judt, Poland was "fore-doomed to the Soviet sphere after World War Two," largely because of its strategic location between Berlin and Moscow. [15] Unlike Finland, however, a moderate amount of local support was there when the Soviet army marched to War-

12 The German concept *Finlandisiserung*, translated as finlandization in English and *suomettuminen* in Finnish, was coined sometime in the late 1960s and early 1970s in German scholarly political debate to refer to the particular conditions of the Finnish-Soviet relationship during the Cold War. But its meaning extends to other situations where a smaller country comes under the influence of a larger nation without necessarily loosing its sovereignty.

13 For more information about Finland's political situation during the Cold War, I would like to refer to Pekka Visuri, *Suomi Kylmässä Sodassa*, Helsinki: Otava, 2006.

14 For more information about the Finnish welfare state model, read Erik Allardt, *Hyvinvoinnin Ulottuvuuksia*, Porvoo: WSOY, 1976.

15 Tony Judt, *Postwar: A History of Europe Since 1945*, London: Penguin, 2005, p. 135.

saw; this is because Poland, unlike Finland, had been a victim rather than an ally of Germany. Soviet control culminated in the signing of the Warsaw Treaty Organization of Friendship, Cooperation and Mutual Assistance between eight communist states including the Soviet Union in 1951, only to be loosened incrementally after Stalin's death in 1953 and followed by the so-called thaw after Nikita Khrushchev's speech denouncing Stalin's reign in 1956, the same year Soviet troops left Finland. [16] However, the thaw was short-lived, lasting only until the building of the Berlin Wall in 1961. Soviet troops did not leave Poland until 1989.

The story of *Le Carré Bleu* unfurls during the approximately five-year period during the thaw from the mid 1950s till the increase of East-West tensions in the early 1960s. It must be noted that by that time the lively Finnish and Polish art and architecture scenes were testing the power of images in sending subtle political messages that affirmed their cultural sovereignty, a point that did not go unnoticed in the Western press. [17] Finnish architecture became known internationally through the "Finland Builds" exhibitions sent abroad by the Museum of Finnish Architecture, founded in 1956 for the purpose of making Finnish architecture known around the world, while Finnish design had gained accolades early in the 1950s at the Milan Triennales. Poland was an active participant in world's fairs and biennials, for which Oskar Hansen designed several highly acclaimed pavilions, both in São Paulo in 1959 and in Milan the following year. It is worth noting that socialist realism was fairly short-lived and Polish art became known soon after the war as an exception in the Eastern Bloc with its adherence to abstraction. [18]

Much has been said about the investment of various governments in using art and design to brand their nations during

16 Khrushchev gave the speech "On the Personality Cult and Its Consequences" to the closed session of the 20th Party Congress of the CPSU on the 25th of February 1956.
17 Reading abstract art as a demonstration of Poland's pro-Western, slightly subversive spirit is argued, for example, in an article called "Art: Polish Modernism" in the August 4, 1961, issue of *TIME* magazine.
18 For further information about art during the so-called thaw, see Piotr Piotrowski, "After Stalin's Death: Modernism in Central Europe in the Late 1950s," *ArtMarginsOnline*, posted October 15, 2001; www.artmargins.com, date of access May 2013.

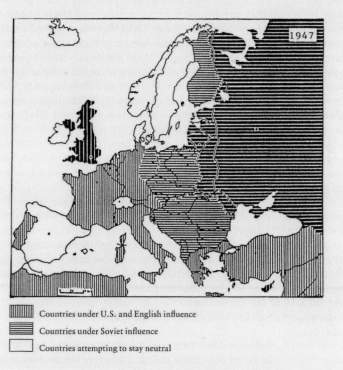

Countries under U.S. and English influence

Countries under Soviet influence

Countries attempting to stay neutral

FIG. 4 "EUROPE BEING DIVIDED INTO EASTERN AND WESTERN BLOCS, 1947," MAP FROM A REPORT BY THE SWEDISH COMMANDER IN CHIEF'S OFFICE

this period. [19] To complement this existing research I am particularly interested in the implicit social critique of their brand of humanist formalism. In what follows, I will therefore trace how the protagonists' understood what the formal principles of architecture of a "true" welfare state and a "true" socialist state should be based on. The focus will be on the transformative years between the mid 1950s and early 1960s, when Finland and Poland, benefiting from the thaw, and Europe as a whole were going through a period of soul-searching about what the continent represented. It is indeed during these years that Europe began its transformation from a "geographic expression (and a rather troubled one at that) into a role-model and magnet for individuals and countries alike," and the continent aspired to the welfare model with the well-being of its citizens as its goal. [20]

In what follows, I will map out how the four key Finnish members of Team 10 and Oskar Hansen, all affiliated with *Le Carré Bleu* in its early days between 1958–1962, understood the new challenge of architecture. Only by focusing on these fundamental aspects of architectural form and space could architecture fulfill the task that mattered most to the citizens of postwar Europe, namely enhancing human life by advancing the relationship between the individual and the collective as well as human relationships to the natural world—all key humanistic principles politicians had failed to address.

Defending the "Fortress of Form" During the Cold War

Le Carré Bleu grew out of a search for architecture based on these humanistic values. Aulis Blomstedt put forward the key maxim of the review and by extension of its founding members: in order to secure such values the architect's task was to defend the "fortress of form." Only in so doing could architecture avoid succumb-

19 For more information about the impact of the "Finland Builds" exhibitions, see Petra Ceferin's important *Constructing a Legend: International Exhibitions of Finnish Architecture, 1957–1967*, Helsinki: Suomalaisen Kirjallisuuden Seura, 2003. For more information about the Polish art scene during the Cold War, see *Primary Documents: A Sourcebook for Eastern and Central European Art Since the 1950s*, edited by Laura Hoptman and Tomáš Pospiszyl, New York: Museum of Modern Art, 2002.

20 Judt, *Postwar*, op.cit., p. 8.

ing to technocratic and economic forces.[21] Influenced by Le Corbusier's *Modulor* (1954), among other proportional theories fashionable at the time, Blomstedt developed his own modular system, "Modular Variations on the 180 cm Measure," launching it in 1957 with the aim of making architecture meet the demands of construction technology without compromising aesthetic standards.[22] [FIG. 5] The goal was to raise architecture beyond mere practical objectives by integrating its specific proportional system with those found in music and science. Blomstedt had already applied a modular system to a vacation-house competition project in 1942, based on a nine-square grid, which facilitated simple frame and panel construction. He named it "Cell" ["Kenno"], referring to a geometric spatial matrix that merged human measurements with mathematical order, which governed the design. His subsequent "Modulor" was based on the belief that by integrating architecture with other arts and sciences we would enable the human mind to gain access to the deeper hidden order that governs the universe as a whole.

It is important to note Blomstedt's interest in creating "universal" aesthetic principles for architectural form after the war. The term has obvious geopolitical connotations: the idea of "universal" architecture gained wide currency against the dominant pre-war geographical narratives in the 1950s, countering such narratives as "national" and "international" architecture.[23] While the latter came into being after the refounding of the nation states in Central Europe in the aftermath of the First World War, the former aimed at defining shared principles and ideals that transcended geographic and political definitions with the goal of healing the traumas of the two world wars, which these political and ideological constructs had sponsored.

21 Aulis Blomstedt first put forward the idea of a "fortress of form" in the article "Architect's Role in Contemporary Society," *The Finnish Architecture Review*, no. 9, 1956, p. 149.

22 For an excellent discussion of Blomstedt's modular theories, see Helena Sarjakoski's *Aulis Blomstedt: Suhteiden Taide [Aulis Blomstedt: Art of Proportion]*, Helsinki: Rakennustieto, 2003.

23 For further information about the various geographic narratives in Aalto and, more generally, in early 20th-century modern architecture, see my book *Alvar Aalto: Architecture, Modernity, and Geopolitics*, New Haven: Yale University Press, 2009.

FIG. 5 AULIS BLOMSTEDT, "MODULAR VARIATIONS ON THE
180 CM MEASURE," INQUIRY INTO HUMAN PROPORTIONS, 1957

FIG. 6 K. PETÄJÄ, REPRESENTATION OF HUMAN
EXPERIENCE OF SPACE, C. 1955. NOTES IN THE MARGINS
TRANSLATE AS FOLLOWS: "REAL SPACE. HUMAN BEING AND
SPACE. PERCEPTUAL RELATIVITY OF SPACE. SENSORY
MULTIPLICITY. AMBIGUITY OF MEANING. EVERY SENSORY
ORGAN HAS ITS OWN ACTUAL SPATIAL PERCEPTUAL
CONCEPTION."

The debate on proportion systems was symptomatic of this wider search for universal principles. It gained currency after the publication of Rudolf Wittkower's seminal *Architectural Principles in the Age of Humanism* in 1949 and the subsequent conference and exhibition on the topic, "La divina proportione," which took place during the Milan Triennale in 1951. Despite its noble aims, the debate was hardly without controversy. [24] Blomstedt was in attendance when Aalto received the RIBA Gold Medal in London, which took place in tandem with a conference on proportions, and delivered his "Architectural Manifesto" ["Taistelukirjoitus"] that challenged the attempt to find a universal modular measure, calling it an outcome of architect's vanity. In its stead, Aalto called attention to the man in the street and his well-being, stating that "[t]here are only two things in art—humanity and its lack." [25] While Aalto was also searching for universal principles, he relied on placing man, not the object, at the center of this search. In his equation, humanist architecture was based on the aesthetic dimension understood in the most modern sense of the term as denoting a specific experience, rather than a set of formal principles governing the object as such.

Like Aalto, the younger generation of Finnish architects behind *Le Carré Bleu*, born in the late 1910s and early 1920s, countered Blomstedt's quest for universal formal principles by shifting their focus to human engagement with form and space. They likewise believed that form, rather than an outcome of mathematical laws and reason, was to be designed by a human being for other human beings. Following Aalto's lead, the younger generation empha-

24 Eero Saarinen, who attended the Milan conference, was another vocal opponent. In undated and unpublished lecture notes, "Eero on Golden Proportions," he criticizes Le Corbusier: "To distort our architecture to fit the [proportional and structural] rules of the Renaissance is fantastic. Any proportion that might seem right to us today will surely be wrong tomorrow." For a full citation, see Eeva-Liisa Pelkonen and Donald Albrecht, *Eero Saarinen: Shaping the Future*, New Haven: Yale University Press, 2006, pp. 342–343. The date of the notes might be later than those given in the book.

25 The prize ceremony coincides with a symposium on architectural proportions, including modular systems. The symposium featured, among others, a paper by Christopher Alexander, "Perception and Modular Co-ordination." Oskar Hansen held two solo exhibitions, "The Choke Chain Exhibition," and "Earth, Sky and Architecture," both in Warsaw. Aalto's lecture is reprinted as "The RIBA Discourse: The Architectural Struggle," in *Sketches. Alvar Aalto*, edited by Göran Schildt, Cambridge: MIT Press, 1978, pp. 144–148.

sized the creative process where architecture was seen as a product of the creative human mind, able to balance a complex set of factors that constitute any given design task. [26] Interest in human cognition and in the various ways human beings make sense of their environment emerges as the realm where human life evolves in all its complexity and incompleteness.

The diagram drawn by Petäjä after the Imatra workshop in 1954 was a first step toward this cognitive approach to architecture. [FIG. 6] It presented the creative process in the form of an atom: the human spirit occupies the position of the nucleus at the center, while "form, matter, structure and function" take on the role of electrons in orbit. [27] Blomstedt's influence is still apparent in Petäjä's motto: "The role of architecture is to bring human life in harmony with its environment." Yet, unlike Blomstedt, Petäjä understood both the genesis and experience of form as an open-ended process governed by the human psycho-physical apparatus rather than by universal laws. Petäjä's thinking was similar to Aalto's in its emphasis on the creative process as one during which the human mind responds and adjusts to its environment—Aalto's much quoted essay "Trout and the Stream" ["Architettura e arte concreta"] from 1947 serves as a reference point. [28] In this equation, the mind is not an isolated entity but is defined by its ability to respond to stimuli from outside. Hence, in his remake of the classical Vitruvian diagram, Petäjä depicts man not at the center of a stable universal system, but rather struggling to come to terms with a dynamic environment consisting of a multitude of stimuli, which are represented as a series of overlapping amorphous ovals pushing and pulling in various directions. [29] Unlike the Vitruvian man, Petäjä's man exists in real space thereby offering a different approach to architectural humanism. This realization goes hand in hand with the reinvention of the concept of "space" as a realm of pure intuition.

26 Petäjä writes how he believes that only "creative spirit" rather than reason would be able balance the different aspects of architecture—matter, function, structure and form—into a unified, harmonious whole.
27 The diagram is drawn on an unpublished typewritten letter dated 28.11.1954 that Petäjä wrote to his brother, in which he discusses the Imatra conference. Office archives of Petäjä Architects, Helsinki.
28 The article appeared in the Italian magazine Domus in 1947 and has been reprinted in English in Göran Schildt, Alvar Aalto in His Own Words, New York: Rizzoli, 1998, pp. 107–109.
29 Petäjä, unpublished diagram from office archives in Helsinki.

These concerns were at the forefront of a three-part essay, "Perception of the Real," which Petäjä published in consecutive issues of *Le Carré Bleu* in 1959. Introduction of time and cognition into the design process led to the acknowledgement of the inherent paradox at the heart of architecture: how could architecture ever come close to responding to the complexity of human life and experience? In the first issue of 1959, Petäjä published another diagram to map out what happens during the design process, focusing on how cognition oscillates between "reality" and "perception." This oscillation is depicted as a series of parabolic, flexing curves, which show how these two strands of information presumably fold into a continuous topology. "The architect is a designer who is able to control the relationship between conceptual and perceptual form," he stated.[30] Importantly, external reality was not seen as a given but something that requires meaning granted through responding to human beings. In this way, both the genesis and experience of form was conceptualized as the result of temporal feedback loops between the two.

His interest in how information is collected, processed and ultimately controlled echoed contemporaneous cybernetic theories—a quintessential product of Cold War mentality—where a system, in this case a cognitive system, was seen as governed by feedback loops. Similarly, the diagram Petäjä published in *Le Carré Bleu* depicted the oscillation of cognition between concepts and percepts without ever loosing its balance: the goal of any successful feedback process.[31] [FIG. 7]

One can read a geopolitical subtext into this interest in how a human being makes sense of reality. The ultimate creative individual was in this case President Kekkonen who, equipped with great personal charm, charisma and intelligence, was well suited to manage and balance the complex parameters that determined Finnish foreign and domestic policy. Parallels can also be drawn between Petäjä's interest in information flows and Finland's geopolitical dilemma, which subjected and engaged its leaders in espionage,

30 Petäjä, letter to his brother from the office archives.
31 I thank Christine Boyer for drawing my attention to the relevance of
 cybernetic theory for various Team 10 members.

FIG. 7 KEIJO PETÄJÄ, TITLE IMAGE OF *LE CARRÉ BLEU*,
NO. 2, 1959, TITLED "PERCEPTION DE L'ESPACE REEL"

FIG. 8 REIMA PIETILÄ, COVER IMAGE OF *LE CARRÉ BLEU*,
NO. 1, 1958, TITLED "MORPHOLOGIE DE L'EXPRESSION
PLASTIQUE"

complex negotiations and misunderstandings, while somehow miraculously avoiding a major conflict. Furthermore, the dichotomy between "reality" and "perceptions" could well be used to characterize Kekkonen's ultimate achievement, which was to convince Western leaders of Finland's alliance while fostering a particular relationship with the Soviet Union and vice versa. Indeed, Petäjä's parabolic diagrams could well be interpreted as the swerving and spinning—to use the contemporary political concept that refers to "a particular bias, interpretation or point of view, intended to create a favorable (or sometimes, unfavorable) impression when presented to the public" [32]—that characterized Finnish foreign policy during the Cold War years.

It is important to acknowledge that Petäjä's approach to how information is processed never comes down to bits and atoms of information; the fluid curves represent a more phenomenological approach, with an emphasis on human processing and the interpretation of information. Petäjä makes his intellectual affinities clear by quoting from Heidegger's essay "Building, Dwelling, Thinking" delivered during the *Darmstädter Gespräche* [*Darmstadt Discussions*] in 1951, which had the theme "Mensch und Raum" ["Human Being and Space"]. [33] The essay captured the ethos of the seminar by recalling that architecture was a fundamental human activity and its main outcome was to form space. Heidegger's emphasis on existence suggested that his notion of space had more to do with human beings and community than with actual political boundaries and territorial maps, an idea that certainly resonated in postwar Europe. One can understand the rise of phenomenology in architectural discourse against this political background where geographical and territorial narratives (e.g., national, international) start to shift toward discussions of space, and where particular attention is given to dwelling as a fundamental human condition shared by people all around the world.

32 See the entry "spin" in www.oxforddictionaries.com; date of access June 2013.

33 For more discussion of the Darmstadt Discussions, see *Darmstädter Gespräch, 1951: "Mensch und Raum,"* edited by Otto Bartning, Darmstadt: Neue Darmstädter Verlagsanstalt, 1951.

Lauttasaari Church from 1958 in Helsinki demonstrates how Petäjä translated these goals into a quintessential architecture assignment of the postwar years: simple geometric forms that highlight the importance of space and light. Heidegger's influence is apparent. The building as an object was never to be the focus: "dwelling" was exalted. If there was a political subtext to be found in this approach, it had to do with the act of dwelling as the core and eternal practice of human life, more fundamental than the activity of drawing boundaries. Therefore, while holding certain geographical implications—dwelling is always situated in a particular place—Petäjä's buildings are devoid of references to what could be interpreted as vernacular or national architecture. This is because the subdued formal expression of carefully proportioned buildings placed against the backdrop of a beautiful landscape acutely underscored Finland's claims to neutrality as a bastion of human values and guardian of nature.

Architecture Degree Zero: Helsinki–Warsaw

In this period of a quest for order, harmony and consensus, Reima Pietilä stood apart from the younger generation of Finnish architects because of his taste for instability and experimentation. He pursued form-giving as an open-ended search and took interest in the unfinished, unknown and understudied aspects of architecture, which, as I will show, had less to do with individual artistic expression than with a new way in which forms both informed and were formed by the life of individuals and societies. Pietilä often used the word "feeling" to describe the human relationship to space in a manner that recalls Susanne Langer who, in her landmark book *Philosophy in a New Key* (1951), searched for a deeper intellectual and emotional life beyond practical reasoning of various spheres— including the economic, social and political.

Pietilä called his experiments "morphological" rather than formal studies: "morphology" implied a study of nature as well as of social systems and structures, suggesting that architecture's formal system was malleable and corresponded directly to the struc-

FIG. 9 REIMA PIETILÄ, TITLE PAGE OF "MORPHOLOGY-URBANISM,"
LE CARRÉ BLEU, NO. 3, 1960

tural functioning of the organism it entailed. [34] [FIG. 8] It therefore comes as no surprise that Pietilä was particularly interested in urban morphology, which meant understanding architecture as part of both natural and social systems. He was critical of state housing initiatives based on a strictly economic and functional imperative, which had led to a rather crude deployment of blocks of flats in a manner insensitive not only to features of the landscape but to the larger cultural and social context as well. He first explored these ideas in the exhibition "Morphology-Urbanism" in 1960, which was published in lieu of a catalogue as a special issue of *Le Carré Bleu*. [FIG. 9] In one of the panels he contrasts "bad" and "good" examples of planning; in the former, housing forms are conceived merely as an "additive accumulation," while in the latter "different buildings constitute various textures of spatial forms, border one another in a sensitive fashion and also the terrain surrounding them." [35]

 Pietilä continued to explore how landform and built form enter the human imagination in his Dipoli Students' Center (1961–1966) located near Alvar Aalto's campus for Helsinki Technical University in Espoo. [FIG. 10] Early concept sketches hint only vaguely at the formal outcome or any sense of spatial closure registering the marks that witnessed the geological landforms on the site. [FIG. 11] In the final outcome, the dominant part of the building consists of a copper-clad wing that seemed to grow without human intervention, as if naturally, from the exposed granite bedrock on the site.

 Pietilä called the building a "torso," something unfinished, even incomprehensible. The concept correlated with his conviction that architecture's social function was not to create order or to "police" but simply to provide an organic link between human beings and a larger cultural and natural context.

 It is hard to know with whom Oskar Hansen felt closest among his Finnish colleagues—Blomstedt was his first contact—yet he was surely impressed by Pietilä's persona and his design method. He later recalled his 1961 visit to Pietilä's studio as follows:

34 The discipline of social morphology was first introduced by Emile Durkheim as a study of how social systems are distributed across space.

35 The panels from the exhibition were published as a special issue of *Le Carré Bleu* no. 3 from 1960 without the text, which was published in *The Finnish Architectural Review* in the same year.

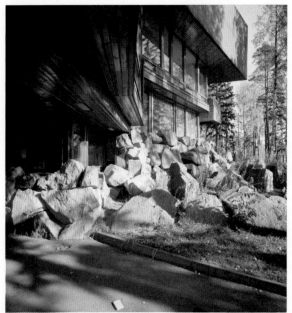

**FIG. 10 DIPOLI STUDENTS' CENTER, DESIGN:
REIMA PIETILÄ, 1961–1965**

**FIG. 11 DIPOLI STUDENTS' CENTER, PLAN SKETCH, DESIGN:
REIMA PIETILÄ, 1961–1965**

I spend a long evening with the architect Reima Pietilä, obsessed with the vision of form. I remember how, standing in a pile of sketches for the famous student house in Otaniemi, he shared his intuitional way of searching for form with me. [36]

Importantly, Hansen uses the word "vision" to capture the essence of Pietilä's creative process; in his word, an architect was equipped with a capacity to capture larger forces and phenomena through form.

Like Pietilä, Hansen saw spatial experience as a realm of nondiscursive knowledge, one that transcended rational patterns of thinking and behavior opening both architecture and the subject to larger processes that governed the world. The 1955 Izmir pavilion in Turkey is a case study of what he in his Open Form manifesto later called the "spatial subtext of a composition." [37] The project was based on repeating hyperbolic roof elements amplified with contrasting stripes, which formed a regulated pattern in the building's interior. [FIG. 12] Surrounded by a pulsating optical graphic environment we are in the presence of a rationally constructed system, yet are unable to grasp how the effect was produced. Instead of relying on understanding, one is physically and optically hypnotized by the surface patterns, which seem to extend forever. The impulse was to make architecture into more than a mere physical and functional apparatus. A measure of good architecture was that it created enticing atmospheres, triggered the imagination and enabled many, often unexpected, uses: these were the core principles of Open Form.

The project "Active Negative" from the same year attempted to capture such multidimensional spatial experience in a palpable form. [FIG. 13] Hansen started by taking a series of photographs of his own design of spaces that mark the boundaries between inside and outside, and proceeded to map out the volumetric luminosity within those liminal spaces in two dimensions. As a third step, he turned these projections into an amorphous three-dimen-

36 Oskar Hansen, "Hermann Hansen, Appelsin and After," unpublished document in the Oskar Hansen Papers, Museum of Modern Art, Warsaw. I thank Aleksandra Kędziorek for providing me with the quotation.
37 Oskar Hansen, "Open Form" (1959), republished at www.open-form.blogspot.com; date of access June 2013.

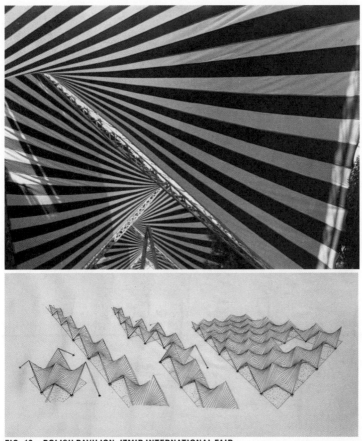

FIG. 12 POLISH PAVILION, IZMIR INTERNATIONAL FAIR,
DESIGN: OSKAR HANSEN AND LECH TOMASZEWSKI, 1955

FIG. 13 OSKAR HANSEN IN COLLABORATION WITH EMIL CIEŚLAR AND
ANDRZEJ J. WRÓBLEWSKI, "ACTIVE NEGATIVE—SCULPTING SPATIAL
SENSATIONS RECEIVED INWARDLY AND IN THE INSIDE'S RELATIONSHIP
WITH THE OUTSIDE," 1955

sional clay model somewhat reminiscent of Henry Moore and Bar-
bara Hepworth's sculptures, which similarly aimed at capturing tex-
tures and sensations. He wrote about the project as follows: "As
a sensory recording, the active negative is modeled by visual struc-
tures. [...] Its main purpose is to conduct an emotional study of an
architectural space's composition even before the technical phase
begins."[38] In this remarkable quote Hansen made it clear that archi-
tecture's main task was to safeguard the realm of feeling and sensi-
bility as an abode of humanity and individuality, and protect it from
being co-opted by knowledge or ideology. He even suggested that in
some cases these core feelings and passions need to be restored or
awakened; hence he argued that the main task of Open Form was to
"awake the desire for existence in all of us."[39]

The word "humanization" that Aalto used frequently in
his lectures from the mid 1950s onward comes up again and again
in Hansen's writings. This interest can be linked to the notion of Marx-
ist humanism that emerged after the fall of Stalinism in 1953, when
a number of Eastern European intellectuals started to call for a more
active role in shaping the world and environment in order to offer
"a human alternative to the dehumanizing aspects of Stalinism."[40]
This recalled that the founding ideas behind Marxism—however
debased they had become along the way—were based on the well-
being and equal treatment of each and every individual. The return
to Marx's early writings on human creativity can be seen as a rejec-
tion of the political apparatus in state socialism that had taken con-
trol of every aspect of individual life. Hansen's notion of Open Form
was based on these principles of Marxist humanism, namely the
power of human imagination to create meanings that are not directly
linked to anything that could be called external reality, which led to
the realization that institutions and patterns of life could be changed
and quality of life could be restored if the human imagination was
given its due. Marxist revisionists in socialist Poland argued that true
Marxism relies on the "emancipation and liberation of human beings"
and the "association of free individuals": a quest that is dominated
by the problem of the greater number.[41]

38 Oskar Hansen, quoted in *Towards Open Form*, op.cit., p. 105.
39 "Open Form" manifesto, op.cit.
40 James H. Satterwhite, *Varieties of Marxist Humanism: Philosophical Revision in
 Postwar Eastern Europe*, Latham: University Press of America, 1992, p. 8.
41 For further discussion about Marxist humanism in Poland, see "Polish
 Revisionism: Critical Thinking in Poland from 1953–1968," in *Varieties of
 Marxist Humanism*, op.cit.

Like Pietilä, Hansen saw housing and urbanism as the pinnacle of his socio-aesthetic vision. It must be noted that while state socialism could not be fully identified with a welfare state they shared a great deal in common, as socialism guaranteed free social services, employment and affordable rent.[42] Design for a multifunctional space for the market square in Pułtusk, Poland (with Zofia Hansen), from 1959 embodied the ethos of Open Form by placing focus on spontaneous events and activities. Like Pietilä's morphological urbanism, the Linear Continuous System (LCS) proposal from 1966 called for a total environment where housing design was concerned, including a productive landscape. In a statement regarding the LCS, Oskar and Zofia Hansen countered what they called current "inorganic environmental forms" by proposing new "poetical parameters of our time and place." It is unclear what exactly was meant by "poetical parameters" but it had something to do with the idea that the "open system" on which the design was based allowed individual and site-specific needs and habits to balance the economic and social conditions put forward by the socialist state.[43] Like for Pietilä, reestablishing the relationship between human beings and landscape was a crucial technique for the Hansens, aimed at establishing a balance between economic and social needs.

Open Form—Open Society?

Oskar Hansen's socio-aesthetic ambitions were best expressed in his "Open Form" manifesto (1959), which can be read against the wider intellectual and political context of postwar Europe. Fellow travelers included architects as well as philosophers who had all come to the conclusion that rationalism had proven inadequate in safeguarding political and social stability and that only by safeguarding core human values could civilization be saved. Michel Foucault's summary of postwar European intellectual life applies to Hansen and others who sought to release the imaginative powers of intellectuals and communities: "During the years 1945–1965 (I am referring to Europe), there was a certain way of thinking correctly,

42 See Judt's discussion about welfare in Eastern Europe, *Postwar*, op.cit., pp. 631–632.
43 Oskar and Zofia Hansen, "Linearny System Ciągły" (1967). English translation from *Towards Open Form*, op.cit., p. 215.

a certain style of political discourse, a certain aesthetics of the intellectual. One had to be on familiar terms with Marx, not let one's dream stray too far from Freud." In addition, the years were dominated by "an amalgam of revolutionary and anti-repressive politics." [44] Hansen, who spent some time in France after the war, was surely aware of the main movements in the European intellectual scene across the Iron Curtain.

Hansen's opposition between open and closed form recalls Karl Popper's notion of "open" versus "closed society" put forward in *The Open Society and Its Enemies* (1945), which contrasts humanism marked by freedom of thought and action with the lack thereof within abstract and depersonalized systems; the former called for human engagement rather than passive acceptance of the given situation. Umberto Eco's book *Open Work* (1962) helps us further frame both Pietilä's "torso" architecture and Hansen's Open Form project from the perspective of the larger humanist project that united various strands of European political and cultural life in the postwar years: an artist should leave an artwork "open" in order to engage the viewer. Similarly, the difference between "open" and "closed" structures was widely discussed during Team 10 meetings in the 1950s in a manner that preferred that building and city designs remain incomplete, to allow the input of inhabitants and residents. [45]

I believe that the call for openness gained particular urgency in Eastern Europe, including Finland and Poland, two countries where there was a sense that something lay dormant under the surface. This hunger for change, however gradual, was best captured in Hansen's call for "diverse individuality, in all its randomness and bustling, [that] will become the wealth of this space, its participant," [46] or in case of Pietilä, the equally open-ended notion of "possible archi-

44 Michel Foucault from his introduction to Gilles Deleuze and Felix Guattari, *Anti-Oedipus: Capitalism and Schizophrenia*, New York: Viking Press, 1977, p. xi.

45 For more information about open structuralism, see Salomon Frausto and Dirk van den Heuvel, *Open Structures: An Introductory Dossier on Dutch Structuralism*, supplement to *Volume 35: Everything under Control*, Delft Faculty of Architecture and Berlage Institute, 2013. I want to thank Dirk van Heuvel for sending a copy of the publication.

46 "Open Form" manifesto, op.cit.

tecture."[47] In their words and works they both placed emphasis on the indeterminacy of the situation, while building upon the core principle of the modern movement in architecture, namely the idea that architecture can change life and, in so doing, improve societies. Neither Pietilä's "torso" architecture nor Hansen's Open Form should be understood as calls for a radical dismantling of order, structure and meaning, but rather as demands for the introduction of more ambiguity and indeterminacy into architecture.

While all our protagonists surely shared a certain healthy skepticism about top-down planning and the economic determinacy of their respective systems, they seem to have believed that Finland, a capitalist welfare state, and Poland, a socialist country, could still sponsor radically engaged subjects able to take their destiny in their own hands. In their reading, this would culminate with the empowerment of a new body of "citizens." What differentiates their work from the work of most of their Western peers is their insistence on form and its "aesthetic regime," that is, making the relationship between individual actions and large-scale political and social forces sensible through feelings and emotions.[48]

Pietilä and Hansen chose abstraction as their preferred mode of expression; as T. J. Clark has argued, the power of abstraction lies in its ability to embody a multiplicity of meanings, including political meanings.[49] Building on the rich legacy of 20th-century European abstract art, Hansen's Open Form, very much like Aalto's curvilinear forms and Pietilä's "torso" architecture, celebrated such ambiguity of meaning. Aalto never saw form as being autonomous but rather a vehicle in this humanization process, that is, as something that is born out of experience and that can trigger experience and feelings. It is this ability to denote sensations that lies at the heart of his 1955 lecture "Between Humanism and Materialism," in which he spoke about "Form being a mystery of which we

47 Reima Pietilä, "Hobbydogs," *Arkkitehti*, no. 6, 1967. Reprinted in *Pietilä. Intermediate Zones in Modern Architecture*, Helsinki: Museum of Finnish Architecture, 1985, p. 73.

48 I have borrowed the concept of "aesthetic regime" from Jacques Ranciére's *Aisthetis: Scenes from the Aesthetic Regime of Art*, London: Verso, 2013.

49 See Timothy J. Clark, *Farewell to an Idea: Episodes from the History of Modernism*, New Haven: Yale University Press, 2001.

cannot tell what it really is, but somehow it makes people feel good in a way that is completely different from efforts at social salvation."[50] By regaining such mystery, architectural form would structure and govern daily life and experience in the deepest sense: tapping into the inner core of human life.

By emphasizing the geopolitical underpinnings of this brand of humanism, I want to emphasize that the humanism put forward by Aalto and the younger generation of Finnish and Polish architects was not about resorting to an ideal world. Rather, it is indeed the synergy of individual life and large-scale historical events that made their brand of humanization gain particular meaning, not least by putting architecture forward as a realm where ambiguities can be celebrated and processed, and where freedom and possibilities could reign, even if momentarily. To be sure, within the challenging geopolitical context of their respective countries, ambiguity of feeling had a rather desired side effect: the production of a certain level of de-territorialization that promised that an individual could take control, undo, remake and posses spaces and places to fit his or her own imagination—despite of social realities or geopolitical destinies.

50 Aalto's "Between Humanism and Materialism" was originally delivered as a lecture at the Vienna Architect's Association in 1955 and has been reprinted in English in Göran Schildt, *Alvar Aalto in His Own Words*, op.cit., pp. 176–180.

Jelica Jovanović is an architectural historian, a PhD candidate at the Vienna University of Technology, Faculty of Architecture, Institute for Art History, Archaeology and Preservation since March 2013. Within the Docomomo International's Serbian working party she is currently working on proposals for the protection and preservation policies concerning the architecture of the modern movement in Serbia. She is the founding member of the Group of Architects, an NGO. She organized the Summer School of Architecture in Bač and coordinated the regional project *Unfinished Modernisations* for the Association of Belgrade Architects. She was the program coordinator of Docomomo Serbia (2010–2013).

ALEXIS JOSIC BETWEEN YUGOSLAVIA AND FRANCE: HOUSING THE GREATEST NUMBER

At the beginning of 1970, a special edition of the Belgrade-based journal *Arhitektura urbanizam* was published with the title "Projects and Developments Abroad."[1] A significant part of this issue was dedicated to the work of Alexis Josic (Aljoša Josić), who by then had been living and working in France for 20 years. As the most prominent among "our builders abroad," Josic was at that time designing a new studio on the Rue de Sèvres, on which he worked together with his wife, Douschanka (Dušanka) Josic; he was finishing the project of the Free University of Berlin in partnership with Georges Candilis and Shadrach Woods; and he was facing an intensifying critique of the welfare-state housing estates to which the partnership Candilis-Josic-Woods (CJW) had contributed a great deal, both in Europe and North Africa. However, the popularity of CJW in professional circles of Yugoslavia, unlike other parts of Europe, was on the rise. The professional respect for Josic never vanished in his native country, although he only once entered a competition in Yugoslavia (the urban regeneration of New Belgrade, 1986) and never was given a commission there. Acknowledging his achievements abroad, the University of Belgrade, his alma mater, awarded him an honorary doctorate in 2004, which was put forward by the Serbian Academy of Architecture.[2] [FIG. 1]

Alexis Josic left Yugoslavia for France in 1950, two years after his graduation from the Faculty of Architecture in Belgrade, and the same year in which the art school of his father, Mladen Josić, was closed in Belgrade. Josic was allegedly opposed to the regime, so he decided to leave the country as soon as the opportunity presented itself. He was a promising young architect of the generation of the "planned distribution of personnel,"[3] which had a great deal of work on their hands during postwar reconstruction and a more systematic approach to the housing crisis designed by the authorities. His contemporaries, of whom Bogdan Bogdanović and Mihailo Mitrović were the most prominent, often recalled the abundance of work for architects during this time even if the tasks were less ambitious than they would have desired.

At the time when Josic left for France, Yugoslavia was a severely undeveloped country, as a glance into the indicators in the Yugoslav and the postwar United Nations reports quickly reveals. The country's modest prewar infrastructure was severely damaged, and this concerned all the aspects of everyday routine: education, traffic, health, food production and housing. As was the case with the context of the CJW housing projects, cities in Yugoslavia including Belgrade were characterized by poor living conditions, overcrowded flats and nonexistent industrial production, which had the priority in government spending before the housing crisis could be addressed.[4] In this sense, while Josic was designing housing for French colonies with the ATBAT atelier, Yugoslavia was struggling to prepare the capacities for tackling the housing question, which included training both scholars and the workforce, improving legislation and raising the industrial capacities of state companies. This explains the delay, in comparison with France, in the application of new housing typologies, which could not have been made without the appropriate prefabrication technology. This technology was only slowly implemented beginning in the 1950s.

During the postwar period, the country first received aid from the USSR, which was suspended after the resolu-

FIG. 1 COVER OF *ARHITEKTURA URBANIZAM*,
NO. 58, 1962

FIG. 2 CONSTRUCTION SITE OF THE TEXTILE FACTORY, VELES, AROUND 1950,
ON-SITE PREFABRICATION

tion of Informbiro in 1948, and then from the U.S. beginning in 1951. Over the following years, other countries of Western Europe joined in to help, offering both financial and technical assistance, which was well received and implemented by professional circles in many construction companies. Yet because of the initial difficult circumstances, new methods of industrialized building were not fully available for application in Yugoslavia until 1960. [FIG. 2]

While it would be difficult to give hard proof of direct influence of Team 10 ideas within professional practices of Yugoslavia, the broader framework in which the work of Candilis-Josic-Woods was executed, namely *Opération Million* [Operation Million] and *Habitat à Loyer Modéré* [State-Subsidized Housing], was observed quite closely by Yugoslav architects, engineers and technicians. The engagements of the CJW partnership with *Opération Million* began with their selection in the 1955 national competition for providing generic plans for low-cost housing, which resulted in the commission to design 2,500 dwelling units in Paris and in southern France. CJW received the task of planning and implementing the expansion of Bagnols-sur-Cèze in 1956, making low-cost housing their principal source of work in the years that followed.[5] In their competition entries, the CJW partnership both implemented and criticized the widespread prefabricated systems, above all the Camus system, which produced monotonous facades in many of the new neighborhoods. This effect found its continuation in the Yugoslav applications of this system, since Camus and its later variations belonged to the first industrialized systems implemented in Yugoslavia, apart from those developed by Yugoslav companies (Jugomont) and research institutes (IMS).[6] [FIG. 3]

This transfer of building systems took place against the background of a broader import of modernization expertise, which included infrastructure, management and production. As determined by the Program of Scientific and Technical Collaboration signed in 1956, Yugoslavia was supposed to send 22 engineers, 22 technicians and 22 fitters to France, 71 workers to West Germany and 26 workers to Switzerland, with an additional 300 workers from the building-material industry to be educated and trained by both of those countries and with many more programs to follow it. Knowledge-transfer projects with socialist countries were launched after the post-Stalinist relaxation of tensions in 1957, and included the USSR, Poland and Czechoslovakia.

The delay between the construction of prefabricated housing in France and the import of these systems to Yugoslavia offered the possibility of evaluating their performance. This critical rethinking of mass-housing projects was further facilitated by access to French debates by means of such journals as *Le Carré Bleu* and *L'Architecture d'aujourd hui*[7], as well as numerous competitions organized by professional associations in Yugoslavia beginning in the early 1960s, which aimed at the advancement of modern architecture in Yugoslavia. [FIG. 4]

Yet another learning experience was provided by the experience of working abroad, based on contracts with the non-aligned countries. With these contracts in mind, the *Compendium of Regulations in the Field of Urban Planning and Zoning*[8] was published in 1968, using French experiences with *Opération Million* as the starting point. The *Compendium* was the basis for the master plan of Belgrade and the master plan of the Socialist Republic of Croatia in 1974. The authors of the *Compendium* created and developed a body of norms and standards for future programming and design processes, later implemented in export projects in Kuwait, Angola and Morocco by the Belgrade state firm *Energoprojekt*. In some North African coun-

tries, French architects were replaced
by Yugoslav architects: another set of
circumstances shared by Yugoslav plan-

ners with the partnership Candilis-
Josic-Woods. [FIG. 5]

1 The preface, "Our Builders Abroad," laments the country's brain drain,
 and was written by Belgrade architect Aleksandar Đokić, then editor of
 the journal. Aleksandar Đokić, "Delatnost arhitekte Aljoše Josića,"
 Arhitektura i urbanizam, no.58, 15 II 1970, pp. 55–65.
2 Mihailo Mitrović, "Sećanje: Arhitekta Aljoša Josić," in Akademija arhitekture
 Srbije, Rad – dela – komentari, edited by Slobodan Giša Bogunović, Belgrade:
 Academy of Architecture of Serbia, 2011, pp. 296–298.
3 In the first years after the Second World War architects were in the
 category of the professions with a severe scarcity of personnel. Upon
 graduation, young engineers of architecture would be "distributed" to
 (state) companies or institutes according to the urgency of the demands
 of production.
4 Tom Avermaete, Another Modern: The Post-War Architecture and Urbanism of
 Candilis-Josic-Woods, Rotterdam: NAi, 2005.
5 Jürgen Joedicke, "Toulouse Le Mirail – Geburt einer neuen Stadt / La
 naissance d'une ville nouvelle / Birth of a New Town," Candilis-Josic-Woods,
 Dokumente der Modernen Architektur 10, Stuttgart: Karl Krämer Verlag, 1975,
 p. 8.
6 Branko Aleksić, "Stambena sredina, Humane – prostorne osnove 1,"
 Postgraduate Studies Housing Course, Belgrade: Faculty of Architecture
 University of Belgrade, 1975. Also, see Mate Baylon, Stambene zgrade,
 Belgrade: Građevinska knjiga izdavačko preduzeće NR Srbije, 1952.
7 Unpublished audio of interviews with Milenija and Darko Marušić,
 Mihailo Čanak and Branko Bojović from the project Unfinished Modernisa-
 tions, exhibition and book Unfinished Modernisations Between Utopia and
 Pragmatism.
8 Zbirka propisa (saveznih i republičkih) iz oblasti urbanizma i prostornog uređenja sa
 objašnjenjima, Belgrade: Newspaper Institution of the Official Gazette of
 SFRY, 1968.

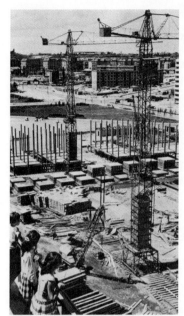

FIG. 3 CONSTRUCTION SITE OF NEW
BELGRADE—IMS ŽEŽELJ PREFABRICATED
TECHNOLOGY

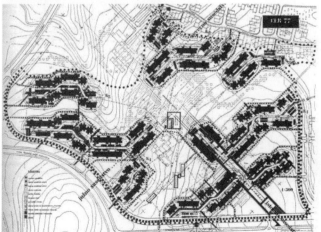

FIG. 4 CERAK VINOGRADI NEIGHBORHOOD, BELGRADE, DESIGN: MILENIJA
& DARKO MARUŠIĆ, NEDELJKO BOROVNICA, 1985

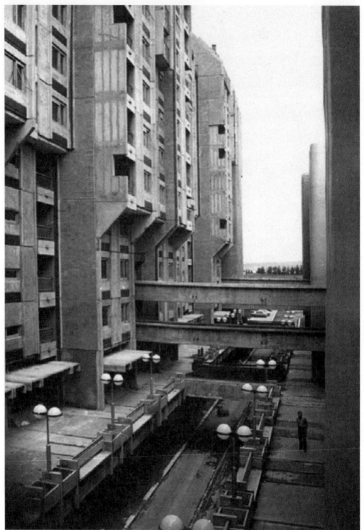

FIG. 5 BANJICA NEIGHBORHOOD, BELGRADE, DESIGN: BRANISLAV KARADŽIĆ,
SLOBODAN DRINJAKOVIĆ, ALEKSANDAR STJEPANOVIĆ (ARCHITECTURE), JOVAN
LUKIĆ, UZELAC, KRŽIĆ (URBAN PLANNING), 1978

Renata Margaretić Urlić is a historian of art and architecture focusing on postwar Croatian modernist architecture. She works as an editor of cultural programs and documentaries in Croatian Radio-Television, and also as an art and architecture critic for various Croatian journals and periodicals. She served on editorial boards of the major Croatian architectural magazines—*Arhitektura* and *Čovjek i prostor*. She is the author of the book *Slavko Jelinek* (Udruženje hrvatskih arhitekata, 2009), on the housing projects of Jelinek, the prominent Croatian postwar architect. She graduated in Art History from the Faculty of Philosophy, University of Zagreb. Her master's thesis focused on Croatian modernism and in particular on the Workers' University designed by Radovan Nikšić and Ninoslav Kučan. Currently, she is completing her doctoral dissertation on the housing architecture of New Zagreb.

Karin Šerman is an architect and Professor of Architectural Theory at the University of Zagreb Faculty of Architecture. She also teaches Architectural Theory at the Faculty of Civil Engineering, Architecture and Geodesy, University of Split. Her work focuses on modern and contemporary architecture and culture, and current theoretical research. She has written extensively on Central European and Croatian architectural history and theory and the contemporary architecture scene. She has been the Head of the Department of History and Theory at the Zagreb Faculty of Architecture since 2010. She is the leader of the module Architectural Thought of the doctoral study program. Karin Šerman graduated in architecture from the Faculty of Architecture at the University of Zagreb in 1989. She received her MDesS (Master's in Design Studies) in Architectural History and Theory from the Harvard University Graduate School of Design in 1996, and her PhD from the University of Zagreb in 2000.

RENATA MARGARETIĆ URLIĆ
KARIN ŠERMAN
WORKERS' UNIVERSITY ZAGREB: TEAM 10 IDEAS
IN THE SERVICE OF SOCIALIST ENLIGHTENMENT

The ideas espoused by Team 10, which so decisively transformed CIAM and led to profound reconceptualizations of the modern project, found their genuine reflections in the architecture world of socialist Yugoslavia. The Croatian architecture scene, with its strong prewar modernist legacy, was particularly receptive to such reconsiderations of functionalist principles. It produced a convincing case of such critical assessment as early as 1955–1961: the Workers' University in Zagreb, which was built according to the design by Radovan Nikšić and Ninoslav Kučan and stood as fine testimony to the life of Team 10 ideas within the socialist sphere.

In this case, proximity to Team 10 theories would not be particularly difficult to establish, as one of the designers, Radovan Nikšić, had firsthand exposure to their decisive influences. He worked as an intern in the Rotterdam office of Jaap Bakema and Johannes van den Broek from January to July 1956, precisely in the period when Bakema, alongside his fellow Team 10 members, was preparing for the decisive 10th CIAM congress to be held in August of that year in Dubrovnik. Yet an affinity with new tendencies in architecture was present even before this important contact. By the time Nikšić arrived in Bakema's office, he had already won, together with Kučan, first prize in the architectural competition for the Workers' University. Their winning proposal was, tellingly, already fully structured along lines provided by the novel architectural ideas in question.

The project for the Workers' University was envisioned for the education of workers, and therefore addressed to the social force that was at the heart of the new socialist system. As a consequence of Tito's break with Sta-lin in 1948 and the country's subsequent ejection from Cominform, Yugoslavia—left without economic ties with Eastern Bloc—was destined to develop a distinctive non-Soviet model of decentralized political and economic decision-making known as "workers' self-management." According to this program, and following the Marxist idea of a "free association of producers," factories would be directly in the hands of producers, subsequently leading to the development of local or "communal self-management." [1] By the beginning of the 1950s Yugoslavia was already practicing this new, supposedly more "humane," variant of socialism—"socialism with a human face," or rather a "system of direct socialist democracy." [2] In order to self-manage and direct factories and communities, workers—in fact, the rural population migrating into the cities—needed to be properly educated. This important education was left mostly to the factories until the mid 1950s, and was held mainly on the premises of the factories, if influenced heavily by the Communist Party and the federal government. In 1955, however, the city of Zagreb decided to take control of education from the factories and to establish a central educational institution run by the city: the Workers' University, committed to the political education of workers and their professional, technical and cultural training. [3]

The significance of the Workers' University, understood as a precondition for the success of the whole "self-management" experiment, was manifest already in its urban position. It was located on the grand new avenue—the Avenue of the Proletarian Brigades, today Vukovar Avenue—a modern urban axis that formed the spine of the ambitiously envisioned new socialist city center, south of the historic city of Zagreb. The

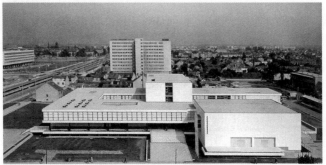

FIG. 1 WORKERS' UNIVERSITY ZAGREB IN ITS URBAN SURROUNDING, DESIGN: RADOVAN NIKŠIĆ AND NINOSLAV KUČAN, 1955-1961

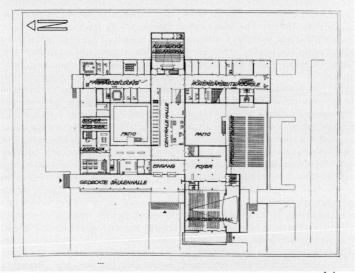

FIG. 2 WORKERS' UNIVERSITY, GROUND FLOOR PLAN, DESIGN: RADOVAN NIKŠIĆ AND NINOSLAV KUČAN, 1955-1961

sweeping new modern avenue was built in the syntax of modernist free-plan urbanism, with widely spaced high-rise buildings detached from the street. Amidst such isolated free-floating slabs, the winning design by Nikšić and Kučan offered a radically different approach: a low-rise, high-density architectural model. [FIG. 1]

On the large parcel the architects proposed an intricate and dynamic asymmetrical composition of various spatial volumes arranged around two inner courtyards, creating an elaborate world of education and culture. It was to house centers for elementary education, professional training, training of workers' managers, the education of managers in economy and industry, a high school for workers, and several other profiled courses.[4] It therefore needed to provide a multitude of different spatial elements: classrooms, seminar rooms, workshops, laboratories, libraries, reading rooms, lecture halls, auditoriums, club and recreation rooms, offices and other spaces. Due to the extraordinary diversity and density of the program, it was labeled a "horizontal skyscraper,"[5] expected to serve 2,000 participants at any given time. This all entailed a highly elaborate ground plan and richly varied relationships between the building's segments. Such complexity, almost an intense spatial field, was secured by a precise modular network and consistent structural grid, combined with the elaborate system of horizontal and vertical communications that enabled spatial flexibility.

With its focus on issues of density, mobility, interconnectivity and active spatial unity, this competition proposal clearly manifested an affinity with familiar Team 10 themes. It was with such a spatial apparatus that Nikšić came to his internship in Bakema's office. In this way, the insights that he gained there reaffirmed his existing design philosophy.

The impact of the period spent in Bakema's office could only be noticed in rather small changes of the realized version, as opposed to the original competition proposal. Primary was the effort to achieve more pronounced geometrical order and clarity. The protruding volumes of separate building segments lost their previously existing Corbusian stereometric plasticity and formal expressivity, and were instead more aligned with a precise geometrical scheme, achieving an appearance of abstract planarity. This shift was most evident in the precise modular grid of transparent facades and their huge glass surfaces set in aluminum frames, which extended from floor to ceiling and which in two parallel bands enveloped nearly the entire horizontally laid-out building. The basic unit of spatial organization remained the elementary 7x7-meter classroom, as the basic unit of the structural grid. Since the educational program was adapted for small groups of 15 to 20 students, and required frequent changes according to modifications in the educational process, the classrooms were expected to be easily transformed and rearranged. This was achieved through the use of an elementary reinforced-concrete skeleton and light partition walls or movable panels. Sequences of classrooms formed larger spatial sectors—the four main wings—organized around two patios. Larger volumes of the main auditorium and lecture hall, with their distinct sizes and modules, were added to the main structure as autonomous bodies. Wide and spacious corridors, proportioned in such a way as to enable larger audiences and house exhibitions, were to be used for art courses, also offered by the university. [FIG. 2]

In its totality, the building was an impressive, pure and abstract spatial construct, veiled in transparency, with space flowing freely through it, connecting the structure in a unified spatial order. The interiors and furni-

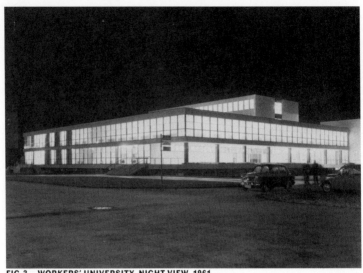

FIG.3 WORKERS' UNIVERSITY, NIGHT VIEW, 1961

ture were designed by Bernardo Bernardi, a member of a Croatian neo-avant-garde group of artists and architects called EXAT-51, who worked closely with the architects aiming at "total plastic reality," as they termed it. The building paid maximum attention to the needs of each individual user, while successfully housing the entire workers' collective, deliberately placing the workers in intense interactions, associations and interconnections. [FIG. 4]

Although seemingly introverted and immersed in its inner spatial complexity, this "fortress of knowledge" was connected with its surroundings through transparent facades and intense visual communication, but also through numerous points of access from neighboring streets. [FIG. 3] It rehabilitated the pedestrian circulation around the site and restored a human scale to the otherwise mechanical grand boulevard. Through its intricate spatial system, the building reinstated a lost sense of urbanity and the feeling of a traditional interconnected urban fabric, thus performing an implied critique of the surrounding fragmented functionalist city. The concepts introduced by Aldo van Eyck lend themselves to a description of the building: its "labyrinthine clarity" created a "reciprocal phenomenon"—the university functioned simultaneously as both a huge house and a tiny city, envisaged as a platform for identity-formation and the rehabilitation of a lost sense of belonging and community.

With insight into this project, it is therefore hardly surprising that Bakema invited Nikšić to join the last 1959 CIAM meeting in Otterlo and present the project. Even if the university had not yet been fully completed, its spatial qualities and social potential were already evident, revealing their proximity to Team 10's aspirations and theories. In his presentation in Otterlo, Nikšić explained that the building was supposed to become "a second home for the workers."[6] It needed to be "as simple as possible, capable of influencing the workers' taste, which would give them a chance to gradually get used to new forms and spaces. Thus the simplicity of space was to become a part of their overall education, bringing them to the level of accepting this new kind of beauty. All the rooms were designed to have an instructive impact on their users, so that they would become able to recognize in their clear proportions, spaces and surfaces the synthesis of architecture, painting and sculpture."[7] In this way, Nikšić argued, "all the rooms were made to stimulate the workers' intellectual and artistic ability."[8]

The impact of this building was felt even outside the strictly professional architecture field. President Tito decided to avail himself of its convincing progressive effect. In September 1961 he officially opened the Workers' University, at the end of the first international conference of the Non-Aligned Movement held in Belgrade that month. The picture that Yugoslavia wanted to project of itself—as a modern socialist state—was suggestively embodied in the image of this captivatingly progressive building. Two years later, Tito continued to exploit the building's potential. Hosting Nikita Khrushchev in Zagreb in 1963, during a slow stabilization of relations with the USSR, Tito took Khrushchev to visit the Workers' University as a space of proper socialist enlightenment. It seems that this example of "humane functionalism" in architecture (as an implied critique of the older strict functionalist modernism), could in its own, architectural terms serve as a proper symbol of the corresponding "humane socialism" that the leader of Yugoslavia implicitly contrasted with the rigid Soviet model. [FIG. 5]

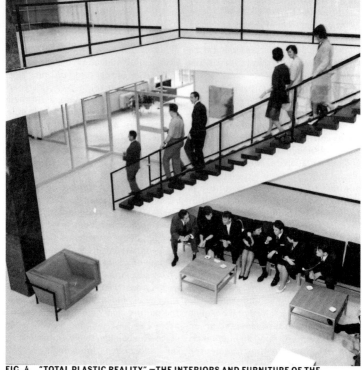

FIG. 4 "TOTAL PLASTIC REALITY" —THE INTERIORS AND FURNITURE OF THE WORKERS' UNIVERSITY, DESIGN: BERNARDO BERNARDI, 1961

FIG. 5 PRESIDENT TITO AT THE OPENING CEREMONY OF THE WORKERS' UNIVERSITY, 1961

1 Eve Blau and Ivan Rupnik, *Project Zagreb: Transition as Condition, Strategy, Practice*, Barcelona: Actar and Harvard University Graduate School of Design, 2007, p. 205.
2 Ivan Leko, "On the Occasion of the Workers' University Fifth Anniversary," in *Workers Education*, Zagreb, 1958, p. 11.
3 Blau and Rupnik, *Project Zagreb*, op.cit., p. 210.
4 Radovan Nikšić, "Workers' University in Zagreb," in Oscar Newman, *CIAM '59 in Otterlo*, Stuttgart: Karl Krämer Verlag, 1961, p. 203.
5 Krešo Špeletić, "Horizontal Skyscraper," in *Večernji list*, January 1, 1962, p. 13.
6 Nikšić, "Workers' University in Zagreb," op.cit., p. 204.
7 Nikšić, as quoted in Renata Margaretić Urlić: "A Multimedia Organism— Total Design of the Workers University 'Moša Pijade' in Zagreb: An Exemplar of Modernism Continuity in the Post-War Croatian Architecture," *Arhitektura*, no. 1 (215), 2003, pp. 150–151.
8 Nikšić, "Workers' University in Zagreb," op.cit., p. 204.

Maroje Mrduljaš is an architect, critic and author. He published and edited several books including *Modernism-in-Between* (with Vladimir Kulić and Wolfgang Thaler), *Unfinished Modernisations* (with Vladimir Kulić), *Design and Independent Culture* (with Dea Vidović) and *Testing Reality—Contemporary Croatian Architecture* (with Vedran Mimica and Andrija Rusan). He is the editor of *Oris* magazine based in Zagreb. He has published numerous texts on architecture and design, curated exhibitions and lectured internationally. In 2009, he established a collaborative research platform *Unfinished Modernisations* (with Vladimir Kulić) which investigates architecture and urban phenomena in the region of the former Yugoslavia from the post-Second World War period to the present. He is an independent expert for the EU Mies van der Rohe Prize for Architecture and member of Committee of experts of the European Prize for Urban Public Space. Mrduljaš works at the Faculty of Architecture in Zagreb.

Tamara Bjažić Klarin is an architect and a historian of architecture. She has received a PhD in 20th-century architecture at the Faculty of Humanities and Social Sciences in Zagreb, History of Art Department. She works as a research associate at the Croatian Academy of Sciences and Arts – Croatian Museum of Architecture on research projects, museum collections and exhibitions. Bjažić Klarin has written a number of scientific papers published in magazines, including *Prostor*, *Radovi Instituta za povijest umjetnosti* and *Život umjetnosti*. She has worked on Croatian television broadcasts and documentary films and contributed to several books, including *Atlas of the Functional City. CIAM4 and Comparative Urban Analysis* (gta, ETH Zurich) and *Allgemeines Künstlerlexikon*. She was awarded a research fellowship from the French government in 2006 (IFA and FLC).

MAROJE MRDULJAŠ
TAMARA BJAŽIĆ KLARIN

ZAGREB REVISIONISTS: "SOCIAL-STANDARD" ARCHITECTURE

From the late 1940s until the early 1970s, a group of research-oriented architects in Zagreb would attempt to react critically to the demands of post-Second World War modernization within the specific sociopolitical context of socialist Yugoslavia. Their work unfolded within the conceptual framework of modernism, in parallel to and on the periphery of CIAM and Team 10, yet their connections with these groups were multiple, especially with the Dutch branch. While mass production of housing in Yugoslavia was led by instrumental goals, the Zagreb research-oriented architects explored advanced spatial models of specialized "social--standards" buildings: educational and health institutions shaped by modern values that educational and health reforms had already advanced. In theory, progressive architects speculated on the radical horizon of total synthesis: abolishing the division between architectural projects and the conditions of production of built environments. In practice, complex and continuously changing self-managed decision-making and the lack of strict typological standards of education and health systems made the bureaucratic apparatus of the socialist welfare state contingent, subjected to

micro-politics and permeable for the realization of singular architectural experiments.

The essential contribution of Zagreb research-oriented architects was the comprehension of educational and health institutions as specific forms of modern civic life, in which architecture operated as mediator between individual experiences and increasingly specialized and fragmented institutional processes introduced by postwar modernization. The main strategy applied was a polemic with typological conventions and programmatic schemes aiming at an articulation of institutions and the social performance of building. As was the case with Team 10, these interests corresponded to a reorientation from biological to a socio-anthropological paradigm.[1] New modern institutions like multipurpose communal health centers or workers' universities aimed at merging advanced architecture with progressive goals of self-managed socialism. While these experiments were at their time hailed as pinnacles of modernist architecture, they were critical counterproposals to mainstream architecture of social-standard buildings and the production of the built environment in Yugoslavia and beyond.

Modernization's Context and "Expanded Field of Synthesis"

Yugoslavia was one of the least developed countries in Europe before the Second World War, and the ravages of war only exacerbated this situation. Instrumental modernization was an absolute priority and catching up with the developed world's standards was a continuous benchmark. After the INFORM Bureau resolution in 1948 and seceding from the Eastern Bloc, Yugoslavia abandoned the "administrative socialist" model and began an experimental sociopolitical project based on the concept of workers' self-management and commons, in contrast to both state and private ownership of the means of production and reproduction (including land). From 1953, a decentralized communal system was developed and local

1 Jean-Louis Violeau, "Team 10 and Structuralism: Analogies and Discrepancies," in *Team 10: In Search of A Utopia of the Present*, edited by Max Risselada, Dirk van den Heuvel, Rotterdam: NAi, 2005, p. 283.

sociopolitical and working organizations[2] gained increasingly significant autonomy, including active participation in management and financing of social-standard systems. The sociopolitical apparatuses of self-management were constantly reformed in attempts to resolve difficulties in the system's development and harmonize various societal antagonisms.

Despite hindrances, the economic results of Yugoslav modernization were significant and social changes were radical. With an annual industrial growth rate of 10.5%, from 1953 to 1969 Yugoslavia was ranked fifth in the world, which was directly reflected in the standard of living, which increased 3.5 times from 1956 to 1972. This dynamic industrial development fundamentally changed both the demographic and economic structure: up to 1972, the participation of agriculture in the GDP was halved, and the participation of industry doubled. Almost 80% of the population were farmers before the war, but by the early 1970s nearly 80% of the new generation pursued nonagricultural occupations.[3] Underdevelopment inherited from royalist Yugoslavia was especially evident in education and health: almost half of population was illiterate in 1945. Architecture and urban planning were caught between an economy of instrumental modernization and the humanization of new forms of everyday and institutional life.

Modern architectural discourse in Zagreb had already been assimilated before the Second World War by architects educated and vocationally trained in Vienna, Prague, Paris and Berlin.[4] After the war, the Zagreb architecture scene renewed contacts with CIAM. Vladimir Antolić, a prewar delegate from Yugoslavia, and Drago Ibler, head of the state Master Workshop for Architecture, the only form of postgraduate education at the time, belonged to the group of mediators. Le Corbusier, whose exhibition was held in 1952 and 1953 in Belgrade, Zagreb, Ljubljana, Sarajevo, Skopje and Split, was the undisputed authority in the whole of Yugoslavia. In general,

2 The theory of self-management named any form of commonly owned economic enterprise a "work organization" or a "labor organization."
3 Dušan Bilandžić, *Historija Jugoslavije, Glavni procesi*, Zagreb: Školska knjiga, 1985, pp. 386–387.
4 The Yugoslav CIAM group *Radna grupa Zagreb* (Work Group Zagreb), initiated by Ernest Weissmann, was active from 1932 to 1934.

Zagreb architects in the 1950s did not question CIAM, which was still considered to be the carrier and epicenter of modern architectural discourse. In the midst of immediate postwar reconstruction, an experimental approach emerged in the visual arts and architecture in Zagreb. The Faculty of Architecture in Zagreb brought together leading architects from different generations, including those who arrived immediately after the war: Zdenko Strižić, Drago Galić, Božidar Rašica, Neven Šegvić and Vladimir Turina. Unlike numerous architecture offices operating on the market after dismantling large centralized design institutes in early 1950, faculty teachers were not burdened by productivity requirements, which provided them with a greater opportunity for research and experiment.[5]

Turina quickly gained a reputation as the front-runner in the research approach,[6] dealing with diverse projects ranging from airports through housing to health and sports facilities. Early postwar experimentation culminated in the project by Turina, Ivan Seifert, Ninoslav Kučan and Zvonimir Radić for the transformable sport complex in Rijeka of 1949, a unique resurrection of the heroic avant-garde spirit of Russian constructivism. Turina became a central figure for a group of students and young faculty teachers who often teamed up for competitions, studies and other projects[7] within a dynamic spirit of collective creativity. Rašica was a link between the faculty and EXAT-51 (Experimental atelier), the independent neo-avant-garde group of architects and artists,[8] which advo-

5 Teachers realized projects through the Faculty Department of Investment Documentation, established in 1937.
6 Turina continued to develop design strategies promoted by Ernest Weissmann, a collaborator of Adolf Loos and Le Corbusier and a CIAM member who followed Mart Stam's constructivist faction. In the 1930s, Weissmann assumed a critical position toward the core of CIAM, and at CIAM 4 he presented a highly politicized alternative to the Athens Charter based on the abolition of private property and technologically founded architecture. Weissmann's concept of architecture was as a constantly changing discipline of scientific research. Along the lines of "analytical functionalism," Weissmann and Turina developed strategies for the recomposition of typological patterns.
7 The core of the group were Radovan Nikšić, Aleksandar Dragomanović, Mladen Vodička, Boris Magaš and Edo Šmidihen.
8 EXAT-51 was active from 1950 to 1956. Members included the artists Vlado Kristl, Ivan Picelj and Aleksandar Srnec and the architects Božidar Rašica, Vjenceslav Richter, Vladimir Zaharović, Bernardno Bernardi, Zdravko Bregovac and Zvonimir Radić, who contributed to the research-oriented approach and collaborated with faculty teachers.

cated the synthesis of "pure and applied arts" along the line of Bauhaus, Neo-Plasticism and Constructivism.[9] EXAT-51 was one of numerous postwar international movements of groups engaged with synthesis, in line with the discussions within CIAM initiated by Sigfried Giedion during the Bridgwater congress and continued by the Synthesis of Plastic Arts Commission at the Bergamo congress. But, unlike Giedion's apolitical concerns for modern monumentality, the research-oriented architects from Zagreb relied on the historical avant-garde and continued to cultivate the constructivist position of Ernest Weissmann, the prewar CIAM delegate for Yugoslavia who emigrated to the U.S. More radical proponents of synthesis, Turina and EXAT-51 members Vjenceslav Richter and Radić thought that synthesis couldn't be restricted to formal research but should be envisioned as a platform of societal change.

Research-oriented architects set two goals: the necessity of continuous experimentation and broadening the synthesis to all fields of social life. According to Turina, synthesis in architecture was analogous to contemporary scientific and technological progress: "The architecture of the new era should be a unique set of values in the technical, spatial and visual sense that—in itself—contains a healthy economic foundation; [...] the problem of architecture and architects may be comprehended as pioneering—technical, cultural and pedagogical."[10]

The implementation of an "extended field of synthesis" was an open issue. At the symposium of the Union of Architects of Yugoslavia in Ohrid in 1960, Richter reflected on the latent potentials contained in self-managing socialism. For Richter, the issue of architectural language was not a crucial one, since modern aesthetics in Yugoslavia had already been accepted. Instead, "progress [...] needs to be manifested in more complex forms [...] at a stage at which programs are created. [...] An architect is no longer a commissioned

9 Members of EXAT-51 established international connections. Ivan Picelj, Božidar Rašica and Aleksandar Srnec exhibited at the 1952 Salon des Réalités Nouvelles, one of the international postwar hubs of abstract art. Picelj established a lifetime of collaboration with the Denise René Gallery in Paris. Vjenceslav Richter's plastic objects gained significant international recognition.

10 Vladimir Turina, *Centar za zaštitu majke i djeteta u Zagrebu – studija*, Zagreb: Vladimir Turina, 1957.

executor of the task set by those who procure the financing, but an equal social partner with a direct social responsibility."[11] This reflected a broader tendency in postwar European architectural culture, where programming was increasingly becoming a specialized field that took over the analytical and functional aspects of the design processes and dominated client interaction.[12] In Richter's view, synthesis should integrate all aspects of self-managed socialist production of space.

Richter's proposal was utopian but launched a project that would be exercised on a smaller scale. This included the work of Zagreb research-oriented architects who transcended the limits of "instrumental modernization" by intervening into building programs of social-standard buildings. Yet the negative consequence of this self-imposed limit was a retreat from experiment in large-scale urban planning managed by specialized municipal institutions or those on the level of the republic. Instead, research-oriented architects attempted to create an "urban condition" within the perimeter of a single building plot.

Forms of New Institutions

The 1950s marked the end of the period of postwar reconstruction, and the period in which the processes of modernization came into full swing. As early as 1945, the constitution guaranteed compulsory and free primary education. Health insurance covered all those employed and their family members.[13] Education and health were subjects of various reformist discussions. General education was under reform in cooperation with UNESCO, and a movement for educational reform was initiated in 1955 that advocated the abandoning of teaching ex cathedra and the introduction of individual and group work, fieldwork and the active development

11 Vjenceslav Richter, without title, in *Razgovori o arhitekturi 2. Ohrid 1960*, edited by Milan Zloković, Beograd: Institut za arhitekturu i urbanizam SR Srbije, p. 6.
12 Hashim Sarkis, "The Paradoxical Promise of Flexibility", in *Case: Le Corbusier's Venice Hospital and the Mat Building Revival*, edited by Hashim Sarkis with Pablo Allard and Timothy Hyde Munich, London, New York: Prestel Verlag, 2001, p. 82.
13 Insurance did not cover farmers, thereby favoring the urban working class and fostering the allurement of the industrial sector. Only in 1980 were farmers completely leveled with urban workers.

of creativity. The modernization of health institutions emphasized the expansion of a network of primary health-care facilities, the development of preventive care and the education of citizens. These changes were reflected in massive construction activities. As much as 2,111,730 m² of school space was built between 1951 and 1963.[14] The number of outpatient health centers nearly doubled from 1955 to 1966, from 2,501 to 4,481. Despite large production, there were no precise regulations for the design of social-standard buildings, nor was there comprehensive research on their prefabrication. Federal and republic institutions and communal health and education administrations commissioned projects, primarily from specialized architecture offices, which produced an overstock of mostly routine projects.[15] This practice ensured speedy project design and lowered costs, but it also "strengthened the existing [typological] framework, sometimes to unprecedented extent."[16]

Yet Zagreb University architects advocated a different path. At the First Congress of Architects of Yugoslavia, held in 1958, Neven Šegvić criticized routine designs of educational institutions and opposed type-designs of social facilities: "The architect is by nature a researcher [...] and it is non-specialization [...] which leads to new, original and bold solutions."[17] Ambitions of research-oriented architects coincided with the goals of the reform movements that had just started to be outlined. Already in 1952, the pedagogical expert Danica Nola challenged architects: "What should be discontinued is current interior decoration and barrack-like order: hall, classrooms, and nothing else—the need for a whole range of new content and thus also of new spaces [...]."[18]

Immediate responses to this challenge were the showcase projects or new types of social-standard institutions in Zagreb,

14 "Preporuka u vezi sa stanjem i problemima osnovnog obrazovanja,"
 Prosvjetni vjesnik, no. 2–3, 1964, pp. 157–158.
15 For example, Architectural Studio AS in the period from 1954 to 1964
 built 114 primary schools. "Stotinu projekata školskih zgrada," Čovjek
 i prostor, no. 137, 1964, pp. 1–3.
16 Duško Rakić, "Natječaj za Dom narodnog zdravlja u Labinu," Čovjek i prostor,
 no. 126, 1963, pp. 7–8.
17 Neven Šegvić, "Reforma školstva i arhitekt," in Referati – 1. kongres arhitekata
 Jugoslavije, edited by Organizacioni odbor kongresa, Belgrade: Savez
 društava arhitekata FNRJ, 1958.
18 Danica Nola, "Suvremena nastava traži i suvremenu školsku zgradu,"
 Arhitektura, no. 5, 1952, pp. 18–19.

the most powerful industrial center of Yugoslavia. In parallel to his EXAT-51 experience, Rašica designed the Firefighting School (1951), the high school in Trešnjevka (1953) and the primary school on Mesićeva Street (1953). All three projects shared similar interests. In the Mesićeva school, Rašica sought an opportunity to apply the open-plan concept and so the corridors assumed the format of wide and well-lit interior streets, which opened onto the dining-room area and the hallway interconnected to a multipurpose hall. [FIG. 1] Stairwells were spacious places of encounter and the vibrant social space of the school was created. The program was enriched with spaces for extracurricular activities and small auditoriums for seminars. Vjera Marsić, Rašica's assistant, pointed out that precisely the lack of accurate standards allowed for flexibility in the sizing and interpretation of the program.[19] [FIG. 2] Spatial generosity allowed for sociability, and in the years to come schools often replaced cultural centers, which were planned but rarely built. Many educational facilities, especially those designed by research-oriented architects, became hubs of local cultural, educational and even political life: this new set of functions was recognized in the mid 1970s and was recommended in a study of school-design guidelines.[20]

The "opening" of institutions initiated by Rašica was radicalized by Turina with Radovan Nikšić and Georgij Nedeljkov in the unrealized competition project for the Teachers' School in Zagreb (1952–1953), an institution that was supposed to become one of the centers of educational reforms. This project offered a complex system of individualized spatial elements tailored to fit specific pedagogical processes. The spatial configurations, scales and relationships corresponded to the psychological needs of various social groups: the individual, the teaching group and the entire school collective. The focus of the school's circulation network was a wide internal street, a site for socializing, which branched into subunits of the school. Hexagonal classroom pavilions intimately located in nature implied that the teaching group was a microcommunity.

19 Vera Marsić, Petar Selem, Zvonko Maković, *Božidar Rašica: arhitektura, scenografija, slikarstvo, pedagoški i znanstveni rad*, Zagreb: Školska knjiga, 2009, p. 86.
20 Andrija Mutnjaković, "Moguća polivalentnost funkcija prostora edukacije i društvenog života," *Arhitektura*, no. 158–159, 1976, pp. 43–45.

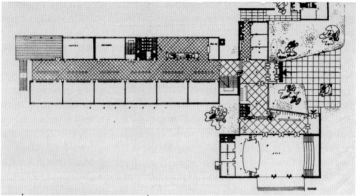

**FIG. 1 PRIMARY SCHOOL ON MESIĆEVA STREET, ZAGREB, GROUND FLOOR,
DESIGN: BOŽIDAR RAŠICA, 1953**

**FIG. 2 PRIMARY SCHOOL ON MESIĆEVA STREET, ZAGREB, DESIGN:
BOŽIDAR RAŠICA, 1953**

The diverse character of the spaces corresponded to the multifaceted processes that the new educational institution was supposed to house.

The Teachers' School should have contained a new type of institution. The same case applied to Turina's project for the Center for the Protection of the Mother and Child in Zagreb (1953–1956). In the 1950s, the process of establishing educational and health-care centers for mothers and children was initiated in cooperation with UNICEF and local experts. The Center in Zagreb was conceived as a showcase model of a modern multipurpose facility that dealt with health care at a biological and social level. The educational role was twofold as the Center also provided counseling and education for citizens, as well as the training of health personnel.

The plot for the construction was extremely restricted, located within a perimeter block alongside an existing Jugendstil sanatorium building in the historical center of Zagreb. Within the plot, Turina interpolated a very long and low, simply designed building that was slightly sunken into the terrain. The Center discreetly meandered through the dense block and left all available space free for a park. Turina organised the program around a two-story passage that linked two sides of the block and served as a waiting room and a space for informal consultation. [FIG. 3] The passage, which approximately followed a previously existing public path, was both an extension of urban space and a core of the highly specialized institution. The skillfully designed cross section with a heated glass roof allowed natural illumination and ventilation to dispensaries, laboratories and conference rooms overlooking the park, and to inner sectors of passageway.[21] [FIG. 4] Turina focused on the psychological effects of the interior, using a carefully selected color scheme and thoughtful proportions of space based on Modulor to achieve a serene yet optimistic atmosphere. The small tower planned for the northern perimeter of the block was not realized. Turina, who often referred to the notions of the "street" and "intimacy," proposed an innovative model for intervention in the existing urban fabric, which was at the same time radical and sensitive to local conditions and is

21 After completion, Turina noted that the building proved a more radical concept: the inversion of disposition was also feasible.

FIG. 3 CENTER FOR THE PROTECTION OF THE MOTHER AND CHILD, ZAGREB,
DESIGN: VLADIMIR TURINA, 1953–1956

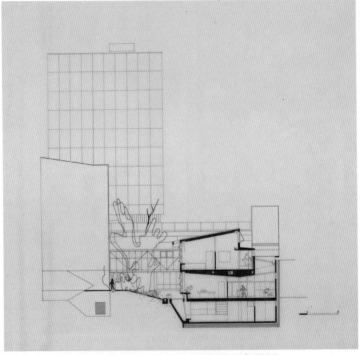

FIG. 4 CENTER FOR THE PROTECTION OF THE MOTHER AND CHILD,
ZAGREB, CROSS SECTION, DESIGN: VLADIMIR TURINA, 1953-1956

comparable to work of Alison and Peter Smithson and their Econo-
mist Building in London (1959–1965).

The experiments by Rašica, Turina and their associates
in the first half of the 1950s were encouraged by the progressive
ambitions of social-standard reforms. The social performance of cir-
culation spaces, the integration with urban flows and original orga-
nizational dispositions were critical responses to both schematic
typological patterns and mass and instrumental modernization. The
societal optimism and élan of the 1950s in Yugoslavia encouraged
a self-perception of research-oriented architects as pioneers who
aimed at an advanced architectural synthesis. However, the realiza-
tions of advanced architecture were a "permanent exception," as
Turina observed. Their singularity made them an "alternative" in con-
text of otherwise generic buildings designed by mainstream offices,
and schematic urban developments. Still, these interests in the
"humanization" of built environments and of architecture's pedagog-
ical role led to and were facilitated by exchanges between Zagreb
research-oriented architects and reformist Dutch architects, most
notably Jaap Bakema.

International Interactions
The new educational and social facilities became
showpiece examples of the achievements of self-managing social-
ism and of local modern architecture. Bakema's partner Johannes
van den Broek, during an official stay in Zagreb in 1956 on return from
the 10th CIAM congress in Dubrovnik, was taken to visit the Center
for the Protection of the Mother and Child, accompanied by Turina.
In the same year Turina's associate Radovan Nikšić worked in van den
Broek and Bakema's studio in Rotterdam. Nikšić was thus the first
direct mediator between Zagreb and Team 10. Along with work in the
studio on the Montessori school in Rotterdam and the IBA tower in
Berlin, Nikšić studied school buildings and housing, and got to meet
van Eesteren, Rietveld and Oud. [22]

Just before going to the Netherlands, Nikšić and his
partners won two competitions in Zagreb: for a primary school in

22 Ivana Nikšić Olujić, "Arhitekt Radovan Nikšić 1920.–1987.," in *Radovan
 Nikšić: 1920.–1987.: Arhiv arhitekta*, edited by Boris Magaš, Zagreb: Hrvatski
 muzej arhitekture Hrvatske akademije znanosti i umjetnosti (HAZU),
 2005, pp. 7–28.

Dubrava (1954) designed with Aleksandar Dragomanović, Zvonimir Jurić and Božidar Murković and for the Workers' University (1955) designed with Kučan and Petar Kušan. Both projects were completed after Nikšić's return from the Netherlands.

The Workers' University in Zagreb (1955–1961) was a part of a well-developed network of institutions for workers that offered lifelong learning and belonged to the most ambitious emancipatory projects of the period. There were 599 people's universities and 129 workers' universities in Yugoslavia by 1959, but none of them were architecturally advanced.[23] Several parameters affected the high ambitions invested in the Workers' University project in Zagreb. The interest of industry in additional professional and cultural education for a large number of workers was complemented by the demand of political institutions to improve workers' knowledge about the theory and practice of self-management in order to enable their active participation in political life. The project gained representational significance, as the decision for the construction of the new building was made by National Committee of the City of Zagreb in 1955 to commemorate the 10th anniversary of Yugoslavia's liberation from the German occupation. Work organizations in Zagreb took on cofinancing of the construction from the funds for professional continuing education as the university complied with "social and economic problems of the Zagreb commune."[24]

The competition brief demanded flexible spaces for an institution characterized by a constantly changing program, to be adapted to the requirements of work organizations, but also to the interests of workers. The institution housed six educational centers equipped with auditoria, workshops, a cinema and a working people's club. The building had to fulfill a dual task. On one hand, it was supposed to enable a multiplicity of educational and social processes. On the other, through its austere visual order, the building was supposed to teach the workers about modern values and represent the new society. [FIG. 5]

23 People's universities were institutions for the training of adults; workers' universities were specialized in the socioeconomic and technical training of workers.

24 Mirjana Krstinić, "Natječaj za Radničko sveučilište u Zagrebu," Arhitektura, no. 1–6, 1956, pp. 60–61.

Nikšić and Kučan's competition project was based on a stereotomic composition of volumes in a Corbusian manner, which, after Nikšić's return from the Netherlands, was replaced with a more compact tectonic configuration. The change was not formal but inherently conceptual, as it included a matrix of expanded circulation spaces linking the elements of the program in an open network. Nikšić explained the intention: "In order to satisfy the needs of the particular activity for the education and cultural development of workers [...] a system of total active space was proposed [...]. The club rooms and the richly dimensioned circulation areas took an active part in the process of ongoing education."[25] Seminars were variable in terms of content and capacity, which prompted the architects to create flexible space—a skeletal structure and removable partition walls. Common spaces generously lit from atriums served as collective living rooms and places of informal or alternative forms of education. [FIG. 6]

Links between Zagreb and the Netherlands ramified in the mid 1950s. Dutch architecture and art were received in Croatia via several reports and reviews, as well as by lectures and exhibitions.[26] Nikšić and Turina contacts with van den Broek and Bakema coincided with the 10th CIAM congress. After discarding the organization of the congress in Algiers, two alternatives were considered: Portugal and Yugoslavia proposed by Drago Ibler at the ninth congress in Aix-en-Provence.[27] At the La Sarraz meeting in September 1955 "the decision was made to accept the invitation of the 'Yugoslav Group in Formation' to hold the Congress in Dubrovnik, in the second half of July 1956. Alfred Roth 'was asked to follow this matter up."[28] But the Zagreb group was not formed yet. Ibler, who was in contact with Roth and in charge of the operational organization of

25 Radovan Nikšić, "Radničko sveučilište Moša Pijade u Zagrebu," *Arhitektura*, no. 158–159, 1976, pp. 69–70.
26 The exhibition of Yugoslav housing architecture in The Hague in 1955, which was prompted by the UIA congress. In 1956, Feinder Blijstra, the Dutch architecture critic, lectured in Zagreb about postwar architecture in the Netherlands and van den Broek about his perceptions of Yugoslav architecture. In 1956, Nikšić lectured about Yugoslav architecture in Kaagsche Kustringin, The Hague.
27 Jose Luis Sert and Sigfried Giedion, "Letter to Drago Ibler," 10.1.1956; gta Archive, ETH Zurich: 42-AR-14-154 .
28 Eric Mumford, *The CIAM Discourse on Urbanism, 1928–1960*, Cambridge, MA: MIT Press, 2000, p. 246.

the tenth congress, was the only Yugoslav architect present at the congress. Neither Nikšić nor Turina participated: Nikšić had returned from the Netherlands just before the congress and Turina was in Dubrovnik but didn't take an active part. In August 1957, Turina and Nikšić, together with Aljoša Josić of Candilis-Josic-Woods and Juraj Neidhardt, Le Corbusier's former associate who had settled in Sarajevo, were on the list of proposed individual members for the reorganized CIAM.[29] This nomination prompted a proposal for the reorganization of CIAM signed by Nikšić, Turina, Radić, Rašica and Ibler. Their text "CIAM in Reorganization" returned in fairly general terms to the problem of synthesis in architecture.[30]

At the end of 1957, Turina wrote to Jaap Bakema to confirm a list of proposed future CIAM members from Zagreb. The signatories of "CIAM in Reorganization," together with Richter were proposed as permanent members of a "future CIAM." As collaborators were listed Bernardo Bernardi, Zdravko Bregovac, Aleksandar Dragomanović, Srebrenka Gvozdanović and Kučan; all of them, except for Ibler, were teachers at the faculty or members of EXAT-51.[31] Nikšić sent to Bakema his own separate list of reformed CIAM members on which he included Drago Galić and Neven Šegvić.[32]

This initiative to form a new CIAM group based in Zagreb, in the period that would lead to the breakup of the organization and the independent operations of Team 10, was unsuccessful. The group dispersed and only Nikšić and Radić were invited to the Otterlo meeting. The epilogue to this attempt by Zagreb architects to take part in the reformed CIAM was Nikšić's participation in Otterlo, where he presented the Workers' University. Nikišić presented his Otterlo experience at his public lecture at the Zagreb Society of Architects in 1960.

The exchange between Zagreb and the Netherlands was bilateral. In 1964, Bakema was invited to propose a sketch for

29 In letter dated February 10, 1957, to P.A. Emery, Turina confirms his membership in the reorganized CIAM after information received from Bakema. *Rukopisi Vladimira Turine*, edited by Vladimir Mattioni, Zagreb: UPI-2M, 2006, p. 252; Eric Mumford, *The CIAM Discourse on Urbanism*, op. cit.,p. 337.

30 Turina and others, "CIAM in Reorganisation," in *Rukopisi Vladimira Turine*, op.cit., pp. 253–256.

31 Vladimir Turina Archive, Muzej grada Zagreba.

32 Radovan Nikšić Archive, Hrvatski muzej arhitekture HAZU.

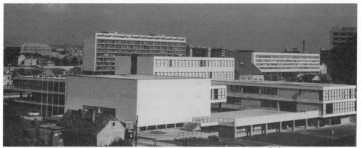

FIG. 5 WORKERS' UNIVERSITY, ZAGREB, DESIGN: RADOVAN NIKŠIĆ, NINOSLAV KUČAN, 1955–1961

FIG. 6 WORKERS' UNIVERSITY, ZAGREB, DESIGN: RADOVAN NIKŠIĆ, NINOSLAV KUČAN, 1955–1961

the New Zagreb city center in response to the master plan of 1962.[33] Bakema reinterpreted the matrix of the historic part of the city and proposed a development founded on the principles of the "visual group" to the main city axis. Zagreb architects organized a discussion on the project and to a certain extent were unimpressed by Bakema's proposal, while Nikšić defended it. This discussion was published in detail in the journal *Čovjek i prostor* [*Man and Space*].[34] Bakema presented his project in one of his three lectures titled "Urbanistic Architecture" held at the Faculty of Architecture in February 1965. Marking the visit, a special issue of the *Arhitektura* journal was devoted to Bakema's reflections selected from his recently published book *Van stoel tot stad* [*From Chair to City*].[35] Translation of Bakema's essay "Public Building of Unified Architecture"[36] appeared in *Čovjek i prostor* in 1968. In general, Bakema was the most prominent of foreign architects in Croatia in the second half of the 1960s. Bakema's dilemma of an "urbanistic architecture" that allowed for "indefinable events"[37] influenced Zagreb architects who continued to explore the urban performance of architecture.

Architecture as Critique of Urban Planning

In 1961, Turina identified a shift in architectural concepts referring to the masters of modern architecture: "The phase of Le Corbusier's domination—the one which I have intensively experienced—is perhaps over in the works of our younger generations. [...] An affirmation of Mies' doctrine is stronger [...] since his architecture is closely related to the industrial physiognomy of our times."[38] In the course of the 1960s, this "affirmation of Mies" was paralleled

33 Altogether, Team 10 members proposed three projects in Yugoslavia: the center of New Zagreb, Bakema and van den Broek's competition plan for Skopje's central city area (1964) and the competition design of Oskar Hansen for the Museum of Modern Art in Skopje (1966).
34 "Razgovori povodom posjeta J. Bakeme Zagrebu," *Čovjek i prostor*, no. 152, 1965, pp. 1–2, 5.
35 Jaap Bakema, "Arhitektura kao instrument u procesu identifikacije čovjeka" and "Pokušajmo učiniti da zgrade ponovno jedna drugoj pruže ruke," *Arhitektura*, no. 89, 1965, pp. 11–42.
36 Bakema, "Javna zgrada ili sjedinjena arhitektura," *Čovjek i prostor*, no. 182, 1968, p. 6.
37 Ben Hinghmore, "Rescuing Optimism from Oblivion," in *Team 10: In Search of a Utopia of the Present*, op.cit. pp. 271–275.
38 Turina, "Opći uvjeti kretanja jugoslavenske arhitekture danas," in *Rukopisi Vladimira Turine*, op.cit., p. 176.

by continued links with the Netherlands, sustained by teachers at Zagreb's Faculty of Architecture. In 1964, Edo Šmidihen carried out further studies in the Bouwcentrum in Rotterdam, while Dragomanović and Nikšić took students on a graduation journey on which they visited van Eyck's Orphanage and the built projects of van den Broek and Bakema. These studies provided new impulses for the tectonic language adopted by research-oriented architects during the 1950s. Dutch "structuralism" was complemented by diverse international sources from metabolism [39] and megastructure movement to contemporary research in arts, but without taking into account anthropological and linguistic theory.

Vjenceslav Richter began researching sculptures and objects based on multiplication of units in the early 1960s and joined New Tendencies, the international neo-constructivist and programmed art movement, for which Zagreb was the focal point from 1961 to 1973. [40] After a series of compelling pavilions and stalls of the 1950s influenced by the historical avant-garde, Richter introduced "structuralism" in the design of the Catering School in Dubrovnik (1961). [FIG. 7] He discarded the corridor-classroom disposition in favor of "kasbah-like" agglomeration. In a suburban context, Richter situated clusters of individual units on a steep slope, which, like the traditional agglomeration, organically merged with topography. The irregular three-dimensional system of circulation space unfolded as a network of platforms and staircases between the units. Given that the project was based on the addition of equivalent elements, it allowed for further growth by adding classrooms and other elements, which facilitated its phased realization. What followed was a project for the Student's Dormitory in 1962 based on the same generative code, which was not built. Richter's project introduced an informal revision of educational architecture, that corresponded to the density and irregularity of the Mediterranean city. [FIG. 8]

Synchronous with the international criticism of modernism, Croatian critics by and large belonging to art-history circles pointed out that the results of instrumental urbanization contra-

39 In April 1966 an exhibition of Japanese architecture was held in Zagreb.
40 The first exhibition in 1961 was followed by "Nove Tendencije 2" (1963),
 "Nova Tendencija 3" (1965), "Tendencije 4" (1969) and "Tendencije 5"
 (1973).

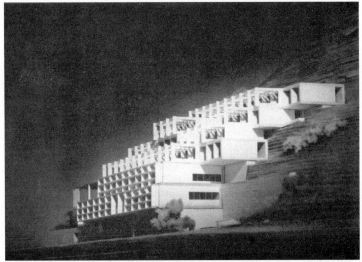

FIG. 7 CATERING SCHOOL, DUBROVNIK, MODEL, DESIGN: VJENCESLAV RICHTER, 1961

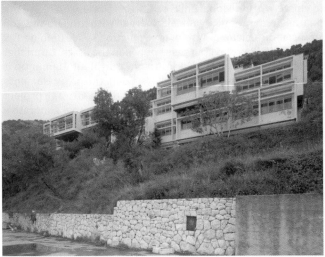

FIG. 8 CATERING SCHOOL, DUBROVNIK, DESIGN: VJENCESLAV RICHTER, 1961

dicted the emancipatory ideas of modernity. Turina was a contributor to this debate and in his 1963 essay, significantly titled "Humanism and the Anti-Humanism of Modern Urbanism," he expounded upon the criticism of mainstream modernism: "It seems to me that everywhere in the world technocratic plans are being created. The technically rational component of contemporary urban architecture has achieved an absolute victory over the lives of human beings [...] One needs to return to the human being and give him the greatest gift: his instinctual space [...]."[41] Yet architects themselves were faced with public criticism for unnecessary luxury and self-promotion. Analyzing the Center of Travno housing estate in New Zagreb designed by Nikšić, Dragomanović and Šmidihen, based on the model of Lijnbaan in Rotterdam by van den Broek and Bakema, the art and architectural historian Žarko Domljan launched an unexpected critique: "[...] a typical paradox: limited funding and savings on every meter when it comes to residential buildings and a generosity bordering on wastefulness when it comes to public 'representative' objects that will later be cited as achievements."[42]

Doubts about "humanism" versus "self-promotion" stirred up in the context of fundamental changes in Yugoslav society. The consolidation of industry in the late 1950s affected the rise of living standards. The reforms in 1961 and 1965 introduced elements of the market economy and increased work organizations' independence in managing accumulation. Health care and education were integrated into a new system, which basically meant less budget planning and charging education and health-fund associations for their services according to the quality and scope of their work. The scope of insured health services was expanded; the option to choose a set physician and medical facility was introduced. The outcome was an increase in demands placed on education and health, but also decrease of investments from 1965 onward.

The response to both the urban crisis and to the expanded offer of medical services included two health centers designed by Mladen Vodička in the small cities of Samobor (1961–

41 Turina: "Humanizam i antihumanizam novovjekog urbanizma," in *Rukopisi Vladimira Turine*, op.cit., pp. 224–225.
42 Žarko Domljan, "Trnsko," *15 dana*, no. 11, 1964, pp. 12–13.

1965) and Labin (first phase: 1963–1969) in association with Boris Magaš. Both projects resulted from competitions held following the rejection, upon review, of direct commissions. Vodička, Turina's university assistant, had been dealing with health-care facilities for many years and developed an expert approach. [43] He continued the discussion on the issues of synthesis and programming: "It is useless to discuss the humanization of conventionally programmed health facilities. [...] It's necessary to analyze and define changes in societal needs always anew." [44] For Vodička, the program should mediate between the meticulous dissection of increasingly complex and specialized medical processes and social and psychological effects of space.

Beginning in the 1950s, the outpatient multipurpose health centers (the House of Health) became the nuclei of the health system focused on prevention, treatment and advising. Vodička considered health centers as "social services," which should be conceived as micro-urban ensembles maximally accessible from public space. [FIG. 9] Vodička was critical of schematic urbanization of the edges of cities and sensitive to the environment. According to him: "A presence of building needs to emphasize the quality of the landscape maximally [...] and be absolutely subsumed within the environment. [...] This type of interpretation has been called anti-architecture." [45] Both in Samobor and Labin, Vodička challenged the competition briefs and changed micro-location and the height of buildings. Samobor was characterized by a medieval scale and a hilly landscape. [FIG. 10] Therefore, it was essential to maintain harmonious proportions and urban density. Vodička designed a single-story atrium complex that extended horizontally and was adjusted gently to the topography. In the new settlement of Labin, "the planner did not use the messages, teachings and associations heralding from the spaces of old Labin, but created a dull space, lacking invention." [46] The answer was a linear "megastructure" stretched between two hills,

43 In parallel to design and teaching, Vodička worked on various research studies and published several scientific works and publications on health facilities.

44 Mladen Vodička, *Maternite*, Arhitektonski fakultet Sveučilišta u Zagrebu, 1985, pp. 48–49.

45 Vodička, *Prilog razmatranju izgradnje i prostorno oblikovne komponente objekata bolničke i vanbolničke poliklinićko dispanzerske službe*, habilitation work, Arhitektonski fakultet Sveučilišta u Zagrebu, 1969, pp. 48–49.

46 Ibid., p. 17.

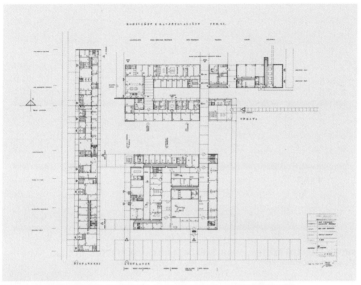

FIG. 9 HEALTH CENTER, SAMOBOR, GROUND FLOOR, DESIGN: MLADEN VODIČKA, 1961–1965

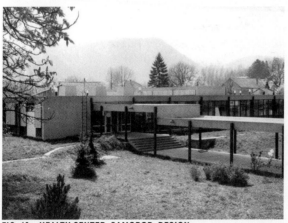

FIG. 10 HEALTH CENTER, SAMOBOR, DESIGN: MLADEN VODIČKA, 1961–1965

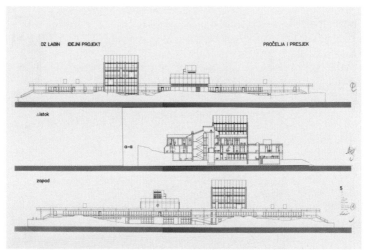

FIG. 11 HEALTH CENTER, LABIN, FACADES AND CROSS SECTION, DESIGN:
MLADEN VODIČKA, FIRST PHASE 1963-1969, SECOND PHASE 1976-1980

FIG. 12 HEALTH CENTER, LABIN, DESIGN:
MLADEN VODIČKA, FIRST PHASE 1963-1969,
SECOND PHASE 1976-1980

permitting the landscape to pass below it. [FIG. 11] The project was organized around a covered pedestrian "hospital street" aimed at creating an articulated core for further urban development. Vodička accessed the functions with precision and invested in cost-effective spatial organization developed by a simple "brutalist" architectural language. The tectonic system of skeletal structure and infill enabled the development and growth of the ground plan within the modular grid. Vodička explained that all the phases of the project were "autonomous and each of them could be built at any time and could tolerate changes."[47] Vodička's concepts proved to be suitable in view of the instability of the financing system. In Samobor, only the first phase of the project was completed. In Labin, the start of implementation was postponed and the program, which was reduced by half, was reviewed. The realization of the first and second phases took a long time, and the third phase was implemented 10 years later. The nonhierarchical structures of the project and the principles of addition enabled the realized segments to function independently from the realization of the other phases, and so the projects managed to maintain their spatial integrity. [FIG. 12]

The experience of the Samobor and Labin projects further contributed to Vodička's research on multidisciplinary programming of health facilities. Vodička initiated a discussion on open systems closely matching the interests of Team 10: "The relations of functional elements are today less static, less determinant and less coercive. They are more elastic, more direct and several-sided [...] with growth and change needing to be taken into account as a constant factor."[48] While "growth and change" in Team 10 discourses were related to broader and more general dynamics of the modern society, Vodička investigated specific dynamics of psychologically sensitive and technology-dependent medical institutions within contexts of instable budgeting.

Reflexive Modernism: A Conceptual Approach

Despite industrial progress, Yugoslavia ranked among the bottom third of most-developed Western European countries

47 Ibid., p. 18.
48 Vodička, *Bolnice*, Zagreb: Školska knjiga, 1994, p. 202.

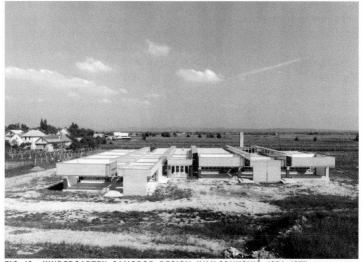

FIG. 13 KINDERGARTEN, SAMOBOR, DESIGN: IVAN CRNKOVIĆ, 1971–1975

with a national per capita income of about $800 in 1971. Economic changes in the 1960s increased the fragmentation of society. The federation was shaken by nationalist antagonisms and social gaps widened. Conceptual art developed in student centers of Ljubljana, Belgrade and Zagreb, questioning the aesthetics of modernism and critical of social reality. In this unstable context, insisting on "architectural synthesis" was not convincing. Architects found hardly any opportunity for experiment, and the revision of modernism became increasingly reflexive.

While the general quality of mainstream architectural design in Croatia in the 1970s decreased, more advanced architectural discourse opened toward current research in cultural and social theory. The most innovative architect among the younger generation of teachers at the faculty, Ivan Crnković, manifestly stated that "form follows concept," and along the lines of Umberto Eco's *opera aperta*[49] he claimed that the architect's intentions were irrelevant after the building was completed and that the users were its interpreters. "Every user of a space understands space differently within the context of his own experience of the world. Even the interpretation of the actual author about what an architectural work really is cannot be taken as absolute," he argued.[50]

"Structuralism" gained a more comprehensive meaning as Crnković's research drew on anthropological interpretations of architectural elements. He embodied these interests in the kindergarten in Samobor (1971–1975). Only 10% of children in Croatia received preschool education in 1970, which nominally gave equal importance to educational goals and to the social mission of care of children of working parents. However, in practice, the educational component was secondary. Crnović embraced both the social and educational tasks of the institution, so he conceived of the preschool project as an "educational tool." [FIG. 13]

For Crnković, the point of reference was explicitly Team 10 and the architects on its margins, such as Louis Kahn. In an axonometric drawing, Crnković quoted van Eyck: "A city is not a city

49 Eco attended "New Tendencies" and contributed to the 1972 issue 8/9 of the movement's magazine, *Bit International*.
50 Edvin Šmit, "Skica za portret arhitekta Ivana Crnkovića," *Glasilo Arhitektonskog fakulteta*, no. 2, 1975, pp. 73–91.

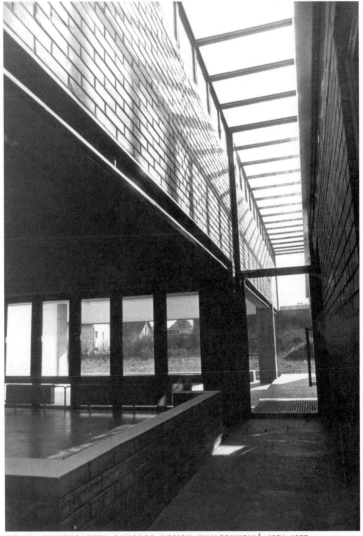

FIG. 14 KINDERGARTEN, SAMOBOR, DESIGN: IVAN CRNKOVIĆ, 1971–1975

if it is not also a big house—a house is a house only if it is also a small city." The pretext for the project of the educational institution was no longer the projected synthesis of societal evolution but the actual effect on the development of a child. The articulation of the building relied on van Eyck's concepts of "configurative discipline" and "dual phenomena" in which the dualities of collective and individual, internal and external, serving and serviced spaces were inseparable parts of the whole. The building was structured as a tight-knit network that could be expanded by lateral addition of tracts or longitudinal additions of kindergarten units. [FIG. 14]

Instead of the readability of the whole, Crnković was interested in labyrinthine clarity and its pedagogical effects. The "abstract" notion of space was replaced with elements that define it or describe it: wall, opening, courtyard, angle, threshold and passageway. These elements were inscribed within disciplined three-dimensional geometric systems. In each segment of the building there were elements that addressed the child's scale and the adult's scale. Crnković handled height as an element of identification, or as van Eyck's concept of "right size." All the openings, whether onto the exterior or inside the interior, were at the same height of 212 cm. While this "right size" was continuous, the ceilings changed height in proportion to the plan area. Terraces were designed as "rooms in the open" and were of equally precise articulation as interior spaces. [FIG. 15]

Although the kindergarten explored unusual relations and qualities of spaces like narrow top-lit "corridors" and openly defined multipurpose rooms, it was derived from the anthropological pattern according to which it was designed. Crnković's kindergarten is arguably the closest to the reflexive and theoretically grounded position of Team 10. Although rooted in modernism, the phenomenological implications of the project announced the rise of postmodernism that would take over the critical discourse of mainstream modernism in forthcoming years.

Responsibility for the construction of the Samobor kindergarten was taken on by the Fund for Immediate Child Protection of the economically prosperous Samobor commune, and additional

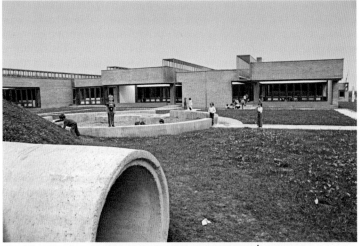

FIG. 15 KINDERGARTEN, SAMOBOR, DESIGN: IVAN CRNKOVIĆ, 1971–1975

funding was raised through a voluntary levy on workers' salaries after a referendum. Despite this financial support, the construction took three years and less than half of the planned project was realized. As was previously the case with Vodička's health-care centers, the structuralist concept and the horizontal spread of the project allowed for a partial realization to be functional and to maintain its conceptual integrity. At the opening of the kindergarten, the president of the local association for preschool and elementary education stressed its "beauty and functionality," but also urged self-criticism and asked if "such expensive construction was necessary." Further phases of the kindergarten were never realized. [51]

Modernization as It Might Have Been

The span from the radical synthesis to phenomenological concerns summarizes the attempt of Zagreb's research-oriented architects to revise mainstream modernism. During the turbulent years of the immediate postwar period, the historical avant-garde remained an important point of reference in local architectural discourse. Croatian architects of the 1950s challenged typological patterns and devised spatial systems meant for accommodating modern reforms promoted by the project of self-managed socialism. A stimulus for this research was provided by exchanges with the Dutch branch of Team 10, leading to comparable fields of interests and design strategies. While the move toward "structuralism" in the 1960s was the result of such shared interests in flexibility and non-composed configurations, it also corresponded to the instability of the social and economic system in Yugoslavia. In the 1970s, they were complemented by research into the anthropological meaning of space, as well as original organizational patterns that transcended functional norms.

Within the domain of social-standard buildings, research-oriented architects sought to provide spatial models that responded to the progressive tendencies in Yugoslav society and opposed the schematics of instrumental modernization and urbanization. The idea of a synthesis, "structuralist" research and a "conceptual" approach were supposed to absorb the "shock" of modern-

51 "Zahvaljujemo radnim ljudima...," *Samoborske novine*, no. 18, 1975, p. 4.

ization and to facilitate the citizens' identification with modern institutions. The reform of modernism in Zagreb was not conducted on the basis of elaborate theoretical debate, but by the medium of the project. This was an architecture not radically experimental in purely architectural terms, but rather operating within the framework of postwar functionalism and brutalism. What was radical was the continuous critical effort to subvert petrified typological patterns and bureaucratic procedures of mainstream modernization.

The design strategies that Zagreb architects explored were analogous to international tendencies of revising modernism. In particular, this included the organization of the program that tended toward "economics of dense plan,"[52] such as the one put forward by "mat-buildings," variability and additivity. The performance of these buildings has been confirmed in more ways than one. The Healthcare Center in Labin did not equal the size and absolute flexibility of a "real" megastructure, but its gradual development has validated its conception. Today, the "totally active areas" of the former Workers' University link new and autonomous programs that include educational, scientific and cultural institutions, as well as a rock club and centers for TV and fitness. Within the self-imposed, rigorous ethics of economic design, revisionist results were achieved through efforts in designing intelligent and even poetic spatial solutions, such as the section in the Mother and Child Center that captures the maximal natural light, or the subtle adjustments of tectonic structure to anthropological patterns, as is the case in the kindergarten in Samobor. The architecture of social-standard buildings was articulated as an urban form that mediated between collective and intimate spheres of the public and private, between institutional and noninstitutional, between socialization and highly specialized processes. This accentuated ethical position was close to the Dutch modernist tradition, which might explain the mutual affinities between Jaap Bakema and Zagreb architects.

This reformed modernism in Croatia was implemented only as an exception and as a precedent, and remained within the domain of individual architecture. Its results, however, confirm

52 Alison Smithson, "How to Recognize and Read Mat-buildings," in Sarkis: *The Paradoxical Promise of Flexibility*, op.cit., p. 100.

"modernization as it might have been" and provide an optimistic vision of one ideal modernized society that was, within the contradictory circumstances of Yugoslav socialism, in accordance with general societal ideals that were never to be achieved.

Aleksandar Kušić is a PhD candidate and a research assistant at the Faculty of Architecture, University of Belgrade. He is currently writing a thesis that deals with paradigmatic shifts from modern to late modern and traditional architecture and urbanism, as exemplified by Belgrade housing estates built during late Yugoslav socialism. His research interests include architecture as a form of ideology, relations between architectural concepts of space, everyday life and urban politics of self-governance. The primary focus of his work has been the architecture of socialist Yugoslavia, with an emphasis on the ambiguous relations between political discourses, architectural design and user interventions. His articles have been published in *Český lid* and *Serbian Architectural Journal* (SAJ).

NEW BELGRADE BLOCK NO. 22:
ORDER AND FREEDOM

In his book *The Man in the Street*, published posthumously in 1975, Shadrach Woods presented a comprehensive vision of a new society. For Woods, this new society could only be built upon a city as the single "physical structure available" for the task at hand. To produce an alternative, nonauthoritarian, fully participatory and productive social edifice, one would need to rely on a new kind of urbanism. In contrast to the "urbanism of constancy," fixated on seemingly ideal spatial compositions, the "urbanism of change" was meant to respond to existing social dynamics. It would focus on open-ended spatial systems, recognizing change itself as the only "natural order." And yet, for all of his critique of constancy, Woods simultaneously recognized the new urbanism as the "ordering of the built world." It was to make room for change, but only in relation to a pre-produced spatiality, as a given invariable.[1] Despite its libertarian presumptions, Woods' alternative world was clearly based on the implication of "an omnipresent, deepseated cultural order and social stability," materialized in a basic spatial framework.[2]

Gradually developed over the previous decades, Woods' vision of a new society had already proven out of touch with the realities of the crisis of the Western European welfare state.[3] If the West proved to be less than favorable, perhaps the fertile ground for Woods' ideas might have been elsewhere, in an entirely different social context. Based on the theory of self-management, Yugoslav socialism was grounded in a thesis stating that the social dynamics of the country would result equally from local self-organization and global coordination. For the theorists of self-management socialism, both Stalinist centralism and anarchist atomization appeared as extreme leftist deviations. Whether through planning, federal governmental policies or the influence of the Party, on the one hand, and direct economic and political democracy, on the other,[4] Yugoslav socialism strived in theory toward a balance between the imposition of overall order and the proliferation of freedom.

This text deals with how the dilemma of Woods and his fellow travelers at Team 10—the compromise between order and freedom—was engaged within the microcosm of a single housing block in the capital of socialist Yugoslavia, Belgrade. It focuses on Block No. 22, located in the socialist urban complex of New Belgrade, erected outside the historic core of the city. Searching for the underlying presumptions that shaped this design, I will confront them with systemic problems that plagued self-management in Yugoslavia during the 1960s. Especially relevant here are growing absenteeism and formalism, as recorded by Sharon Zukin's research in Belgrade. According to Zukin, the residents of the city saw self-management as remote from their personal experience. Striving for higher living standards and consumerist pleasures, they were quite indifferent toward the obligations of political and economic participation, leaving such activities to a minority controlling the decision-making procedures.[5]

In 1968 an architectural competition was held for New Belgrade Blocks Nos. 22 and 23. They belonged to the residential area of New Belgrade's central zone, which was arranged as six individual blocks, or units of local, i.e., territorial self-management.[6] Blocks Nos. 22 and 23 comprised quite different tasks. The former occupies one of the focal points of the central zone, a 19-hectare plot of land located at its

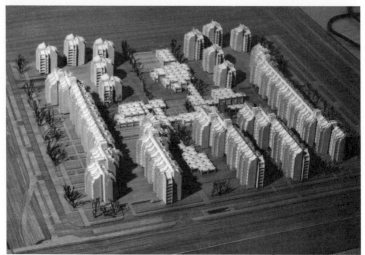

FIG. 1 MODEL OF BLOCK NO. 22 IN NEW BELGRADE, DESIGN: BOŽIDAR JANKOVIĆ, BRANISLAV KARADŽIĆ AND ALEKSANDAR STJEPANOVIĆ, 1968–1972

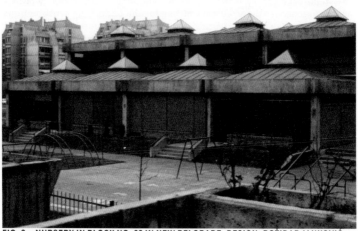

FIG. 2 NURSERY IN BLOCK NO. 22 IN NEW BELGRADE, DESIGN: BOŽIDAR JANKOVIĆ, BRANISLAV KARADŽIĆ AND ALEKSANDAR STJEPANOVIĆ, 1976

south corner. Almost half that surface area (10 ha), the latter was seen initially by the planners of New Belgrade as a "neutral" element of the larger whole.[7] [FIG. 1] The winning proposals for both blocks were signed by architects Božidar Janković (b. 1931), Branislav Karadžić (b. 1929) and Aleksandar Stjepanović (b. 1931). Despite the understated position of Block No. 22, they managed to design it as much more vibrant than its larger counterpart. Block No. 23 followed the standard practice of the day, with individual buildings housing a school and nurseries placed at its center, in a large green space surrounded by housing slabs and towers. In contrast, Block No. 22 was designed by the architects as a subtle gradation of common spaces, previously unseen in New Belgrade modernist and late-modernist architecture. Pursuing spaces of human exchange through the interlinking of various activities, much like Team 10 members such as Giancarlo De Carlo or Aldo van Eyck,[8] they based their design on the merging of two distinct elements. The first involved corner positions of the block, which were held by platforms housing garages, with their roofs dedicated to children's use. These were further fixed with residential slabs and towers of an average height of seven stories, with narrow passageways between slabs clearly reminiscent of traditional streets. The second element occupied the central position of the block, with various facilities that, instead of being separated in a number of individual buildings, were gathered as one "complex organism." Housing a community center (with a small library, two meeting halls, offices and shops), a school and a nursery in one single, diffused volume, gently slithering between its surroundings, the organism was comprised of a repeating element: a 7x7m individual cell.[9] [FIG. 2]

The design involved platforms, towers and slabs clearly holding the composition in order, delineating the dynamic space of the facilities at the center. The free articulation of cells between the strong points of the composition implied the possibility of growth and shrinkage. Given the self-referential arrangement of New Belgrade's residential blocks, with each representing one local community, these developments were intended, as we may assume, to relate to the needs of Block No. 22 residents. Here, the community would not only be housed, but also expressed, with its inputs being articulated into tangible and changeable spatial form.

Out of the two elements initially envisaged by the architects of Block No. 22, only the first had its full, subsequent realization. With the construction of residential buildings around four platforms being largely completed by 1976, the central area of the block remained empty, as a stretch of sand and grass. Belgrade's Executive Council, the highest governmental body of the city, voted for a program in 1975 that aimed to solve the chronic deficit of facilities in newly built housing estates and blocks, including the ones in New Belgrade. The program defined 37 locations in total, which were to be covered by the construction of relatively typical community centers, far less intriguing in their design than the one of Block No. 22. In the New Belgrade central zone, these were built in five out of six residential blocks. With its facilities partially included in a neighboring center, Block No. 22 was the only one left without a center on its own territory,[10] with only a nursery being constructed in 1978. While this decision probably resulted from the smaller size of the block, the very absence of center's realization seems highly symptomatic. It is as if the structure designed to act as a direct expression of the presumed dynamics of block's community was simply out of touch both with the real functioning of power (ultimately situated at higher lev-

els of socialist bureaucracy, exemplified by Belgrade's Executive Council) and less than functional local politics.

It seems that order existed without freedom in Block No. 22, as materialized in the spatial framework organized around the void of its very heart. In its lack of realization, the local center clearly signified the gap between the vision of a social edifice, constructed by the theorists of self-management, and everyday realities on the ground.

1 Shadrach Woods, *The Man in the Street. A Polemic on Urbanism*, Middlesexes, Baltimore and Victoria: Penguin Books, 1975.
2 Simon Sadler, "Open Ends. The Social Visions of 1960s Non-Planning," in *Non-Plan. Essays on Freedom, Participation and Change in Modern Architecture and Urbanism*, edited by Jonathan Hughes and Simon Sadler, Abingdon and New York: Routledge, 2000, p. 139.
3 Max Risselada, "Changing Conditions I: Questioning the Welfare State;" and Dirk van den Heuvel, "Changing Conditions II: The Consumer Society," in *Team 10 1953–1981. In Search of a Utopia of the Present*, edited by Risselada and van den Heuvel, Rotterdam: NAi, 2005, pp. 163–164 and pp. 202–203.
4 Branko Horvat, "An Institutional Model of a Self-managed Socialist Economy," in *Self-governing Socialism. A Reader. Volume 2*, edited by Horvat, Mihailo Marković and Rudi Supek, White Plains: International Arts and Sciences Press, 1975, pp. 307–327.
5 Sharon Zukin, *Beyond Marx and Tito. Theory and Practice in Yugoslav Socialism*, Cambridge: University Press, 2008, pp. 95–112.
6 Ljiljana Blagojević, "The Residence as a Decisive Factor: Modern Housing in the Central Zone of New Belgrade," *Architektúra & urbanizmus*, no. 3–4, 2012, pp. 228–249.
7 "Detaljni urbanistički plan Mesne zajednice u bloku 28 – jedna faza razrade idejnog rešenja Centralne zone Novog Beograda," *Arhitektura urbanizam*, no. 41–42, 1966, p. 84.
8 John McKean, *Giancarlo De Carlo. Layered Places*, Stuttgart and London: Edition Axel Menges, 2004, pp. 14–28.
9 Aleksandar Stjepanović and Boško M. Jovanović, "Stambeni blokovi 22 i 23 u Novom Beogradu," *Izgradnja*, no. 12, 1976, pp. 7–13.
10 Vera Paunović, "Izgradnja centara mesnih zajednica u novim naseljima," *Arhitektura urbanizam*, no. 85, 1980, p. 12.

Aleksandra Kędziorek is an art historian and a coordinator of the Oskar Hansen research project at the Museum of Modern Art in Warsaw. She participated in international research projects on architectural history launched at ETH Zurich and Universidade de Campenas, São Paulo, and contributed as a curatorial and research assistant to exhibitions on modern and contemporary architecture in the SPOT Gallery in Poznań, the Fourth Design Festival in Łódź and the Museum of Modern Art in Warsaw. In 2013, she co-organized a conference on Oskar Hansen's oeuvre at the Museum of Modern Art in Warsaw. Currently she is co-editing the volume *Oskar Hansen—Opening Modernism: On Open Form Architecture, Art and Didactics* (together with Łukasz Ronduda, Museum of Modern Art in Warsaw, 2014) and working on the Oskar Hansen traveling exhibition that will be presented in Spain and Portugal in 2014 and 2015.

THE MUSEUM OF MODERN
ART IN SKOPJE AND THE POTENTIALITY OF
AN EXHIBITION SPACE

In the beginning of 1966 the Warsaw Office of the Society of Polish Architects (SARP) announced an open competition for the design of the Museum of Modern Art in Skopje, the capital of the Socialist Republic of Macedonia in Yugoslavia. Together with Skopje's master plan coordinated by Adolf Ciborowski, the chemistry high school designed by Jan Zdanowicz and 30 single-family houses,[1] the winning proposal was to form part of the Polish contribution to reconstructing the city after it was significantly damaged by an earthquake in July 1963.

Among the 89 proposals submitted for the competition was the "gallery-instrument" designed by Oskar Hansen and his team: Barbara Cybulska, Lars Fasting, Svein Hatløy and the engineer Jerzy Dowgiałło. Not only meant to serve as a repository of artworks but also a space provoking their creation, the museum distinctively corresponded to the idea of user participation, which often appeared in Team 10 approaches to architectural design.[2]

Planned as an architectonic symbol of the immortality of Skopje, which was emphasized by the museum's location on Kale Hill, a site often compared with the Acropolis,[3] the building was expected to house a large collection of works donated by international artists in a gesture of solidarity after the disaster. Dr. Boris Petkovski, an art historian and future director of the museum, laid out the program for the building and the rules of the competition. According to the draft proposal, the exhibition space was to be divided into a well-lit part devoted to the permanent collection, more flexible spaces for temporary displays, and a studio dedicated to small archival shows. An additional open-air sculpture exhibition was planned in the surrounding area.[4] Among the expectations voiced was that of the flexibility of the building: the proposed technical solutions had to adapt easily to different media to be introduced by artists, as well as facilitating the usage of space in unpredictable ways and allowing for the expansion of its program in the future. It had to be an "instrument to follow contemporary processes happening in the art of the 20th century."[5] As to the architectural shape, the competition draft did not encourage monumentality: "the object, it stated, cannot be aggressive and must be related to the surrounding space [...]; its artistic expression should reflect the image of the time and explain the name—the Museum of Modern Art."[6] Another important requirement was the fulfillment of restrictive laws for constructing on seismically active areas.[7]

Hansen's design, titled "Process and Art," did not seem to have been noticed by the jury. Probably registered as competition entry no. 80,[8] it proposed a two-part structure, which literally expressed Petkovski's expectations. [FIG. 1] The first part was dedicated to the permanent exhibition and was a simple structure situated on pilotis, later compared by Hansen to the platonic cube he proposed for the Zachęta Gallery extension—a project prepared together with Lech Tomaszewski and Stanisław Zamecznik in 1958, which recommended extending Warsaw's historic building with a tetrahedral construction that could be divided both horizontally and vertically with partition walls according to current exhibition needs [FIG. 2]—or to Richard Rogers and Renzo Piano's Centre Pompidou, which is similar in expression. The most characteristic part of this design was the sector dedicated to temporary exhibitions situated above the main building. Composed of hexagonal

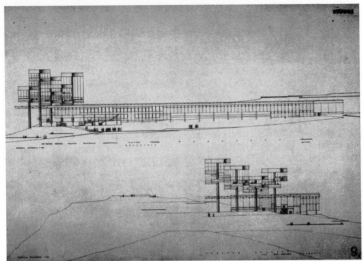

FIG. 1 MUSEUM OF MODERN ART IN SKOPJE, A CONCEPTUAL
DRAWING, DESIGN: OSKAR HANSEN AND TEAM, 1966

FIG. 2 EXPANSION DESIGN OF ZACHĘTA GALLERY IN WARSAW, OSKAR
HANSEN, LECH TOMASZEWSKI AND STANISŁAW ZAMECZNIK, 1958

elements that leaned on hydraulically powered rotating telescopic poles [FIG. 3, 4], the structure allowed for completely free transformation. Mobile elements could be folded and unfolded in various ways, creating a changeable structure whose dimensions could be modified both horizontally and vertically. They could be also folded away and hidden when not needed.

"We need to invent a space changeable and modular so that it can be shaped into many different spaces. That would enable the museum to develop a special relation with every exhibited object," explained Hansen with respect to the assumptions underlying his transformative competition entry.[9] His statements recalled Alexander Dorner's concept of "the museum on the move," when he declared: "Art is unpredictable in its development. We assumed that the role of the contemporary gallery should be to go toward the unknown in art. Not only in exhibiting it, but encouraging and provoking its birth."[10]

The artists were able to reveal the hidden potential of the space and thus to become active participants in this architectural performance. They were authorized to control the shape of the exhibition space and change it electronically according to actual needs. This invitation for the artists to cocreate the exhibition space was due largely to Hansen's idea of the Open Form, first presented at the CIAM congress in Otterlo in 1959, where he stated that the role of the architect in shaping space was limited to the creation of a "perceptive background." The architecture was supposed to expose the diversity of events and individuals present in the space. Focusing on the process, subjectivity and creation of frames for individual expression, architecture was supposed to become an instrument that could be used, developed and transformed by its users, and adapted easily to their changing needs. Continually sculpted anew in parallel to the creation of artworks and constantly reinterpreted, the architectural space of the Museum of Modern Art in Skopje would become an event in its own right. It was not conceived as a building that existed, but rather as a building that happened.

This performative aspect was also important in establishing the museum's relationship to its surroundings. With its palatial dome, the 15th-century Mustafa Pasha Mosque situated on Kale Hill was a precise example of Closed Form—patriarchal, dominant and clear in its possible interpretations. By introducing to its vicinity a light, transformative structure for the museum, Hansen established an agonistic relationship, where the past represented by the mosque and the future represented by the museum polemicized with one another.[11]

Announced in May 1966, the competition results gave first prize to Wacław Kłyszewski, Jerzy Mokrzyński and Eugeniusz Wierzbicki, the so-called Warsaw Tigers trio, whose design—a rather conventional two-level modernist building—was executed in November 1970.[12] Hansen's entry, rejected by the jury because of the technical impossibility of its execution,[13] nevertheless remained an inspiring proposal for the future—as Hristina Ivanoska noticed, it was "physically impossible, but conceptually real."[14]

1 Concerning Polish aid, see *Gabinet Ministra. Notatki dot. stosunków Polski i Jugosławii cz. 2*, Archive of the Polish Ministry of Foreign Affairs, file 26/46/5, pp. 97–98 [*Polska pomoc dla stolicy Macedonii – Skopje*]. The engagement of the People's Republic of Poland in the reconstruction of the Macedonian city was also underlined in a traveling exhibition organized by the Municipality of Skopje, see *Wystawa "Skopje – Miasto Międzynarodowej Solidarności,"* Archive of the Society of Polish Architects [later referred to as: SARP Archive], file 18/66.

FIG. 3 MUSEUM OF MODERN ART IN SKOPJE, A MODEL OF THE TEMPORARY
EXHIBITIONS SPACE, DESIGN: OSKAR HANSEN AND TEAM, 1966

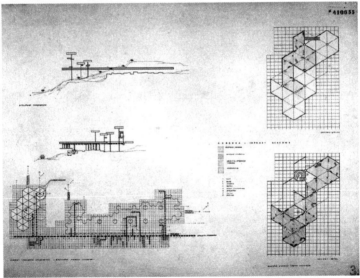

FIG. 4 MUSEUM OF MODERN ART IN SKOPJE, CONCEPTUAL DRAWINGS OF THE
TEMPORARY EXHIBITIONS SPACE, DESIGN: OSKAR HANSEN AND TEAM, 1966

2 Comp. Giovanni Damiani, "Anarchy Is Not Disorder. Reflections on Participation and Education," in *Team 10. In Search of a Utopia of the Present*, edited by Max Risselada, Dirk van den Heuvel, Rotterdam: NAi, 2005, p. 286f.

3 Jerzy Hryniewiecki, "Konkurs na muzeum w Skopje," *Architektura*, 1966, no.10, p. 422.

4 *Konkurs 383 Muzeum sztuki współczesnej w Skopje – Jugosławia 1965 r.*, SARP Archive, file 3/5132; Grażyna Jonkajtys-Luba, "Symbol przyjaźni i pomocy," *Architektura*, 1974, 4, pp. 140–143.

5 *Konkurs 383*, SARP Archive, op.cit.

6 Ibid. Nonetheless, numerous submitted proposals treated the museum as a conventional commemorative monument; see "Transcript from the Jury Proceedings," ibid.

7 Ibid, p. 11f [*Tymczasowe przepisy techniczne o budowie na terenach sejsmicznie aktywnych wg Dziennika Urzędowego Socjalistycznej Federacyjnej Republiki Jugosławii Nr 39 Rok XX z 1964 r.*].

8 The names of the authors of non-awarded projects were destroyed just after the announcement of competition results. Therefore, the registration number of Hansen's proposal could only be deduced from the project description. See Ibid., p. 53.

9 Interview with Hans Ulrich Obrist and Philippe Parreno, reprinted in Oskar Hansen, *Towards Open Form / Ku Formie Otwartej*, edited by Jola Gola, Warszawa: Fundacja Galerii Foksal, Muzeum ASP w Warszawie, Frankfurt: Revolver, 2005, p. 213.

10 Ibid., p. 116.

11 See Hansen, *Towards Open Form*, op.cit., p. 116.

12 See Hryniewiecki, "Konkurs na muzeum w Skopje," op.cit.; Jonkajtys-Luba, "Symbol przyjaźni i pomocy," op.cit.

13 According to the jury's entries, the doubts related to the transformable elements composing the galleries for temporary exhibitions—they were assessed as expensive, complicated and too risky for the seismically active area. *Konkurs 383*, SARP Archive, op.cit.

14 "Imagining the Museum: Sebastian Cichocki Talks to Hristina Ivanoska and Yane Calovski," in *Oskar Hansen's Museum of Modern Art*, edited by Sebastian Cichocki, Hristina Ivanoska, Yane Calovski, Bytom: CSW Kronika, 2007, p. 45.

Łukasz Stanek is a lecturer at the Manchester Architecture Research Centre, University of Manchester. Stanek wrote *Henri Lefebvre on Space: Architecture, Urban Research, and the Production of Theory* (University of Minnesota Press, 2011) and he is currently editing Lefebvre's unpublished book about architecture, *Vers une architecture de la jouissance* (1973). Stanek's second field of research is the transfer of architecture from socialist countries to Africa and the Middle East during the Cold War. On this topic, he published "Miastoprojekt Goes Abroad. Transfer of Architectural Labor from Socialist Poland to Iraq (1958–1989)" in *The Journal of Architecture* (17:3, 2012) and the book *Postmodernism Is Almost All Right. Polish Architecture After Socialist Globalization* (Fundacja Bęc Zmiana, 2012). He taught at ETH Zurich and the Harvard University Graduate School of Design, and received fellowships from the Jan van Eyck Academie, Canadian Center for Architecture, Institut d'Urbanisme de Paris, and the Center for Advanced Study in the Visual Arts (CASVA), National Gallery of Art in Washington, where he was the 2011–2013 A.W. Mellon Postdoctoral Fellow.

OSKAR AND ZOFIA HANSEN: ME, YOU, US AND THE STATE

In her polemical text "The Violent Consumer, or Waiting for the Goodies" (1974), Alison Smithson launched a bitter critique of the subjectivity created, in her estimation, by the postwar British welfare state, which valorized neither personal responsibility for the common good nor a sense of obligation and "reasoned" choice. Her criticism was directed at the very subjectivity of the "users" who vandalized the then recently opened Robin Hood Gardens housing estate designed by the Smithsons.[1] Alison Smithson argued that this "vandalism" was in no way a response to architecture but, rather, a symptom of the redistribution system of the welfare state that offered uniform solutions to a nonexistent collective and, in response, she proposed "to allow society to freely fragment, to become compartmented, group in its own loose way, seek difference in quality through effort in work... or not, as the case may be."[2]

In spite of these expressions that seem to feed into the neoliberal wave that was about to take over British politics, Smith-

[1] Alison Smithson, "The Violent Consumer, or Waiting for the Goodies," *Architectural Design*, May 1974, pp. 274–279. I would like to thank Aleksandra Kędziorek and Monika Stobiecka for their help in my archival research, and Jola Gola of the Warsaw Academy of Fine Arts Museum for making the archival materials available to me.
[2] Smithson, "The Violent Consumer," op.cit., p. 279

son's dissatisfaction with the welfare state was informed by what she called a "socialist dream." [3] Careful ambiguity was a part of political references in Team 10 discourse since the group began in the 1950s, and the "socialism" Smithson referred to would have more to do with Sweden of the 1930s, along with postwar Switzerland and the Netherlands, than with state socialism in Soviet-dominated Poland, where Oskar Hansen worked. [4] Yet for Hansen, it was precisely the reality of socialism and, above all, the socialist state as the agent of the production of space, that allowed for a solution to the challenge of the "greatest number" in all aspects of postwar societies identified within Team 10: technological advancement, personal mobility, the increasing importance of leisure, scales of human associations and multiple modes of belonging. While the laws of social development apply to both capitalist and socialist societies, it is only the latter that is able to apply these laws for economic coordination by the institutions of state planning—as was suggested by the Soviet scholar Iosif Paschawer in his *Law of Great Numbers and Laws of Mass Processes*. [5]

In this chapter, I will address the entanglement between architecture and the state in Hansen's work, and his rethinking of architectural agency in state socialism from within the project of the Linear Continuous System (LCS). This project, on which Oskar and Zofia Hansen worked in the 1960s and 1970s, was formulated in line with the theory of Open Form: a paradigm shift envisaged in the design of the built environment at every scale, which would "help us to define ourselves and find ourselves in the space and time in which we live." [6] LCS was conceived as a model for the urbanization of socialist Poland by means of four large settlement bands stretching throughout the whole country: an alternative to traditional, concentric cities. [FIG. 1] The decision to scale the project in relation to national territory immediately reveals the essen-

3 Ibid, p. 274.
4 Dirk van den Heuvel, "Alison and Peter Smithson: A Brutalist Story Involving the House, the City and the Everyday (Plus a Couple of Other Things)," PhD dissertation, TU Delft, 2013.
5 Iosif Paschawer, *Prawo wielkich liczb i prawidłowości procesu masowego*, Warszawa: Państwowe Wydawnictwo Ekonomiczne, 1967, p. 130.
6 Oskar Hansen, "Forma Otwarta," *Przegląd Kulturalny*, no.5, 1959, p. 5, translated as "Open Form Manifesto," available at www.open-form.blogspot.com, date of access August 26, 2012.

tial entanglement between the Linear Continuous System and the Polish postwar state. The state was indispensable for the execution of Hansen's project; yet, far from being a "utopia in the service of the regime,"[7] the project was not simply instrumental for the state, which needed to be radically transformed in order to execute LCS. Hansen's project was both a project "by" the state (to be implemented by the state) and "of" the state (of its modernization); in other words, Hansen aimed at rethinking the state and forms of statecraft as the subject of an architectural project.

LCS as a State Project

Dependent on the shifting political climate in socialist Poland, the work of Hansen was at times marginalized while in other periods, particularly the late 1960s to mid 1970s, he received funding and attention from Party technocrats looking for new models of socialist governance and economy. Hansen's reports to the ministerial planning committees, his memoranda to the Polish Academy of Sciences and statements published in planning and economic journals conveyed the idea of the Linear Continuous System as a model of urbanization suited to the socialist state. He wrote that "the realization of LCS is possible above all in a socialist state, which alone decides about land use, is responsible for the planning of building activities and controls funds and the construction industry."[8] Hansen argued that LCS is an "anti-city," an alternative to both the feudal model of urbanization, built against an external onslaught, and the capitalist city, constructed against the enemy within: the working class.[9] In this account, the socialist state is an avant-garde agent that replaces profit with an equal distribution of social welfare as the objective of the production of space.

Hansen did not withdraw from this opinion in the decades that followed. In an interview in 1977, when mocked by the

7 Hubert Mącik, "Utopia w służbie systemu?," in *Wobec Formy Otwartej Oskara Hansena: idea – utopia – reinterpretacja*, edited by Marcin Lachowski, Magdalena Linkowska, Zbigniew Sobczuk, Lublin: Towarzystwo Naukowe KUL, 2009, pp. 69–79.
8 "Antymiasto – propozycje polskich architektów," typescript, Oskar Hansen Archive, Warsaw Academy of Fine Arts Museum.
9 "LSC czyli jak budować antymiasta" (Interview with Oskar Hansen), *Życie Gospodarcze*, no. 9, 1969, pp. 1–2.

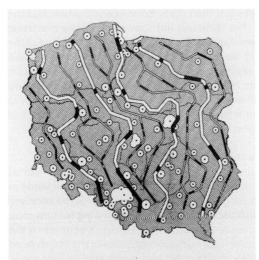

FIG. 1 OSKAR HANSEN AND TEAM, CONCEPTUAL DIAGRAM
FOR THE SPATIAL DEVELOPMENT OF POLAND WITHIN THE
LINEAR CONTINUOUS SYSTEM, 1972

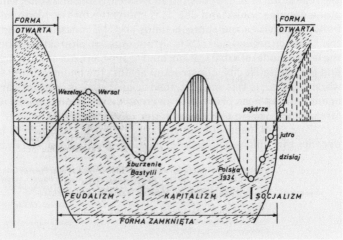

FIG. 2 OSKAR HANSEN, "DIAGRAM OF THE PULSATION PRINCIPLE OF CHANGES IN
SOCIAL RELATIONSHIPS AND SOCIAL PHENOMENA," 1974

architect and anticommunist activist Czesław Bielecki, who asked if "socialist architectural space" was not something like a "socialist square copybook," Hansen confirmed that there is a strict "conformity" between space and social system. [10] Even after the end of socialism he argued, no doubt against the general climate of opinion, that socialist Poland had offered opportunities for original solutions based on "holistic thinking"— which were impossible after Poland's return to peripheral capitalism. [11]

The most explicit account of Hansen's thinking about the relationship between socialism and Open Form—and, by extension, of LCS—can be found in a diagram he included in a 1974 research report titled "The City of the Future." [12] [FIG. 2] This diagram shows two curves of historical development. The oscillating curve charts the progress of socioeconomic formations as theorized by Marx, from feudalism through capitalism to socialism. This curve illustrates the apexes of Marx's historical narrative with architectural examples such as the Vézelay Abbey and the Palace of Versailles, which Hansen saw as defined by feudalism and religion, with the destruction of the Bastille as the turn to the new capitalist order. The year 1944, with the liberation of Poland from German occupation and its inclusion in the Soviet Bloc, marks the shift toward socialism. [13] Writing in 1974, Hansen marked the present moment on the ascending curve and in the accompanying text he suggested that the rise of socialism was the "kingdom of freedom": a direct reference to Marxian discourse. [14]

The second curve shows the movement from a period of Open Form to Closed Form and back to Open Form again. These spans of time are much greater than those of socioeconomic formations, and the period of "Closed Form" encompasses most of his-

10 See Czesław Bielecki, "The Pragmatism of Utopia / Pragmatyzm utopii," interview with Oskar Hansen, *Architektura*, 1977, no. 3–4, p. 22.
11 Hansen, letter to the organizers of the conference "Conceptual and Formal Motives in 20th century Architecture in Poland," March 5, 2000, typescript, Oskar Hansen Archive, Warsaw Academy of Fine Arts Museum, p. 1.
12 Hansen, "Miasto przyszłości," in *Miasto przyszłości*, no. 1, 1974, in the series *Polska 2000*, Wrocław: Zakład Narodowy im. Ossolińskich. Wydawnictwo PAN, p. 24.
13 Ibid., pp. 23ff. In the drawing, the date is 1934; this is corrected in the text, p. 34.
14 Ibid., p. 38. Engels described the proletarian revolution in Hegelian terms as the "ascent of man from the kingdom of necessity to the kingdom of freedom," Friedrich Engels, *Socialism: Utopian and Scientific*, 1880, www.marxists.org, date of access August 1, 2013.

torical time, stretching from feudalism to capitalism and the "present" of socialism, as indicated by Hansen. In other words, the Open Form, and by extension the Linear Continuous System, are independent of the distinction between capitalism and socialism. This allowed Hansen to see his work within a broad genealogy of linear models of urbanization since the late 19th century, among which he included schemes by Arturo Soria y Mata, Nikolai Milutin and Le Corbusier.[15] In Poland, this pertained particularly to the work of Jan Chmielewski, who had developed linear models of urbanization since the 1930s, including the Functional Warsaw plan, presented together with Szymon Syrkus during the CIRPAC meeting in London in 1934.[16] However, it was only after the Second World War that Chmielewski's ideas were spelled out in the National Plan in the late 1940s (the unattributed drawings from the documentation of this plan were used by Hansen in his presentation of LCS [FIG. 3]).[17] Chmielewski argued that socialism allows for integrated socioeconomic planning combined with spatial planning on regional, national and international scales, and that in the Polish context the best solutions would be offered by linear urbanization systems[18]—the very arguments Hansen would repeat as of the 1960s. [FIG. 4]

While Hansen's diagram shows that tendencies toward Open Form and toward socialism are independent, it also suggests compatibility between them. Hansen argued that inherited planning doctrines should be replaced with Open Form theory, "compatible with the socioeconomic model of the current formation."[19] Otherwise the spatial structure of Poland would continue in accordance

15 Hansen, "Linearny System Ciągły," *Architektura*, no. 4-5, 1970, pp. 125–136.
16 Jan Olaf Chmielewski, Szymon Syrkus, *Warszawa Funkcjonalna: przyczynek do urbanizacji regjonu warszawskiego*, Warszawa: Wydawnictwo Stowarzyszenia Architektów Polskich, 1935.
17 Chmielewski, "Podstawowe problemy planowania przestrzennego obszarów odnowy i rozwoju sił człowieka," *Problemy Uzdrowiskowe*, no. 1 (38), 1968, pp. 5, 9; for discussion, see: Sławomir Gzell, "Miastotwórcza rola transportu w teorii urbanistyki," *Czasopismo Techniczne. Architektura*, no. 1A (107), 2010, pp. 5–19.
18 Adam Kotarbiński, "Jan Chmielewski – sylwetka twórcy i zarys działalności," in *Początki planowania przestrzennego w Polsce, Studia i Materiały do Teorii i Historii Architektury i Urbanistyki*, no. XV, Warszawa: Wydawnictwo PWN, 1979, pp. 13–68.
19 Hansen, "Prognoza rozwoju układu osadniczego Polski w oparciu o Linearny System Ciągły," Oskar Hansen Archive, Warsaw Academy of Fine Arts Museum, p. 1.

FIG. 3 OSKAR HANSEN, LINEAR CONTINOUS SYSTEM IN THE SCALE OF POLAND AND
EUROPE BASED ON THE DIAGRAM BY JAN CHMIELEWSKI AND TEAM

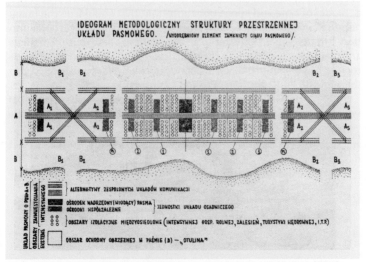

FIG. 4 JAN CHMIELEWSKI, "METHODOLOGICAL DIAGRAM OF THE SPATIAL STRUC-
TURE OF A LINEAR [URBANIZATION] PATTERN," 1968

with patterns inherited from 19th century, the period of the emergence of capitalism in Polish territories, at that time annexed by the neighboring powers of Russia, Prussia and Austria. [20] Hansen's questioning of the relationship between urbanization models and social justice reflected debates on the intersection between architecture, urban planning and sociology in postwar Poland, pioneered by Helena Syrkus and Stanisław Ossowski during the war, and carried out in the work of the urban sociologist Aleksander Wallis. [21] In his texts from the early 1960s, Wallis argued that the mechanisms of sociospatial segregation, typical for capitalist urbanization, did not disappear in Polish cities, which in spite of fundamental socialist restructuring in the two decades after the war were generally characterized by the stratification of income and social privileges. [22]

Gathering many of these arguments, Hansen claimed that the model of urbanization of Poland inherited from 19th century had three fallacies, and the LCS project could be reconstructed as a specific response to each of them. [FIG. 5] First, the disparity between life in the city and the countryside, which stems from inherited models of urbanization, contradicts the egalitarian character of socialism. [23] The then current urbanization of Poland did not advance a "model of time and space consumption" that could free the imagination of an egalitarian society from the capitalist model of consumption. [24] In response, LCS offered an alternative redistribution of times and places for everyday life: through binding parallel functional zones together, the system offered a balance between work and leisure, production and consumption, city and countryside.

Second, the historical model for the urbanization of Poland did not facilitate the integration of the country; it slowed the

20 Ibid.
21 For the bibliography of numerous papers on social neighborhoods from the 1940s by Helena and Szymon Syrkus, see: Józef Piłatowicz, "Poglądy Heleny i Szymona Syrkusów na architekturę w latach 1925–1956," *Kwartalnik Historii Nauki i Techniki,* no. 3–4 (54), 2009, pp. 123–164, in particular footnote 33; Stanisław Ossowski, *Dzieła* vol. 3, *Z zagadnień psychologii społecznej,* Warszawa: Wydawnictwo Naukowe PWN, 1967.
22 Aleksander Wallis, *Socjologia i kształtowanie przestrzeni,* Warszawa: Państwowy Instytut Wydawniczy, 1971, in particular the chapters: "Socjologia miasta a planowanie urbanistyczne," pp. 11–40; and "Możliwości zastosowania socjologii w urbanistyce," pp. 41–62.
23 Hansen, "Pro domo sua," *Miesięcznik Literacki,* no. 6, 1971, p. 96.
24 Hansen, "Prognoza rozwoju układu osadniczego Polski," op.cit., p. 1.

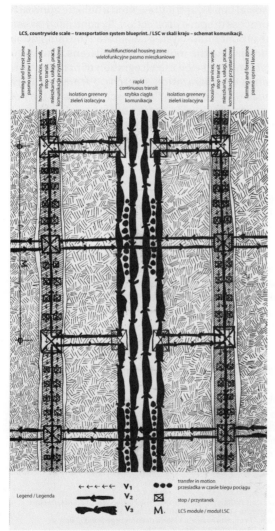

FIG. 5 OSKAR HANSEN AND TEAM, "LCS IDEOGRAM,
MULTIFUCTIONAL HOUSING ZONE SCALE"

emergence of new social bonds, and it prevented a holistic approach to the investment process in space production. By contrast, Hansen argued that the Linear Continuous System facilitated the integration of the country by enhancing the mobility of its citizens. This argument alluded to state discourse on the integration of national territory: the linear bands of urbanization stretching from the Tatra Mountains to the seashore "convey to the consciousness of the Polish inhabitant the image of a specific socio-geographical belonging, an image of Poland stretching from the mountains to the sea."[25] Hansen wrote this passage in 1972, only two years after West Germany formally recognized the western border of Poland. In this sense, the Linear Continuous System subscribed to the official discourse of the socialist state about the "return" of Upper Silesia and Pomerania to Poland and can be seen as a counterproposal to the 1941 planning of occupied Poland during the Second World War by means of the central-places theory of the German geographer Walter Christaller.[26] [FIG. 6]

Third, according to Hansen the inherited model of urbanization did not adequately represent the socialist formation, as the egalitarian character of LCS would manifest.[27] He argued that the redistribution of times and places according to the egalitarian principles of socialism is not only the responsibility of the state but also fulfills propagandistic aims. Hence LCS would "show to the societies of the capitalist countries that a different form of social relationships can lead to a better life than in other [social] formations; in different, correctly composed spatio-temporal division."[28]

Biotechnological Urbanism

The Linear Continuous System was embraced by several intellectuals close to the regime in Poland. For example, in 1968 the poet Julian Przyboś wrote in the newspaper *Życie Warszawy* that Hansen's project "can capture minds, rouse dreams, and stir energy," and urged the delegates of the fifth congress of the Polish United

25 Ibid., p. 2.
26 Walter Christaller, *Die Zentralen Orte in den Ostgebieten und ihre Kultur und Marktbereiche*, Leipzig: K. F. Koehler Verlag, 1941.
27 Hansen, "Prognoza rozwoju układu osadniczego Polski," op.cit.
28 Hansen, "Pro domo sua," op.cit., p. 99.

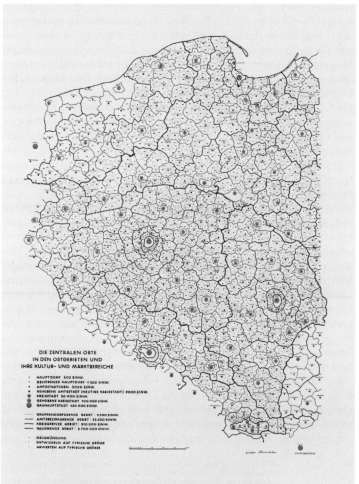

FIG. 6 WALTER CHRISTALLER, "CENTRAL PLACES IN THE EASTERN TERRITORIES AND THEIR CULTURAL AND MARKET ZONES," 1941

Workers' Party (*Polska Zjednoczona Partia Robotnicza*, the ruling Communist Party) to study LCS. [29] LCS was not unnoticed by government agencies, and in the early 1970s the project was given support by various ministries, state planning offices, and the Polish Academy of Sciences. For a period of several years, Hansen's theory of Open Form seemed to fit into the "opening" of Poland under Edward Gierek, the first secretary of the Polish United Workers' Party between 1970 and 1980. This included intensified international contacts and accelerating economic exchanges, in particular the import of technologies and consumer goods with loans from Western financial institutions. The mobility of Polish citizens was on the rise, with the first Polish Fiat leaving the factory in 1973 and with more people allowed to travel abroad, either as tourists or on export contracts, supported by the regime in its constant need for "hard" currency. [30]

Hansen's project fed into what Gierek called a "second industrialization," with industrial modernization and large-scale infrastructure investments, including roads, rail and power stations, which have formed the backbone of the country to the present. This was paralleled by accelerated processes of urbanization and migration from the countryside to cities, and in 1978, for the first time, the number of people working in Poland in industry surpassed the number working in agriculture. [31] The Linear Continuous System likewise responded to this tendency through attempting to accommodate the generation of baby boomers of the mid 1950s who entered the labor market in the 1970s, and the project of the efficient distribution of work and welfare answered to the effort of the state to grant them employment as well as social infrastructure. [32] At the same time, Hansen's project reflected the shift in the spatial planning of the city of Warsaw, where he lived and worked. In the first half of the 1970s, previous deglomeration attempts were abandoned and the city embraced speedy development and explosive investment pro-

29 Julian Przyboś, "Jak Polskę budować?," *Życie Warszawy*, no.259, 1968, p. 3, quoted in Mącik, "Utopia w służbie systemu?," op.cit., p. 70.
30 Łukasz Stanek, "Miastoprojekt Goes Abroad. Transfer of Architectural Labor from Socialist Poland to Iraq (1958–1989)," *The Journal of Architecture*, vol.17, no. 3, 2012, pp. 361–386.
31 Krzysztof Rybiński ed., *Dekada Gierka: wnioski dla obecnego okresu modernizacji Polski*, Warszawa: Wyższa Szkoła Ekonomiczno-Informatyczna, 2011.
32 Ibid.

cesses, including the construction of the Central Railway Station, two large thoroughfares (Wisłostrada, Trasa Łazienkowska), several large-scale housing developments (Targówek, Ursynów, Gocław) and the reconstruction of the Royal Castle. This was accompanied by new visions of the metropolitan future of the capital, captured in the 1978 master plan, which laid out the development of Warsaw within the region and privileged linear urbanization patterns. [33]

But the "opening" of Gierek also included a new vision of an "advanced socialist society." It was described by him in a 1973 speech as consisting of "educated and productive workers" who "multiply the legacy of past generations of the country while integrating their work into the efforts of the fraternal socialist nations." [34] This reverberated with Hansen's imagination about the society for which LCS was designed and that he described as a "postindustrial" society with its consumer needs fulfilled and plenty of free time at its disposal through the automation of production and services—an "active" society with the dramatic rise of voluntary social contacts facilitated by mass information exchange. [35]

As was the case with the project of the Workers' University by Radovan Nikšić and Ninoslav Kučan (1955–1961), aimed at the education of the masses toward self-management socialism in Yugoslavia, [36] so Hansen argued that Polish citizens needed to be educated toward the envisaged "advanced socialist society." He pointed out that this renewed collective subjectivity could be facilitated by the settlement network, turned into a "tool of the authority within a given socioeconomic formation to shape [...] the conditions of human life and psyche." [37] Statements like this puzzled several commentators, who perceived the Linear Continuous System as based on contradictory objectives. On one hand, the statement above suggested that LCS was intended to be a centralized project of social engineering; some commentators argued that when fully

33 Adam Kowalewski, *Warszawa: problemy rozwoju*, Warszawa: Książka i Wiedza, 1981.
34 Quoted in Jan Filip Staniłko, "Tęsknota za 'drugą Polską'," Rybiński ed., *Dekada Gierka*, op.cit., p. 51.
35 Hansen, "Miasto przyszłości," op.cit., pp. 38–39; Hansen, "Pro domo sua," op.cit., p. 97.
36 See the papers in this volume by Maroje Mrduljaš and Tamara Bjažić Klarin; as well as by Renata Margaretić Urlić and Karin Šerman.
37 Hansen, "Pro domo sua," op.cit., p. 95.

realized it would be a total system.[38] On the other, Hansen constantly described LCS as allowing for "maximal individual freedom," where inhabitants create their everyday space and architecture is but a background for the discharge of social energy.[39] In this instance, his favorite reference was the Rue Mouffetard in the 5th arrondissement of Paris, with its vibrant daily life, social mixture and sociability: a "jewel" as Hansen said, where he had lived during his apprenticeship in the Pierre Jeanneret studio in the late 1940s.[40]

Yet there is nothing contradictory about these two sides of Hansen's project in the context of late 1960s and early 1970s Poland, when Party functionaries recognized the necessity of introducing mechanisms of innovation, responsibility and criticism into the bureaucratic apparatus and the increasingly ossified planned economy. Quite along the same lines, the "coordination" of individual initiative by "organizers of space" was the general aim of the Open Form theory.[41] In 1974, Hansen wrote enthusiastically that "the tomorrow of our cities and villages has begun today" and several government activities are influenced by "thinking and acting according to the convention of Open Form, which to a large extent motivates the society to activity."[42] This aim of coordinating individual creativity was captured by Hansen's description of architecture as "background" that puts individual actors to the fore but also links them into a collective gestalt.[43]

Hansen stressed that the Linear Continuous System combined the collective potential of the state with a "rational" mobilization of individual potential.[44] These statements come from his 1974 report "The City of the Future" that was delivered to the Poland

38 Mącik, "Utopia w służbie systemu?," op.cit., p. 72.
39 Hansen, "Forma Otwarta," Polska, no. 1, 1972, p. 48.
40 Hans Ulrich Obrist, Philippe Parreno, "Entretien avec Oskar Hansen, Szumin, 21 décembre 2003," video in the collection of the Museum of Modern Art in Warsaw. Strikingly, the Rue Mouffetard was also a favorite example of Paul-Henry Chombart de Lauve in his discussions on the urban renewal projects in Paris of the 1950s, see: Rue Mouffetard: À la découverte des français 3, 1959, Archives INA / Paris.
41 Hansen, "W kierunku architektury '30 tysięcy cesarzy'," Poezja, no. 6, 1966, p. 75.
42 Hansen, "Miasto przyszłości," op.cit., p. 50
43 Hansen, "Studium humanizacji miasta Lubin," typescript, Oskar Hansen Archive, Warsaw Academy of Fine Arts Museum, p. 3; Hansen, "Forma Otwarta," Polska, op.cit., p. 48.
44 Hansen, "Miasto przyszłości," op.cit., p. 43.

2000 Committee, a think tank at the Polish Academy of Sciences. The committee was created in 1969 in order to conceive of possible scenarios of socioeconomic development for Poland until the year 2000, both through theoretical speculation about the future of the society according to Marxist laws of historical development, and by means of specific research studies commissioned by government planning institutions. [45] Many proposals of the committee pointed out that the progress of socialism depended on the mobilization of the population to individual initiative based on the cybernetic processing of sociological data, stimulation of innovation and information feedback within the system. These proposals were a part of a general rethinking of socialist management by research institutes at the Polish Academy of Sciences, which included a project to introduce competition among small-scale state enterprises, along with a proposal to create of a group of 100,000 unemployed people in order to motivate those who were employed. [46] The idea that even unemployment must be planned in a planned economy was not appreciated by Party officials, but some other suggestions were accepted, including the administrative reform of 1975. [47] Aiming at a more balanced development of the country, this reform doubled the number of provinces, or voivodeships [województwa], and hence the number of regional centers that, one might speculate, would lend themselves to being connected with bands of urbanization, as foreseen by Hansen. [48]

Among its various activities, the committee focused on national spatial planning, settlement structures and future housing standards. The conferences "Prognosis of Spatial Structure of the Settlement Network in Poland" (1970) and "The City of the Future"

45 Jan Danecki, "Prognozy rozwoju społecznego w pracach komitetu 'Polska 2000'," in *Perspektywy rozwiniętego społeczeństwa socjalistycznego w Polsce (wybrane problemy)*, no. 2, 1971, in the series *Polska 2000*, Wrocław: Zakład Narodowy im. Ossolińskich. Wydawnictwo PAN, pp. 94–95.

46 Witold Kieżun, "Reforma powiatowa z 1975 roku," in Rybiński ed., *Dekada Gierka*, op.cit., pp. 32–33.

47 Ibid.

48 Comp. Kowalewski, *Warszawa*, op.cit., pp. 61–63, see also the publications of Witold Kieżun, author of the administrative reform; *Autonomizacja jednostek organizacyjnych: z patologii organizacji*, Warszawa: Państwowe Wydawnictwo Ekonomiczne, 1971; *Tendencje zarządzania w warunkach rewolucji naukowo-technicznej*, Rzeszów: Towarzystwo Naukowe Organizacji i Kierownictwa, 1973; *Elementy socjalistycznej nauki o organizacji i zarządzaniu*, Warszawa: Książka i Wiedza, 1978.

(1973), with Hansen participating in both, as well as the symposium "Housing of the Future: the Function and Role of Housing in View of the Possible Standards of the Year 2000" (1972), gathered contributions of architects, planners, economists, sociologists, philosophers, administrators and Party officials. [49] For Hansen, the work of the Poland 2000 Committee, together with the employment of open prefabrication structures by the Polish construction industry, the integration of the country's electricity infrastructure and countrywide water management were "kernels" of a new reality brought forward by socialist Poland. [50] He argued that the urbanization models connected to the railway network, as developed by the committee [FIG. 7, 8], and the construction of linear settlements in Warsaw (Legionowo, Ursynów) and in Poznań-Piątkowo were tangible examples of the paradigm shift in Polish planning that the Linear Continuous System would bring to completion. [51]

In his report to the committee, Hansen distinguished three phases of the realization of LCS, and his description reveals it as a biopolitical system of governance that activates the population according to a predefined norm established by the analysis of population groups. The first phase deals with "objective parameters at the scale of the country," and the construction of "shelves," or "racks," for dwellings, that is to say large infrastructure that would accommodate housing projects. The second is a "specific public commission" developed at the scale of particular social groups, for example that of a housing cooperative, which includes the planning of the number of apartments, their typology and allocation of plots. The third level is assigned to "subjective elements" and the realization of the apartment by the inhabitant either by commissioning a (state) enterprise, by participating in a housing cooperative, by self-help of prospective neighbors or by individual means. Besides economic gains, Hansen argued that the engagement of inhabitants in the creation of their everyday environment has an important pedagogical

49 *Miasto Przyszłości*, op.cit.; *Mieszkanie przyszłości. Funkcje i rola mieszkania na tle perspektywicznego standardu w roku 2000*, no. 2, 1973, in the series *Polska 2000*, Wrocław: Zakład Narodowy im. Ossolińskich. Wydawnictwo PAN; *Prognozy rozwoju sieci osadniczej*, no. 2, 1973, in the series *Polska 2000*, op.cit.
50 Hansen, "Forma Otwarta," *Polska*, op.cit.; Hansen, "Miasto przyszłości," op.cit., p. 38.
51 Ibid., p. 51.

FIG. 7 SCHEMES FOR SETTLEMENT NETWORKS PLANNED ALONG THE LINES OF POLISH STATE RAILWAYS (THE ABBREVIATION "M" STANDS FOR INHABITANTS)

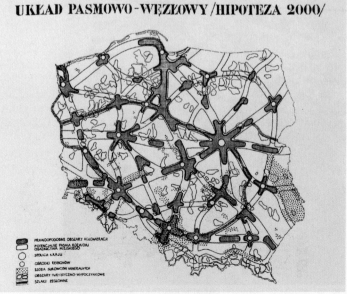

FIG. 8 "BAND AND NODE PATTERN, HYPOTHESIS 2000"

FIG. 9 SECTION THROUGH A HOUSING "RACK" FOR LUBIN IN WESTERN BELT PROJECT (II), DESIGN: OSKAR HANSEN AND TEAM, 1976

FIG. 10 MODEL OF THE SETTLEMENT STRUCTURE IN LUBIN IN WESTERN BELT PROJECT (II), DESIGN: OSKAR HANSEN AND TEAM, 1976

sense and includes a new experience of space and "new type of feeling" about the daily life, "different from the capitalist model." [52]

Hansen's project, which belongs among the clearest examples of the "biopolitics of scale" in European postwar urbanism, [53] was conveyed in his proposal for Lubin, designed as a part of the Linear Continuous System during the mid 1970s. This proposal offers a didactic image of a powerful state that provides a general framework to citizens while delineating specific spaces to be filled by individual initiative. In Lubin, an industrial town in Lower Silesia, Hansen suggested elevated terraces constructed by the state on the basis of the old mining infrastructure. [FIG. 9] Each family would be free to commission their house on the terraces or to build it by individual means. In this project, the central government was responsible for the construction of infrastructure and housing racks, various cooperatives decided about the quantity of houses and their types, and each family would be in charge of the construction of the individual housing unit. [FIG. 10] The latter one could imagine, perhaps, like Hansen's own house in Szumin, which he designed and built with Zofia and their son, Igor, in 1968, only two years after the first proposals for LCS. [FIG. 11]

The Lubin study reveals that what was at stake was the mobilization of the inhabitants—their mobilization to creativity—within a framework provided by a strategically self-limiting state. While subscribing to the general Team 10 theme of designing the city in terms of permanent and temporary elements, or those offered to the inhabitants and those appropriated by them, it goes further by making the accommodation unit the subject of individual responsibility. This project has much in common with the resettlement studies of Charles Polónyi in Ghana, which, like Hansen's, were above all projects of the state as an architectural agent where the main task of the architect was to draw the line between what is developed by the state and what is left to be constructed by the inhabitants by

52 Ibid. pp. 43, 46.
53 Łukasz Stanek, "Biopolitics of Scale: Architecture, Urbanism, the Welfare State and After," in *The Politics of Life–Michel Foucault and the Biopolitics of Modernity*, edited by Sven-Olov Wallenstein, Jacob Nilsson, Stockholm: Iaspis, 2013, pp. 106–120.

FIG. 11 THE HANSENS' HOUSE IN SZUMIN, DESIGN:
OSKAR, ZOFIA AND IGOR HANSEN, 1968

means of self-help. [54] Hansen called the performance of LCS "bio-technological," [55] and this term communicates the stake of the project: the management of life by drawing a line between state governance, self-management and self-discipline.

Architectural Agency in State Socialism

Recalling his studies at the Warsaw Academy of Fine Arts in the late 1960s, the artist Krzysztof Wodiczko said: "I was trained to be a member of the elite unit of designers, skillful infiltrators who were supposed to transform existing state socialism into an intelligent, complex and human design project." [56] Wodiczko referred to Jerzy Sołtan as the dean of the academy, who had hired Hansen as an assistant in 1950, thus opening Hansen's career path at the academy and to his becoming a professor in 1968. [57] While in Wodiczko's recollection the Gierek era meant a shift to technocracy and consumerism, [58] Hansen's engagements with institutions like the Poland 2000 Committee in the early 1970s point instead to the advances of such "infiltration" as conceived by the staff of the academy in the previous decade.

If it really was an "infiltration," after all. Hansen's various engagements with the regime cannot be captured by one metaphor, not only because of his constant readjustments in response to a meandering Party line, but also because the authorities' responses to his proposals were themselves ambiguous. These responses straddled a whole spectrum: praise of Hansen's "constructive criticism" that could be productive for the development of

54 J. Max Bond, J. Falconer, Charles Polónyi, "De la transformation à l'innovation," *Le Carré Bleu*, no.1, 1968, unpag.; comp. Ákos Moravánszky, "Peripheral Modernism: Charles Polónyi and the Lessons of the Village," *The Journal of Architecture*, vol.17, no. 3, 2012 , pp. 333–359.

55 Hansen, "Pasmo Zachodnie," in Hansen, *Towards Open Form / Ku Formie Otwartej*, Warszawa: Fundacja Galerii Foksal, Muzeum ASP w Warszawie, Frankfurt: Revolver, 2005, p. 55.

56 Douglas Crimp, Rosalyn Deutsche, Ewa Lajer-Burcharth and Krzysztof Wodiczko, "A Conversation with Krzysztof Wodiczko," *October*, vol. 38, Autumn 1986, p. 33.

57 Ibid., see also: "Chronology," in Hansen, *Towards Open Form*, op.cit., pp. 168–241.

58 Crimp et al., "A Conversation with Krzysztof Wodiczko," op.cit., p. 33; on Wodiczko and Hansen, comp. the paper by David Crowley during the conference "Oskar Hansen—Opening Modernism," Museum of Modern Art in Warsaw, June 7, 2013, www.artmuseum.pl, date of access August 1, 2013.

socialist Poland; suspicion toward his "reformism" that diluted the socialist project; his irresponsible "utopianism," which might have led to squandering the resources of the state; condemnation of his stubborn "dogmatism," which misunderstood the logic of the historical moment; his dangerous "revisionism" undermining the fundamentals of the Party; or political "dissidence."

In the final part of this chapter, I suggest reading Hansen's engagements with the state as an integral component of the Linear Continuous System, which was based on his rethinking of agency as an architect in real existing socialism. Consequently, it is his drawings more than his writings that convey an internal critique of the processes of urbanization in socialist Poland—while in his writings Hansen tended to omit structural antagonisms within the socialist system, these came to the fore in his specific proposals developed as facets of the Linear Continuous System.

For example, his proposal for Lubin aimed at alleviating the unbalanced development of the town caused by the domination of the copper mine and its supporting industries, while schools and kindergartens, commerce, services, transport and jobs for women were neglected. This condition resulted from specific antagonisms of political economy of space in state socialism. As was shown by the geographer Bohdan Jałowiecki, the main actors in space production in Poland were political authorities, including the central planning committee and the territorial planning agencies and planning offices of respective industry branches.[59] While they were supposed to be coordinated centrally, the planning decisions were resulting from a struggle and competition between industry branches and large state enterprises, typically heavy industry. Not competing in terms of costs and quality of their products, the enterprises were struggling for the maximalization of assets that would allow them to sustain their monopolist position and to secure their political importance in relation to local and central authorities. Among these assets, space was one of the most important, and in Jałowiecki's account socialism is presented as a competition for space between enterprises that emancipate from the control of the

59 Bohdan Jałowiecki, *Społeczne wytwarzanie przestrzeni*, Warszawa: Książka i Wiedza, 1988.

central power and aim at securing a constant growth not only of the production plant, but also of its subsidiaries. These processes led to the phenomenon of "overindustrialization" in cities where one dominant enterprise and several complementary factories, constituting one productive entity, subordinated all investments in space: transportation, housing and social infrastructure.[60] This often had disastrous consequences for the environment and the well-being of people, as in Lubin, where the relatively high income of the inhabitants was combined with solitude, absence of social contacts and lack of identification with the town.[61] That Hansen's project conveyed a critique of the urbanization of socialist Poland did not go unnoticed by reviewers, and one of them argued that Hansen's scheme "flawlessly captured the main drawbacks of the current urban structure in Lubin, which make it a town ill-disposed for inhabitation."[62]

In other words, while Hansen's account of the urbanization processes in postwar Poland (restricted to factors of the socialization of land, capital and industry, and the centralization of planning) was fundamentally incomplete, he developed a critical rethinking of these processes from his specific interactions with actors of space production in Poland. They included research centers such as the Architecture and Urban Planning Institute, but also housing cooperatives, as was the case with the project for the Rakowiec neighborhood in Warsaw (1958), town councils including Lubin, Przemyśl and Chocianów, and state industrial enterprises.[63] His extra-academic employment included the Warsaw Housing Cooperative (1958–1966), the Center for Building Research and Design in Warsaw (1966–1968) and the BIPROMASZ research institute in Warsaw (1973–1975).[64] This implied a collective mode of working with a range of collaborators, in particular with Zofia Hansen, his spouse,

60 Ibid.
61 Mikołaj Kozakiewicz, „Uwagi do projektu perspektywicznego zagospoda-rowania Lubina w aspekcie 'humanizacja miasta'," Warszawa, March 25, 1976, typescript, Oskar Hansen Archive, Warsaw Academy of Fine Arts Museum.
62 Ibid., p. 4.
63 "Miasto od Tatr do Bałtyku," Express Wieczorny, no. 9, 1969, p. 3, Hansen, "Studium humanizacji miasta Lubin"; Hansen, Towards Open Form, op.cit., pp. 225, 229.
64 Hansen, "Curriculum Vitae," typescript, Oskar Hansen Archive, Warsaw Academy of Fine Arts Museum.

but also with other architects, sculptors, painters, planners, engineers, and specialists in hydrography, meteorology and climatology, traffic engineers, sociologists and economists. The teams headed by Hansen often included more than 10 people. [65] This interdisciplinary approach was a part of the design process of LCS. For example, before designing the Juliusz Słowacki Housing Estate (1963–1966) in Lublin in southeast Poland, the architects used a questionnaire developed by sociologists from the Housing Institute in Warsaw. [66] [FIG. 12] Also, the analysis of the economist Tadeusz Michalak of LCS supported yet another exemplification of this project, now in the district of Ursynów in Warsaw. [67]

It is from such engagements that Hansen rethought the agency of an architect: working with local Party bureaucrats, housing cooperatives, building companies, construction industries, research institutes and administrative bodies. The housing project of Przyczółek Grochowski in Warsaw is a case in point. [68] Designed by Zofia and Oskar Hansen and constructed between 1969 and 1973, Przyczółek Grochowski is an ensemble of 22 separate blocks of flats that are joined by a gallery into a 1.5 kilometer unit. Due to the shape of the plot, the buildings meander with spacious courtyards and service areas in between, where the architects had foreseen a primary school, two kindergartens, nursery, trade and service center and administration office as well as a sports and cultural center. [FIG. 13]

Both Oskar and Zofia were highly critical of the realization of the project because of the fact that, among other things, the inhabitants were not allowed to choose their apartments, thus compromising one of the premises of the design philosophy. In retrospect Oskar Hansen said: "Why didn't we back out [from the project] when we found out that in that housing estate the technological pressures would not let us build houses in agreement with dwellers' own needs? Because in the Słowacki Housing Estate we have already

65　　　　"LSC czyli jak budować antymiasta," (Interview with Oskar Hansen), op.cit.; "Miasto od Tatr do Bałtyku," op.cit.
66　　　　Obrist, Parreno, "Entretien avec Oskar Hansen," op.cit.
67　　　　Hansen, "Miasto przyszłości," op.cit., pp. 47ff.
68　　　　Aleksandra Kędziorek, Łukasz Stanek, "Architecture as a Pedagogical Object: What to Preserve of the Przyczółek Grochowski Housing Estate by Oskar & Zofia Hansen in Warsaw?," *Architektúra & Urbanizmus*, no. 3–4, December 2012, pp. 2–21.

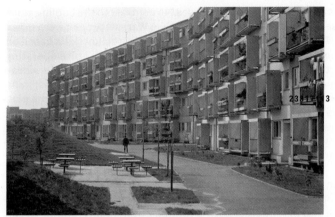

FIG. 12 JULIUSZ SŁOWACKI HOUSING ESTATE IN LUBLIN, DESIGN: OSKAR AND ZOFIA HANSEN, 1963–1966

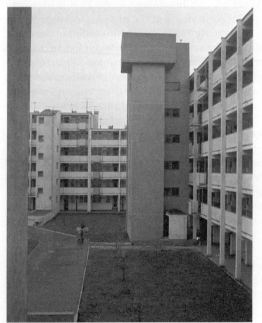

FIG. 13 PRZYCZÓŁEK GROCHOWSKI HOUSING ESTATE IN WARSAW, DESIGN: OSKAR AND ZOFIA HANSEN, 1968–1973

shown people how to build houses." In contrast to the Lublin estate, Hansen explained that the stakes of the Warsaw project were different: "The spatial organization [of Przyczółek Grochowski] is based on the break with separate houses-objects. It is a structure operating by virtue of communicating vessels in the sphere of social services—circulation, lifts, chutes, etc."[69] In this sense, one way of imagining architectural agency in Przyczółek Grochowski was to see the project as an experiment, a "trial run" as he put it,[70] one of many within a sequence. This provided an explanation—or an excuse—for the fact that Przyczółek Grochowski did not accumulate the gains of previous projects.

But besides being an experimenter, Hansen was, above all, an educator. This role was not limited to his tenure at the Academy of Fine Arts, and education needs to be grasped here in a broad sense and extended toward a fundamental understanding of the Open Form as a program of radical pedagogy, straddling both his contribution to education and his design work. This bridge was clearly formulated in Hansen's vision of the pedagogical reorganization of the academy in the early 1980s, which he worded in the same way as he described his architecture. In an article published in a journal of the branch of the anticommunist trade union *Solidarność* [Solidarity] at the academy, he sketched a vision of "open education" that offered choice to the students in terms of the program, organization, timing and assessment, and would train "organizers of space" who coordinate "subjective elements" into larger wholes.[71]

Beyond the context of studio teaching, Hansen considered his architectural projects, plans, drawings and realized buildings as facets of a pedagogical experience, a part of the "building of imagination."[72] In response to the questionnaire from the Institute of Housing Management (1972) about the "housing of the future" he argued that in socialism, where housing is not a commodity but a tool of individual development, it is necessary to move away from capitalist, disposable "houses-objects" and to imagine an alternative

69 Bielecki, "The Pragmatism of Utopia," op.cit., p. 24.
70 "Miasto od Tatr do Bałtyku," op.cit.
71 Hansen, "Czy potrzebne są zmiany w naszej uczelni?," *Numer*, no. 1, 1981, pp. 20–21.
72 "LSC czyli jak budować antymiasta," op.cit., p. 2.

everyday life. However, in Poland the past still weighs heavily on modes of thought, feeling and ways of life. [73] Hansen expressed similar criticism in 1967 when looking back at the last 20 years of Polish architecture: "it does not show that it has been created in new social-economic conditions." [74] He added that "we did not live up to the idea, we were unable to make use of the privileges and conditions, and create an ambitious oeuvre for today and a foundation for the future environment of socialist men." [75] He blamed this disappointing development on entrenched models of thought based on Closed Form and the limited scale resulting from capitalist ownership. But he also pointed out that various actors of space production in socialist Poland did not rise up to the challenges and lost the initiative: housing cooperatives that more often than not forgot about the pioneering role of the Warsaw Housing Cooperative in the interwar period, working with avant-garde architects including Helena and Szymon Syrkus; the state construction industry, suppressed by bureaucracy and inefficient logistics; and architects, irresponsibly following fashions from historicist decoration to "modernism" and hence not deserving the confidence of society. [76]

All these actors were targeted in Przyczółek Grochowski, which was designed to be a pedagogical experience for those involved. It was a training experience for the building industry in applying a more flexible prefabrication system: the Hansens introduced a new precast building system named Żerań-brick that, after a series of adjustments coordinated with the factory, allowed for the cascading form of the building and facilitated a distribution of load-bearing walls that made possible future mergers of adjoining apartments. [77] [FIG. 14] It was a lesson for the architectural authorities facing a new type of design complexity, and resulted in intense negotiations, including those about the size and position of the galleries and their materials. It was a testing ground for the housing cooper-

73 Hansen, Letter to the Institute of Housing Management, Warsaw, January 2, 1972, unpag., Oskar Hansen Archive, Warsaw Academy of Fine Arts Museum.
74 Hansen, "Całość i detal," *Architektura*, no.3, 1967, p.89.
75 Ibid.
76 Ibid., pp.89–90.
77 For discussion, see: Kędziorek, Stanek, "Architecture as Pedagogical Object," op.cit.

ative, to understand itself as a community, with numerous spaces envisaged to encourage social contacts and collaboration among the inhabitants, from the galleries to the entrance areas shared by two neighbors. Finally, it was a demonstration of the architects' pragmatism and ability to compromise while keeping long-term goals in view. To understand the Hansens' architecture as a pedagogical object might explain the energy invested by Oskar and Zofia into a seemingly endless chain of negotiations, with small victories achieved at the price of substantial compromises, in which some of the main ideas of the project were spoiled, as Zofia pointed out.[78] They hoped these compromises would prove correctable in the near future by now-educated inhabitants, builders and administrators.

But if Przyczółek Grochowski was a pedagogical experience, the lessons were hard to learn. The antagonisms of socialist urbanization not only prevented the realization of LCS, but some suggested that even when realized, the project would reflect these antagonisms—as early as 1968, Aleksander Wallis argued that even within LCS new social inequalities would emerge, at least those related to differences in education and professional life.[79] On several occasions, Hansen's overidentification with the socialist regime resulted in his design becoming a manifestation of the regime's contradictions. In retrospect he commented on the changed position of the galleries in Przyczółek Grochowski, which prevented the privacy of the inhabitants. He stressed that this change was imposed on him. But he decided to carry on, justifying his actions as follows: "people will anyway find out which system was better—whether the authorities were right, or the authors."[80] Faced with the bureaucracy of the administration and building industry, Hansen reached for yet another hat—that of the polemicist.

It is through polemics, by trying out and debating various approaches, that architects can reclaim the role of "producers of space," he argued.[81] Once again, his approach resembled that of Charles Polónyi, who resigned from the idea of becoming a journal-

78 Joanna Mytkowska, Interview with Zofia Hansen, unpublished; Filip Springer, *Zaczyn. O Zofii i Oskarze Hansenach*, Kraków–Warszawa: Karakter, Muzeum Sztuki Nowoczesnej w Warszawie, 2013.
79 "Linearny System Ciągły," *Projekt*, no. 2, 1968, pp. 37-51.
80 Bielecki, "The Pragmatism of Utopia," op.cit., p. 25.
81 Hansen, "Całość i detal," op.cit., p. 90.

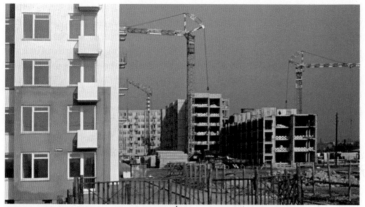

FIG. 14 CONSTRUCTION OF THE PRZYCZÓŁEK GROCHOWSKI HOUSING
ESTATE IN WARSAW, DESIGN: OSKAR AND ZOFIA HANSEN, 1968–1973

FIG. 15 OSKAR HANSEN, "A DREAM OF WARSAW," 2005, FOKSAL GALLERY
FOUNDATION, WARSAW, EXHIBITION VIEW

ist and became an architect, just to discover that polemics is what is shared by both professions.[82] Hansen's polemics spanned several decades and unfolded in weekly journals, economic magazines, art journals and the daily press. This understanding of architecture as a polemical event, which was meant to influence debate and bring the realization of LCS closer, became more and more characteristic of Hansen's later career. In a 1977 interview, he embraced his role of polemicist and he accepted that his projects were mocked:

> The LCS model will not be realized in my lifetime, therefore, I must be *l'enfant terrible*, and do so-called utopian designs, so as to wake and shape social consciousness as early as today, in order that tomorrow LCS might become reality. The fact that people write about LCS, that we are talking about LCS now, can be seen as our success.[83]

This polemical approach was conveyed by one of his last projects, "A Dream of Warsaw" (2005), conceived for the surroundings of the Palace of Culture and Science in Warsaw, the highrise designed by Soviet architect Lev Rudnev in the socialist-realist idiom (1955).[84] The Palace was for Hansen everything he protested against, a hierarchical structure that he saw as, by definition, "sociologically and economically incorrect in a socialist country."[85] Hence, in a conversation in 1968 he explained the Linear Continuous System by its opposition to the Palace: LCS was "not about the Palace of Culture and Science, around which everything rotates."[86] The Palace was a paradigmatic closed form and hence a pendant of dogmatic regimes, as Hansen suggested by juxtaposing in his last book (2005) a photograph of a 1960s celebration of Party leadership in front of the Palace and the celebration of a Catholic mass in the same place after the end of socialism.[87] In "A Dream of Warsaw," Hansen suggested constructing a tower with a contrasting, anthropomor-

82 Charles Polónyi, *An Architect-Planner on the Peripheries: The Retrospective Diary of Charles K. Polónyi*, Budapest: Műszaki Könyvkiadó, 2000.
83 Bielecki, "The Pragmatism of Utopia," op.cit., p. 25.
84 Artur Żmijewski, *A Dream of Warsaw*, film, 2005.
85 "Linearny System Ciągły," *Projekt*, no. 2, 1968, p. 45.
86 Ibid., p. 46.
87 Hansen, "Zobaczyć świat," Warszawa: Zachęta Narodowa Galeria Sztuki, Muzeum ASP w Warszawie, 2005, p. 103.

phic shape next to the Palace: a thin building with an elliptical head. [FIG. 15] Rather than destroying or covering the Palace, as was suggested by numerous proposals discussed in Warsaw in the course of the 1990s, he suggested that the new building ought to "polemicize with it, like cultured people."[88]

This project shows how Hansen's polemical approach was carried on after the end of socialism in Poland. Since he saw the distinction between Open and Closed Form as much more general than that between socialism and capitalism,[89] he continued advocating for his Open Form theory. In a 2005 interview, he commented on Przyczółek Grochowski, in which the fallacies of the socialist building industry were exacerbated by the privatization of space and the processes of social segregation in post-socialist Warsaw. Hansen looked "to draw up a study of Przyczółek's 'humanization'" and to restore "its original guiding principle," rather than its original form.[90] This would have required reclaiming the position of the architect in the processes of space production and embracing Przyczółek Grochowski, once again, as an architectural project. Architecture understood in the broad sense that he advocated: starting with the fundamentals of the discipline—the perception of light and shadow, the relationship between the body and the mass, experiential scales—and extending them toward a project of experimentation, education, criticism and polemics.

88 Ibid.
89 Obrist, Parreno, "Entretien avec Oskar Hansen," op.cit.
90 Hansen, "In Conclusion. On the 'Humanization,' or, Basically, the Restoration of Przyczółek's Public Space," in Hansen, *Towards Open Form*, op.cit., p. 100.

FRONT COVER:
© Jan Smaga, courtesy of the Foksal Gallery Foundation

BACK COVER:
© Museum of Architecture in Wrocław

INSERT:
© CIAM Archive, gta Archive, ETH Zurich

P. 15, FIG. 1
Photo by Joachim Pfeufer. © Joachim Pfeufer

p. 16, FIG. 2
© Ungers Archiv für Architekturwissenschaft, Cologne

P. 19, FIG. 3
© The State Archives of the Republic of Macedonia, Department of Skopje

P. 22, FIG. 4
© TTEN f17, Het Nieuwe Instituut, Rotterdam

P. 26, FIG. 5
© TTEN f12, Het Nieuwe Instituut, Rotterdam

P. 36, FIG. 1
Source: *Magyar Építőművészet*, no. 1, 1962. Courtesy of MÉ - meonline.hu

P. 36, FIG. 2
Source: *Magyar Építőművészet*, no. 4, 1962. Courtesy of MÉ -meonline.hu

P. 40, FIG. 3, P. 43, FIG. 4, P. 48, FIG. 6
Source: *Magyar Építőművészet*, no. 4-5, 1958. Courtesy of MÉ - meonline.hu

P. 45, FIG. 5
Source: Oscar Newman, *CIAM '59 in Otterlo*, Stuttgart: Karl Krämer Verlag, 1961

P. 51, FIG. 7
© Anikó Polónyi

P. 51, FIG. 8
Source: *Kumasi Study: Report on the Postgraduate Urban Planning Course. Occasional Report No. 7* by B.T. Fewings and C.K. Polónyi, 1967. © Kumasi: Faculty of Architecture, University of Science & Technology

P. 53, FIG. 9
Source: *Le Carré Bleu*, no. 1, 1968. © Le Carré Bleu

P. 56, FIG. 10 and FIG. 11
© TESCO-KÖZTI Survey and Development Plan for Calabar, Budapest 1970

P. 59, FIG. 12
© Oskar Hansen Archive, courtesy of Igor Hansen, Karolina Hansen, Svein Hatløy

P. 61, FIG. 13
Source: *Architektura*, no. 3, 1971

P. 66, FIG. 1 and FIG. 3
Source: Charles K. Polónyi, *An Architect-Planner on the Peripheries. A Retrospective Diary of C. K. Polónyi*, Budapest: Műszaki Könyvkiadó, 2000. © Műszaki Könyvkiadó

P. 68, FIG. 2
Source: the program of the "International Workshop Seminar—Gül Baba," 1987

P. 84, FIG. 1
Photo by Viktor Rudiš. © Viktor Rudiš

P. 86, FIG. 2
Source: *Československý architekt*, 25-26, 1966. © Československý architekt

P. 89, FIG. 3, P. 90, FIG. 6, P. 93, FIG. 7
© Viktor Rudiš

P. 89, FIG. 4, P. 90, FIG. 5
Photo by Viktor Rudiš. © Viktor Rudiš

P. 94, FIG. 8, P. 97, FIG. 9, P. 98, FIG. 10 and FIG. 11
© Miroslav Masák

P. 103, FIG. 1
Photo by Joachim Pfeufer. © Joachim Pfeufer

P. 104, FIG. 2
Source: *Architectural Design*, no. 5, 1960

P. 110, FIG. 1, P. 112, FIG. 4
© Warsaw Academy of Fine Arts Museum

P. 112, FIG. 2
© Museum of Architecture in Wrocław

P. 112, FIG. 3, P. 113, FIG. 5
Source: *Architektura*, no. 8, 1957

P. 121, FIG. 1
Source: the inaugural issue of *Le Carré Bleu*, no. 0, 1958. © Le Carré Bleu

P. 124, FIG. 2 and FIG. 3
© Oskar Hansen Archive, courtesy of Igor Hansen, Karolina Hansen, Warsaw Academy of Fine Arts Museum

P. 127, FIG. 4
Source: Pekka Visuri, *Suomi Kylmässä Sodassa*, Helsinki: Otava 2006

P. 130, FIG. 5
© Museum of Finnish Architecture, Helsinki

P. 130, FIG. 6
© Maria and Juha Petäjä

P. 134, FIG. 7
Source: *Le Carré Bleu*, no. 2, 1959. © Le Carré Bleu

P. 134, FIG. 8
Source: *Le Carré Bleu*, no. 1, 1958. © Le Carré Bleu

P. 137, FIG. 9
Source: *Le Carré Bleu*, no. 3, 1960. © Le Carré Bleu

P. 139, FIG. 10 and FIG. 11
© Museum of Finnish Architecture, Helsinki

P. 141, FIG. 12, P. 142, FIG. 13
© Oskar Hansen Archive, courtesy of Igor Hansen, Karolina Hansen, Warsaw Academy of Fine Arts Museum

P. 150, FIG. 1
Source: *Arhitektura urbanizam*, no. 58, 1962. © Arhitektura urbanizam

P. 150, FIG. 2
Source: photo album of Štip, gift of the cotton industry "Makedonka" Štip, 1957. Collection of photo albums of Museum of Yugoslav History, Belgrade

P. 153, FIG. 3
Source: Aleksandar Spasić, *Novi Beograd*, Belgrade: Direkcija za izgradnju Novog Beograda, 1967, p. 64

P. 153, FIG. 4, P. 154, FIG. 5
© Magazine Izgradnja

P. 158, FIG. 1
Photo by Krešimir Tadić, source: *Arhitektura*, no. 3–4, 1961. © Architektura i Urbanizam

P. 158, FIG. 2
Source: Oscar Newman, *CIAM '59 in Otterlo*, Stuttgart: Karl Krämer Verlag, 1961

P. 160, FIG. 3
© Croatian Museum of Architecture in Zagreb

P. 162, FIG. 4 and FIG. 5
© Open Public University Photo Archive, Zagreb

P. 173, FIG. 1
© Croatian Architects' Association Archive

P. 173, FIG. 2, P. 175, FIG. 3
© Tošo Dabac Archive, Museum of Contemporary Art, Zagreb

P. 176, FIG. 4
© Vladimir Turina Archive, Zagreb City Museum

P. 181, FIG. 5 and FIG. 6
© Peoples' Open University Archive, Zagreb

P. 184, FIG. 7 and FIG. 8
© Croatian Architects' Society Archive

P. 187, FIG. 9 and FIG. 10, P. 188, FIG. 11 and FIG. 12
© Mladen Vodička Archive, Department of Architectural Technology and Building Science, Faculty of Architecture, University of Zagreb

P. 190, FIG. 13, P. 192, FIG. 14, P. 194, FIG. 15
© Ivan Crnković

P. 200, FIG. 1 and FIG. 2
Photo by Aleksandar Stjepanović. © Aleksandar Stjepanović

P. 206, FIG. 1
© Oskar Hansen Archive, courtesy of Igor Hansen, Karolina Hansen, Warsaw Academy of Fine Arts Museum

P. 206, FIG. 2
Photo by Wojciech Zamecznik. © Stanisław Zamecznik Archive, Museum of Modern Art in Warsaw, courtesy of Marianne Zamecznik

P. 208, FIG. 3 and FIG. 4, P. 214, FIG. 1
© Oskar Hansen Archive, courtesy of Igor Hansen, Karolina Hansen, Warsaw Academy of Fine Arts Museum

P. 214, FIG. 2
Source: *Miasto Przyszłości*, no. 1, 1974 in the series *Polska 2000*, Wrocław: Zakład Narodowy im. Ossolińskich, Wydawnictwo PAN

P. 217, FIG. 3
© Oskar Hansen Archive, courtesy of Igor Hansen, Karolina Hansen, Warsaw Academy of Fine Arts Museum. Based on the diagram by Jan Chmielewski and team, "Poland in Europe," in *National Study Plan*, Head Office of Spatial Planning 1947–48, in Adam Kotarbiński, "Jan Chmielewski—sylwetka twórcy i zarys działalności," Początki planowania przestrzennego w Polsce, *Studia i Materiały do Teorii i Historii Architektury i Urbanistyki*, no. XV, Warszawa: Wydawnictwo PWN, 1979

P. 217, FIG. 4
Source: Jan Chmielewski, "Podstawowe problemy planowania przestrzennego obszarów odnowy i rozwoju sił człowieka," *Problemy Uzdrowiskowe*, no. 1(38), 1968. © Polskie Towarzystwo Balneologii i Medycyny Fizykalnej

P. 219, FIG. 5
© Oskar Hansen Archive, courtesy of Igor Hansen, Karolina Hansen, Warsaw Academy of Fine Arts Museum

P. 221, FIG. 6
Source: Walter Christaller, *Die Zentralen Orte in den Ostgebieten und ihre Kultur und Marktbereiche*, Leipzig: K.F. Koehler Verlag, 1941

P. 227, FIG. 7
Source: Władysław Czerny, "Miasto przyszłości—struktury osiedlenia," in *Miasto Przyszłości*, no. 1, 1974 in the series *Polska 2000*, Wrocław: Zakład Narodowy im. Ossolińskich, Wydawnictwo PAN

P. 227, FIG. 8
Source: *Prognozy rozwoju sieci osadniczej*, edited by Włodzimierz Wesołowski, Komitet Badań i Prognoz "Polska 2000", Wrocław: Zakład Narodowy im. Ossolińskich, Wydawnictwo PAN, 1974

P. 228, FIG. 9 and FIG. 10, P. 230, FIG. 11, P. 235, FIG. 12 and FIG. 13, P. 239, FIG. 14
© Oskar Hansen Archive, courtesy of Igor Hansen, Karolina Hansen, Warsaw Academy of Fine Arts Museum

P. 239, FIG. 15.
Photo by Jan Smaga. © Jan Smaga, courtesy of the Foksal Gallery Foundation

Team 10 East. Revisionist Architecture in Real Existing Modernism

This volume is an outcome of two events dedicated to Team 10 members and fellow travelers from Central and Eastern Europe, organized at the Museum of Modern Art in Warsaw: a panel "Team 10 East" held during the conference "Oskar Hansen—Opening Modernism" (curated by Aleksandra Kędziorek and Łukasz Ronduda in collaboration with Łukasz Stanek, June 6–7, 2013) and a research workshop "Team 10 East" (organized by Łukasz Stanek in collaboration with Aleksandra Kędziorek, June 8, 2013). Organization of those events would not be possible without a generous support from the Graham Foundation for Advanced Studies in the Fine Arts, EEA grants, the Adam Mickiewicz Institute and the British Council.

This publication has been supported by

ERSTE Stiftung

Series editors
Marta Dziewańska
Katarzyna Szotkowska-Beylin

Volume editor
Łukasz Stanek
Editorial assistance: Aleksandra Kędziorek
Copyrights assistance, Index: Katarzyna Janusik

Copyedited by
C. Cain Elliott

Proofread by
Mark Bence, Alan Lockwood

Design concept
Ludovic Balland, Typography Cabinet, Basel

Typesetting and lithography
Noviki Studio, Katarzyna Nestorowicz,
Marcin Nowicki

Typefaces
Ludwig Pro

Printed by
EPEdruk Sp. z o.o.
ul. Konwiktorska 9, 00-216 Warszawa

Cover photographs
Front cover: Oskar Hansen, "A Dream of Warsaw," 2005, Foksal Gallery Foundation, Warsaw, exhibition view, photo by Jan Smaga
© Jan Smaga, courtesy Foksal Gallery Foundation
Back cover: Jerzy Sołtan, Zbigniew Ihnatowicz, Lech Tomaszewski and Wojciech Fangor, Polish pavilion at Expo 58 in Brussels, a competition board (coloring: Tadeusz Babicz)
© Museum of Architecture in Wrocław

Copyrights
All texts © Museum of Modern Art in Warsaw and Authors, Warsaw 2013 / 2014
Photo credits: pp.243–245

Publisher
Museum of Modern Art in Warsaw
Pańska 3
00-124 Warsaw
www.artmuseum.pl

ISBN: 978-83-64177-03-3

Distributed by
The University of Chicago Press
www.press.uchicago.edu

BOOKS

THE MUSEUM UNDER CONSTRUCTION
BOOK SERIES

WE ARE BUILDING
A MUSEUM OF MODERN ART IN WARSAW
WE ARE WRITING
A NEW HISTORY OF ART

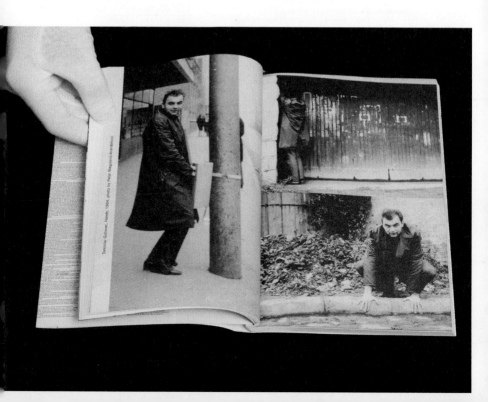

BOOKS

THE MUSEUM UNDER CONSTRUCTION BOOK SERIES

EDITED BY MARTA DZIEWAŃSKA AND
KATARZYNA SZOTKOWSKA-BEYLIN

No. 1 **1968–1989: POLITICAL UPHEAVAL AND ARTISTIC CHANGE**
Edited by Claire Bishop and Marta Dziewańska
Museum of Modern Art in Warsaw, 2009
The texts assembled in this reader are a selective record of presentations from the "1968–1989" seminar, held as a comparative reflection on the artistic significance of 1968, the political transformation of 1989 and methods of communication in art.
ISBN 978-83-924044-0-8

No. 2 **ION GRICORESCU: IN THE BODY OF THE VICTIM**
Edited by Marta Dziewańska
Museum of Modern Art in Warsaw, 2010
This book is an attempt to read the work of one of the most charismatic and original artists from the former Eastern Bloc, who worked in relative isolation until 1989, and whose art can be viewed in relation to similar positions artists have taken in other parts of the world.
ISBN 978-83-924044-1-5

No. 3 **WARSZAWA W BUDOWIE 2009**
[Warsaw Under Construction 2009]
Edited by Marcel Andino-Velez
Museum of Modern Art in Warsaw, 2010
This book is a record of events that took place as part of the "Warsaw Under Construction" festival's first edition, focused on design, architecture and town planning and attempting to capture the spirit and creative energy that had then begun taking over the city. Book in Polish language.
ISBN 978-83-924044-2-2

No. 4 **AS SOON AS I OPEN MY EYES I SEE A FILM. EXPERIMENT IN THE ART OF YUGOSLAVIA IN THE 1960S AND 1970S**
Edited by Ana Janevski
Museum of Modern Art in Warsaw, 2010
This book is inspired by the first exhibition organized by the museum. It is a journey to a country that has ceased to exist, but which gave rise to the most important art myth in our part of Europe: the myth of radical art.
ISBN 978-83-924044-3-9

No. 5 **ALINA SZAPOCZNIKOW AWKWARD OBJECTS**
Edited by Agata Jakubowska
Museum of Modern Art in Warsaw, 2011
The book addresses the life and work of one of the important women of 20th-century art, who always put herself in the difficult, pioneering position of heading toward the new and unknown.
ISBN 978-83-924044-6-0

No. 6 **LOVELY, HUMAN, TRUE, HEARTFELT: THE LETTERS OF ALINA SZAPOCZNIKOW AND RYSZARD STANISŁAWSKI 1948–1971**
Edited by Agata Jakubowska and Katarzyna Szotkowska-Beylin
Museum of Modern Art in Warsaw, 2012
The previously unpublished correspondence between Alina Szapocznikow and Ryszard Stanisławski, a woman of increasing importance in 20th-century art and a man who was an eminent critic and museum director. Their letters bear witness to Szapocznikow's artistic path, offering a rare window into her own work, and yielding a rich portrait of their love, marriage and friendship.
ISBN 978-83-933818-6-9

No. 7 **POST-POST-SOVIET?**
Edited by Marta Dziewańska, Ekaterina Degot, Ilja Budraitskis
Museum of Modern Art in Warsaw, 2013
By placing emerging artists in their political and social contexts, this book attempts to confront the activist scene that has arisen in today's art world in Russia.
ISBN 978-83-933818-4-5

BOOKS

ALSO ON A TEAM 10 ARCHITECT:

No. 8 **OSKAR HANSEN—OPENING MODERNISM:**
ON OPEN FORM ARCHITECTURE, ART AND DIDACTICS
Edited by Aleksandra Kędziorek and Łukasz Ronduda
Museum of Modern Art in Warsaw, 2014

This book is a result of the conference "Oskar Hansen—Opening Modernism" organized at the Museum of Modern Art in Warsaw in 2013, and analyzes diverse aspects of the oeuvre of the renowned Polish member of Team 10. The volume accompanies the Hansen exhibition that premieres at the MACBA in Barcelona in 2014.

ISBN 978-83-64177-05-7